NINETEENTH-CENTURY ART

From Romanticism to Art Nouveau

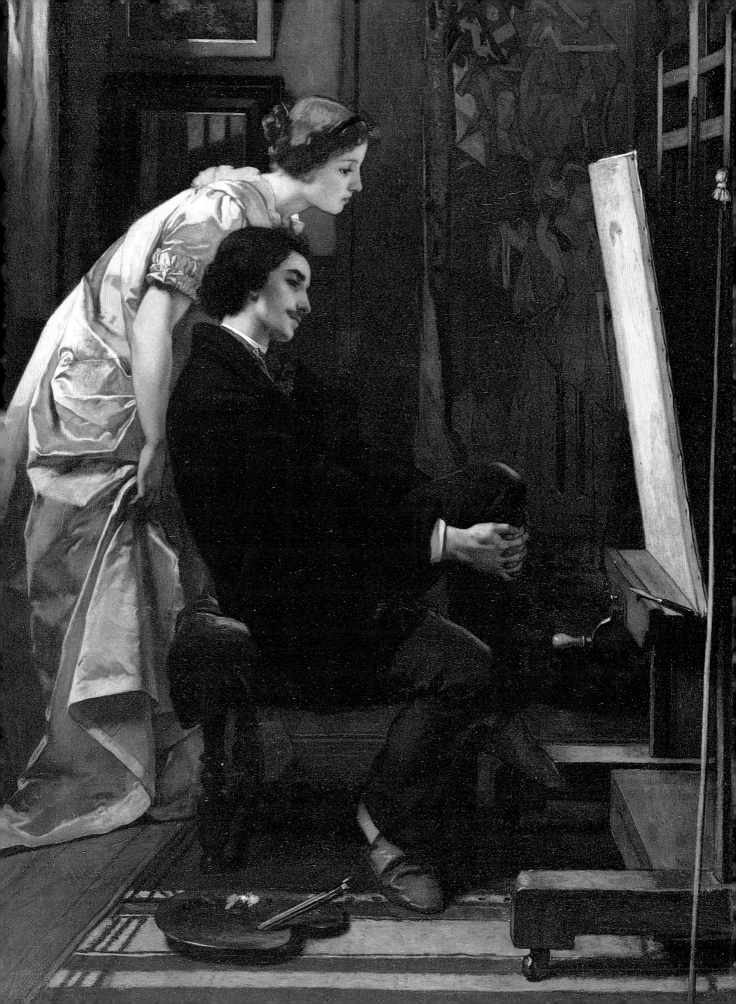

NINETEENTH-CENTURY ART

From Romanticism to Art Nouveau

The Walters Art Gallery, Baltimore

William R. Johnston

This publication is supported by
an endowment established by
The Jacob and Hilda Blaustein Foundation

THE WALTERS ART GALLERY SCALA PUBLISHERS LIMITED

SCALA

Copyright © The Walters Art Gallery, 2000

First published in 2000 by
Scala Publishers Ltd
143–149 Great Portland Street
London WIN 5FB

Distributed outside The Walters Art Gallery
in the USA and Canada by
Antique Collectors' Club
Market Industrial Park
Wappingers Falls
NY 12590

ISBN (trade edition): 1 85759 226 3
ISBN (museum edition): 1 85759 243 3

All measurements are in inches followed by centimeters;
Height precedes width precedes depth.

The Walters Art Gallery Editor: Deborah Horowitz
Editor: Moira Johnston
Designer: Andrew Shoolbred
Photographer: Susan Tobin
Printed and bound by Editoriale Lloyd s.r.l. in Trieste, Italy

Cover/jacket illustrations

Front: Julius LeBlanc Stewart,
Detail from *Portrait of Mrs Stanton Blake*, 1908
(37.2465)

Back: Dutch, Vase, 1902
(48.2356)

Title page illustration: Alfred Stevens,
Detail from *The Painter and his Model*, 1855
(37.322)

CONTENTS

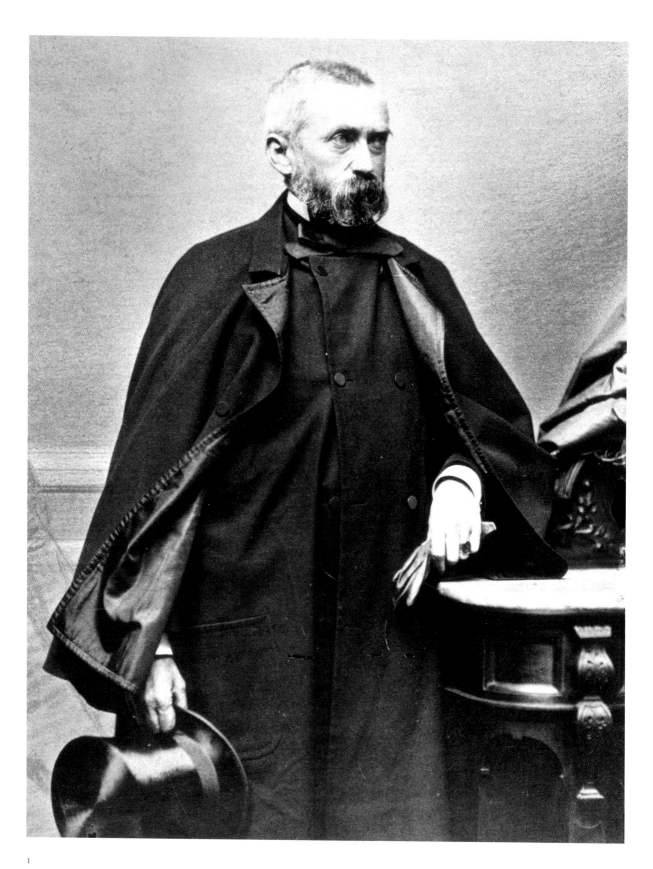

I

William T. Walters, 1880s

INTRODUCTION:

The Nineteenth-Century Collection at the Walters Art Gallery

The origins of the Walters Art Gallery can be traced to a "parlor" collection of contemporary pictures assembled by William Thompson Walters (1819–94) in the late 1850s. A native of Liverpool in central Pennsylvania, Walters had been attracted to Baltimore in 1840 by the city's burgeoning economy. He established a wholesale liquor house which prospered, providing him with the means to purchase a residence in fashionable Mount Vernon Place and to indulge in collecting art. Initially, he patronized local talents including Alfred Jacob Miller, a Baltimorean who had recorded a fur-trading expedition to the Far West in 1837. Walters also ventured into the New York art market, commissioning works from such artists as Asher B. Durand, then president of the National Academy of Design. Perhaps because he was not yet fully confident in his own judgment, he allowed the artists considerable leeway in choosing subjects and in setting fees, insisting only that the resulting paintings be small enough to be accommodated in his parlor.

At the outbreak of the Civil War, Walters decided to depart for Europe with his wife, Ellen, and their young children, Henry and Jennie. Upon their arrival in Paris, they were greeted by George A. Lucas, a Baltimorean who had arrived in the French capital in 1857 and would reside there until his death 53 years later [134].

To supplement his income, Lucas charged Americans nominal fees for advice regarding art matters. However, his relationship with William T. Walters, and later with Henry, would become one of lifelong friendship. Given his familiarity with the Paris art market, he would play a critical role in the formation of their collection. Although William Walters' funds were limited when he arrived in Paris, and he would be obliged to sell most of his American art holdings as the war progressed, he nevertheless commissioned several significant works from prominent artists including Gérôme, Camille Corot and Honoré Daumier.

During their sojourn abroad, William and Ellen left their children with a nanny in Paris and toured Europe. While attending the International Exhibition in London in 1862, they were captivated by a display of oriental artifacts that had been assembled by an English physician, Sir Rutherford Alcock. Subsequently, Far Eastern art, particularly ceramics, rivaled European painting and sculpture as the focus of the Walters' collection. Tragically, while on their London trip, Ellen succumbed to pneumonia after visiting the Crystal Palace in Sydenham on a chilly autumn day.

William Walters and his children returned to Baltimore in 1865. Withdrawing from the liquor business, he joined several local financiers associated with the Safe Deposit Company (now the Mercantile-Safe Deposit and Trust Company) who were investing in the railroads in the Carolinas which had been devastated by the war. Over the next three decades, these lines would be consolidated as the Atlantic Coast Line R.R.

Meanwhile, with ever increasing zeal, Walters resumed collecting [1]. He attended New York auctions and relied on Lucas to ferret out appropriate additions in Paris. Catholic in his tastes, he was drawn to both the works of the Barbizon school of landscape painters and to those of the academic masters so much acclaimed at the Paris salons. On occasion, he developed strong commitments to individual artists, acquiring their works in depth: his collection of drawings by the caricaturist Paul Gavarni is exceptional, as is a group of botanical watercolors by a little known realist, Léon Bonvin.

Most remarkable was his patronage of Antoine-Louis Barye. With the assistance of Lucas, himself a passionate devotee of the French *animalier*, Walters dedicated his efforts to compiling a superlative collection of the artist's bronzes and watercolors and also took the lead in organizing the Barye Monument Association Exhibition held in

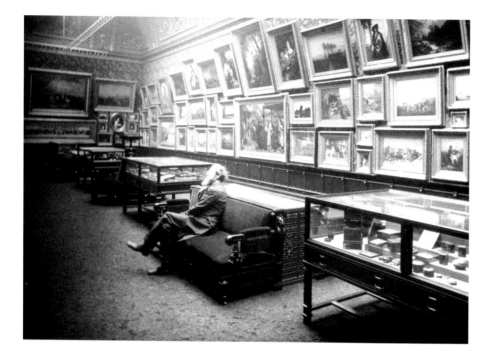

New York (1889) to raise funds for the Barye Monument on the Île St Louis in Paris.

Walters frequently returned to Europe to attend international exhibitions and to make the rounds of artists' studios and dealers. Becoming nationally known as a collector and connoisseur, he was appointed to a number of advisory committees in America. William W. Corcoran asked him to serve as trustee as well as to head the acquisitions committee of his new museum, the Corcoran Gallery of Art, established in Washington, D.C., in 1869. Walters also was designated an honorary United States commissioner to the Vienna International Exhibition in 1873. Perhaps, as a consequence of these experiences, his own mission as a collector began to assume a seriousness of purpose which was reflected in such purchases as Paul Delaroche's *The Hemicycle*, the ultimate pedagogical statement of its time, and Corot's monumental *St Sebastian Succored by Holy Women*. A proselytizer for art, Walters, in the 1870s, began to open his house to the public every spring and to distribute catalogues for the edification of his visitors, practices which would be continued by his son, Henry. By 1884, the "parlor" collection had outgrown the house, thereby necessitating the addition of a Picture Gallery [2].

Unlike his self-taught father, Henry Walters (1848–1931) received a formal education at Georgetown College in Georgetown, D.C., and at the Lawrence Scientific School of Harvard University. When William Walters died in 1894, the 46-year-old Henry had already served as general manager of the Atlantic Coast Line R.R. He then assumed control of the railroad and more than doubled the mileage of track within a few years [3].

From his youth, Henry had participated in the formation of the collection. With far broader horizons than his father, he set out to assemble a comprehensive body of art which might one day provide the basis for a public museum. In 1902, he took a momentous step in this direction, purchasing the contents of the Palazzo Accoramboni in Rome. Compiled by Don Marcello Massarenti, an assistant almoner to the Holy See, the collection comprised Greek and Roman antiquities and Renaissance and Baroque paintings of predominantly Italian origin. With such a grand acquisition, Henry could no longer postpone construction of a museum building to house his now vast holdings. In 1903, he employed a young architect, William A. Delano (1874–1960), to design the palazzo-like structure which opened in time for the 1909 annual public viewing. The bronze bust of William Walters, mounted in a cartouche above the entrance, confirmed that the new gallery was built as a memorial to the senior Walters.

Henry's other acquisitions, embracing every aspect of the fine and decorative arts, ranged from prehistoric

3
Henry Walters, about 1910

artifacts to works of the early twen-
tieth century. However, not neglecting
his father's mid-nineteenth-century
holdings, he augmented them with
paintings by both earlier and later artists.
Now represented in depth were such pivotal
figures from the romantic era as J. A. D. Ingres
and Eugène Delacroix, and even though he was
not personally drawn to Impressionism, he also added
significant works by Edouard Manet, Claude Monet,
Alfred Sisley and Edgar Degas. Undoubtedly, Henry's
tastes had been set in his youth and it was perhaps for
reasons of nostalgia that he continued to collect paintings
by Théodore Rousseau, Gérôme and Rosa Bonheur long
after they had fallen out of vogue.

Henry was noted for his commitment to fine crafts-
manship, whether demonstrated by a Pre-Columbian gold
amulet, a thirteenth-century Syrian brass ewer inlaid with
silver or an exquisitely wrought eighteenth-century
gold chatelaine. Although he may have shunned Post-
Impressionism and other aspects of late nineteenth-
century painting, he took a keen interest in contemporary
decorative arts. Frequently, he selected "exhibition
pieces," such as the Tiffany sapphire iris corsage featured
at the 1900 Paris Exposition Universelle and René
Lalique's fabulous jewelry shown in the Louisiana
Purchase Exhibition held in St Louis in 1904.

Henry Walters bequeathed the
Gallery and its contents to the City
of Baltimore. Given the building's
already overcrowded conditions, the
first curators refrained from adding to the
nineteenth-century collection. Only with the
expansion of the museum in 1974 did it become
feasible to exhibit a significant portion of the collection
and to begin to augment it. Subsequently, a balance has
been sought between preserving the collection's essential
character as defined by Henry Walters and extending its
scope to include such works as Gustave Doré's imposing
Landscape in Scotland and Joseph Cordier's bronzes of
Saïd Abdullah and a companion-piece.

During his lifetime, William Walters' holdings of the
art of his era had been regarded as exceptional. Unlike
many other private collections assembled during America's
"Gilded Age," his has been neither dispersed nor absorbed
by other institutions. With the advantage of a historical
perspective, Henry Walters supplemented the collection
with major works by artists who had eluded his
father's grasp. Despite certain limitations, including their
decidedly French bias, the two generations of the Walters
family created a collection which provides a unique
insight into the art of the nineteenth century as seen from
contemporary and near-contemporary vantages.

4
**Jean-Auguste-Dominique
Ingres**
French, 1780–1867
Odalisque with Slave, 1842
oil on canvas
30 × 41 ¹/₂ in (76 × 105.4 cm)
purchased by Henry Walters,
1925 (37.887)

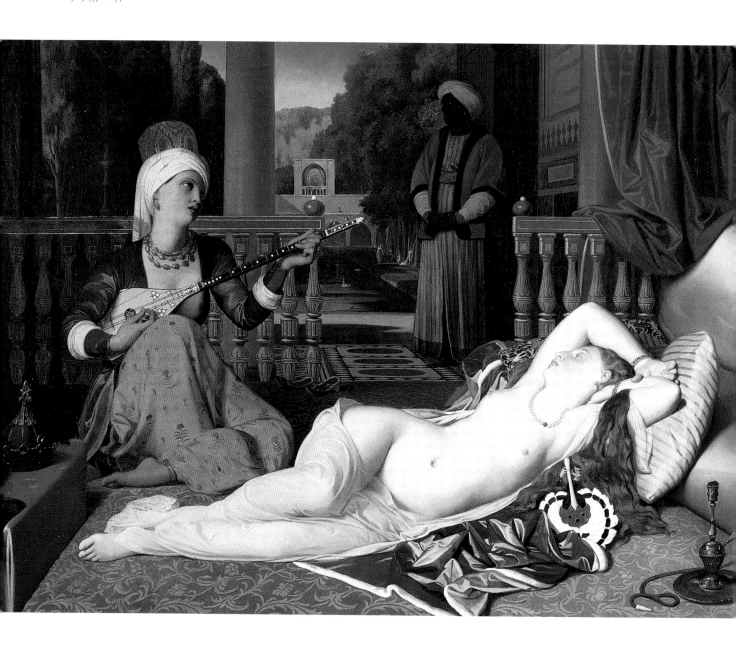

NEOCLASSICISM AND ROMANTICISM

European and American art at the beginning of the nineteenth century fell between two poles—Neoclassicism and Romanticism. As early as the 1760s, progressive artists had sought to reform the visual arts by creating a "correct" style of universal validity. Emphasizing a highly rational approach befitting the "Age of Enlightenment," the neoclassicists adopted idealized forms, simple geometric shapes and restrained ornament inspired by classical Greece and Rome. One of their fundamental beliefs was in a hierarchy in painting, with subjects drawn from biblical or ancient history ranked the highest and landscapes, portraits and still-lifes the lowest.

Disenchanted by the social unrest and political turmoil throughout Europe at the close of the eighteenth century, the succeeding generation of artists turned their vision inwards to initiate what became known as the romantic movement. Romanticism was first manifested in literature, but its impact was soon reflected in the visual arts. In contrast to the lucid and stable sense of order found in Neoclassicism, the romantic artists emphasized emotion and imagination over rationality, the greater significance of the individual over society, the subconscious over the conscious and the bizarre over the norm. In search of the sensational and the dramatic, they often resorted to exotic subjects, remote either in time or geography.

In French art, particularly in painting, the dichotomy between Neoclassicism and Romanticism was overlaid with a longstanding division between those artists who looked to Italy for inspiration and those who turned to Flanders. The former claimed as their artistic forbear Nicolas Poussin, the French seventeenth-century master who had worked in Rome, whereas the latter looked to Peter Paul Rubens. The "Poussinists" exploited line to create sculptural forms, in contrast to the "Rubenistes" who relied on color and expressive brushwork. Although the neoclassical approach was favored by French officialdom, most nineteenth-century artists drew in varying degrees from both traditions.

Napoleon Bonaparte, the first consul of France from 1799 to 1804, and emperor from 1804 to 1814, appreciated the propaganda value of the arts and encouraged their production. During his reign, Neoclassicism both reached its zenith and underwent a transformation. Instead of looking back to classical Greece and Republican Rome for models, Napoleon's artists turned to the Roman Empire. The emperor encouraged the manufacture of the decorative arts which had been temporarily halted by the Revolution. As a result, France again became renowned for sumptuous products, now decorated in the new empire style.

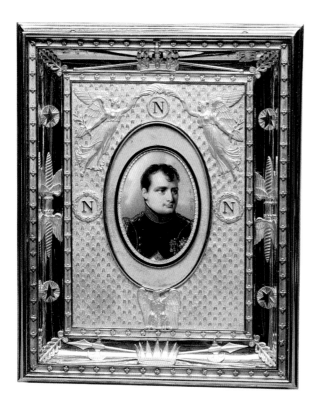

Among the artists patronized by Napoleon was Jean-Baptiste Isabey who is primarily remembered for his flattering portrait miniatures of members of the imperial family. In an example of 1812, he portrayed a youthful Napoleon wearing the uniform of an officer of the Foot Grenadiers [5]. The ornate frame, which predates the miniature by four years, is richly decorated with imperial symbols. The bees, for example, allude to the Merovingian Frankish kings (jewels discovered in the tomb of Childeric I in 1653 were mistakenly identified as representing bees rather than cicadas, which symbolize death and resurrection), while the eagle is associated with Charlemagne.

5
Jean-Baptiste Isabey
French, 1767–1855
Napoleon I, 1812
miniature on ivory
H: 1⅞ in (4.8 cm)
gold frame, Paris, 1808
purchased by Henry Walters, 1906 (38.59)

The late neoclassical or empire style promulgated in France during Napoleon's reign was widely disseminated across Europe. A particularly spectacular example is a pitcher and basin produced by the Russian Imperial Porcelain Manufactory in St Petersburg at the beginning of the nineteenth century [8]. The pitcher is in the form of a classical *oinochoe* or wine ewer, and it is entirely gilded and decorated with a band of palmette motifs in deep blue, a popular color combination at the time. A landscape has been painted in the center of the basin, which also bears the palmette border.

The empire style persisted well into mid-century, as is demonstrated by a pair of Sèvres vases decorated with portrait medallions of Louis-Philippe, "King of the French" from 1830 to 1848, and his wife, Marie-Amélie [6]. The decorator, Adolphe Moriot, drew from lithographs of likenesses of the royal couple which had been painted by François-Xavier Winterhalter. Known as "vases *Étrusque Caraffes,*" these pieces are classical in both form and decoration. They are decorated in gold and platinum with such classical motifs as laurel wreaths, ancanthus leaves and key patterns.

Turning to French sculpture, Joseph Chinard, a native of Lyons, stayed in Italy on a number of occasions. While residing in the Tuscan town of Carrara, he gained

6
Pair of Sèvres Vases
("vases *Étrusque Caraffes*")
Sèvres Porcelain Manufactory, 1844
decorator: Adolphe Moriot
hard-paste porcelain, decorated in gold and platinum
H: 17½ in (44.4 cm)
purchased by Henry Walters
(48.555/6)

7
Joseph Chinard
French, 1756–1813
Antoinette Perret, 1805
terracotta
H: 25¼ in (65.5 cm)
museum purchase, 1974
(27.584)

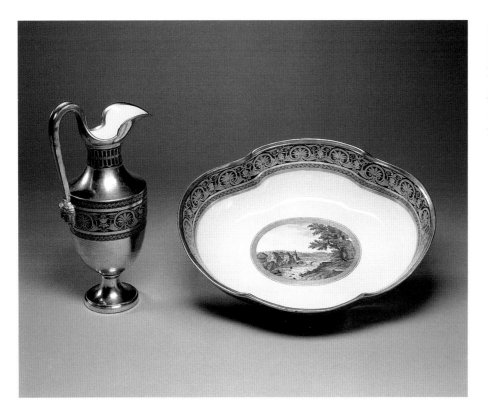

8

Pitcher and Basin

St Petersburg, 1800/10

hard-paste porcelain

pitcher: H: 11 1/8 in (28.2 cm);

basin: H: 3 9/16 × 13 1/2 in

(9 × 34.3 cm)

purchased by Henry Walters,

1930 (48.964/5)

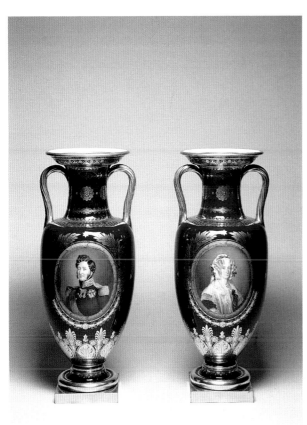

the patronage of Napoleon's sister, Elisa Bonaparte, who governed the Duchy of Tuscany, and soon he became one of the imperial family's favorite portrait sculptors. Among Chinard's more personal works is a terracotta bust of his first wife, Antoinette Perret, who had died in 1805 [7]. The inscription on the bust reads:

> You are always present
> in my thoughts
> The memory of your virtues
> serves as my guide
> and consoles me until the moment
> when we are reunited

The sculpture has been executed in a restrained, neoclassical style and yet it retains such realistic details as the mole on the subject's lip.

French painting at the beginning of the century was dominated by Jacques-Louis David. He had been politically engaged in the Revolution and his paintings had served as manifestos for the cause of liberty. But with the establishment of the Empire, David changed his allegiance and produced works glorifying Napoleon. In this way, he continued to exert an influence on another generation of painters. With the restoration of the Bourbon monarchy in 1816, David sought exile in Brussels and continued to paint neoclassical subjects, but of a rather decorative nature. In his portraiture, however, there was no diminution in his incisive ability to delineate character. An extremely candid portrait of an elderly, strong-featured woman against a neutral gray background has been attributed to David or one of his pupils [9].

David's most influential pupil, Jean-Auguste-Dominique Ingres, enrolled in the master's studio in 1797. Although he was the foremost exponent of the classical tradition in France during a career spanning seven decades, Ingres' paintings are frequently tinged with romantic overtones. He won the Prix de Rome at the École des Beaux-Arts in 1801, but did not assume residency in the Villa Medici until six years later. While in

9
Attributed to Jacques-Louis David
French, 1748–1825
Portrait of an Elderly Woman,
about 1820
oil on canvas
25 7/8 × 21 5/8 in (64.8 × 54 cm)
purchased by Henry Walters,
1908 (37.392)

10
Jean-Auguste-Dominique Ingres
French, 1780–1867
The Betrothal of Raphael and the Niece of Cardinal Bibbiena, 1813
oil on paper mounted on canvas
23 3/8 × 18 1/4 in
(59.36 × 46.3 cm)
purchased by Henry Walters,
1903 (37.13)

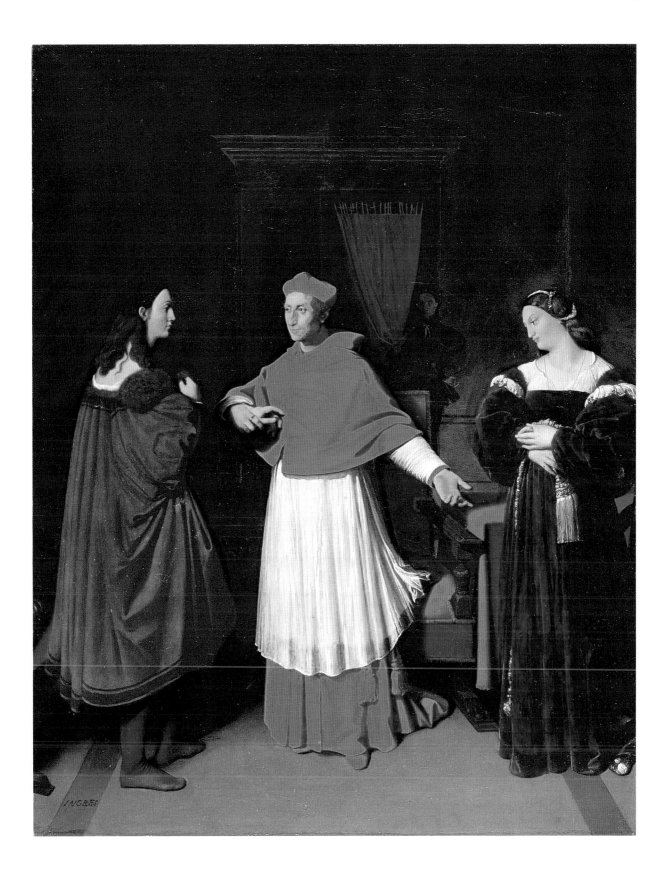

Rome, he studied firsthand the art of antiquity as well as that of the Renaissance, both of which were major influences on his development.

In 1813, Ingres painted *The Betrothal of Raphael and the Niece of Cardinal Bibbiena*, one of a number of works he intended to undertake illustrating incidents in the life of the Renaissance master he particularly revered [10]. This painting, commissioned by Napoleon's sister, Caroline Murat, shows Raphael's friend, Bernardo Dovizi il Bibbiena offering his niece in marriage to the artist. Tragically, she died before the wedding could take place. For the artist's likeness, Ingres drew on what at the time was regarded as a self-portrait by Raphael (*Portrait of Bindo Altovitti*, Washington, D.C., National Gallery of Art) and for the cardinal he relied on Raphael's own portrait of Bibbiena (Florence, Pitti Palace). The *Betrothal* is frequently cited as Ingres' major contribution to the "troubadour" style, an early nineteenth-century manifestation of the romantic movement in which events from the Middle Ages or early Renaissance were recreated in seemingly authentic settings.

Ingres held the influential position of director of the French Academy in Rome from 1835 to 1841. He then returned to Paris where he staunchly championed the academic principles of the state-sponsored École des Beaux-Arts. A painstaking craftsman, he often repeated earlier compositions, seeking to improve them. The *Odalisque with Slave,* commissioned in 1842 for King Wilhelm I of Würtemberg, was a variant of a work he had painted three years earlier (Fogg Art Museum, Harvard University). In the later version, executed with the assistance of his pupil Paul Flandrin, a garden vista has replaced the closed interior space [4]. Otherwise, the compositions showing an odalisque, or concubine, langorously reclining in a seraglio, enraptured by a servant's lute music, are nearly identical. In the sensuously delineated, idealized forms, marble-like surfaces and meticulously rendered detail, Ingres has upheld the tenets of Neoclassicism. However, his selection of this exotic theme, inspired by a passage from Lady Mary Wortley Montagu's *Turkish Letters* (1763), reveals the romantic side to his character.

Ingres' classicizing bent is fully demonstrated in his many versions of *Oedipus and the Sphinx* [11]. As narrated by the second-century B.C. Athenian writer Apollodorus (*The Library*, III, v. 8), the mythological monster, part woman, part lion and part bird, terrorized Thebes by periodically devouring its citizens because no one could

11
Jean-Auguste-Dominique Ingres
French, 1780–1867
Oedipus and the Sphinx, 1864
oil on canvas
41^1/$_2$ × 34^1/$_4$ in (105.5 × 87 cm)
purchased by Henry Walters, 1908 (37.9)

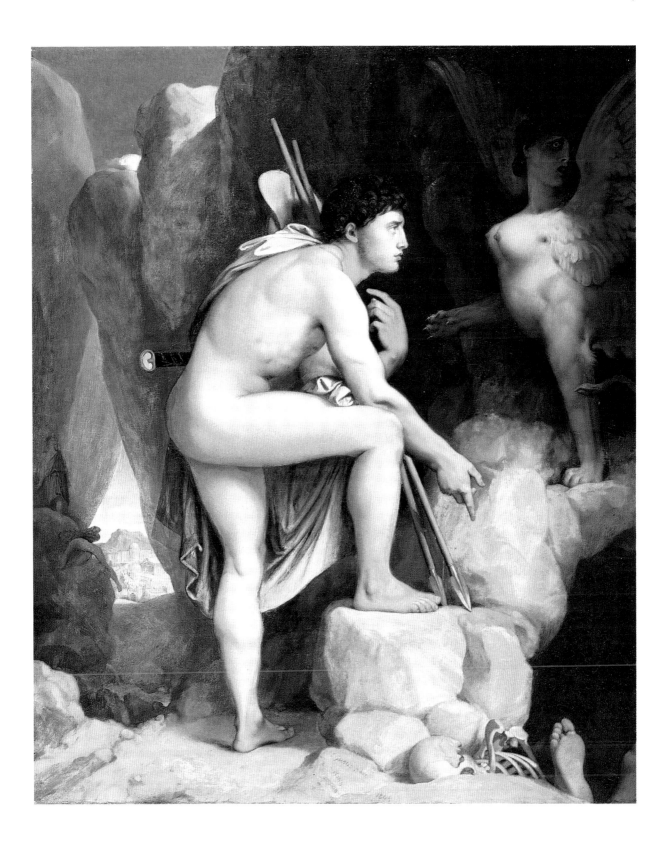

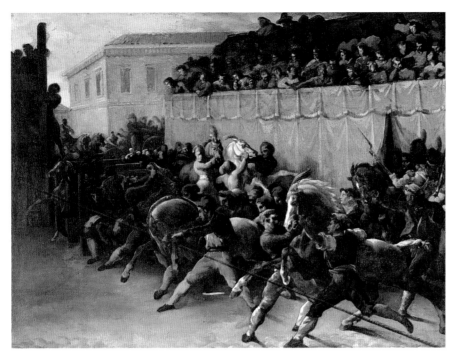

answer her riddle, "What is that which has one voice and yet becomes four-footed, two-footed and three-footed?" When Oedipus correctly responded that it was man, who moved on four limbs as an infant, two as an adult and three (with a staff) in old age, the Sphinx, in fury, dashed herself to pieces on the rocks below. Although consummately neoclassical in style and subject, this *Oedipus and the Sphinx* is imbued with romantic overtones in the monster's macabre, cavernous lair and in the telltale bones and limbs of her victims.

Théodore Géricault, who also struggled to reconcile the divergent neoclassical, romantic and realistic trends, might well have left an even more profound mark on French painting had he lived beyond the age of 33. To supplement his formal training, which had been limited to

brief sessions in the studios of the historical painter Carle Vernet and of the neoclassicist Pierre Guérin, Géricault visited the Louvre. Then known as the Musée Napoleon, its holdings had been temporarily enriched with Renaissance and Baroque paintings looted by Napoleon's victorious armies.

Failing to win a Prix de Rome, Géricault traveled to Italy at his own expense. A keen equestrian, he was drawn to the spectacle which traditionally marked the close of the Roman Carnival, the *corsa dei barberi*, or "race of the Barbary horses." With the blast of a trumpet, the riderless horses, frenzied by weighted balls tipped with spikes dangling against their flanks, raced the length of the Via del Corso. Géricault undertook a number of oil studies and drawings portraying the mayhem at the starting line

12
Jean-Louis-André Théodore Géricault
French, 1791–1824
Riderless Racers in Rome, 1817
oil on paper mounted on canvas
17 ⁸/₁₆ × 23 ⁷/₁₆ in (44.9 × 59.5 cm)
purchased by Henry Walters, 1907 (37.189)

13

**Ferdinand Victor Eugène
Delacroix**

French, 1798–1863

Sketch for *The Battle of Poitiers*,
1829/30

oil on canvas

20 ¹/₂ × 25 ¹/₂ in (52 × 64.8 cm)

purchased by Henry Walters,
1899 (37.110)

as the grooms struggled to restrain the horses [12]. In the Walters Art Gallery's study, he presents a descriptive view of the race with a contemporary background, whereas in other examples he tended to situate the event in a classical or timeless setting.

Eugène Delacroix is generally regarded as Géricault's principal successor. He was reared in privileged circumstances, received a classical education and was widely cultured. Like Géricault, he trained in Pierre Guérin's studio and also studied the Old Masters at the Louvre, focusing on the works of Raphael and of the renowned colorists Titian, Veronese and Rubens. Delacroix transcended the classical-romantic schism in French art. Although he

prided himself on being a classicist, he is viewed as one of the foremost exponents of the romantic movement.

Just prior to the fall of the Bourbon dynasty in France in 1830, the Duchesse de Berry, the daughter-in-law of Charles X, the last Bourbon monarch, commissioned Delacroix to paint the *Battle of Poitiers* (Paris, Musée du Louvre). In 1356, in one of the most decisive battles of the Hundred Years' War, King John the Good of France and his fourteen-year-old son Philip were captured by Edward, the Prince of Wales (also known as the Black Prince). Delacroix must have welcomed the opportunity to paint this subject, given his preference for themes drawn from France's medieval past rather than from antiquity. In

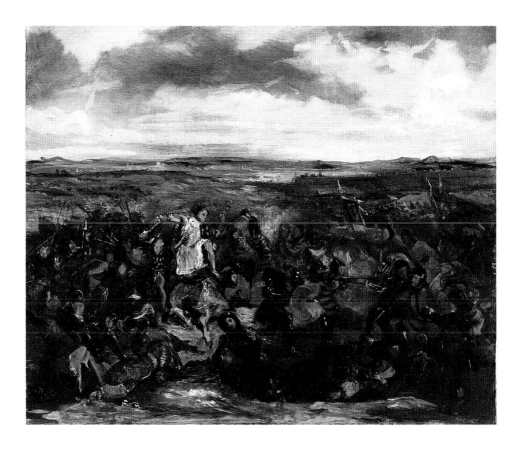

13

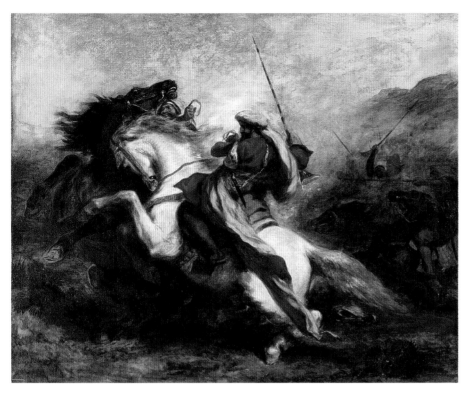

preparation, he painted this study, which is characterized by the bravura of its brushstrokes and the vividness of its color [13].

Delacroix had treated Near Eastern themes as early as 1824, the year he completed *The Massacres at Chios* (Paris, Musée du Louvre), his early masterpiece showing a particularly tragic episode from the Greek War for Independence. However, it was only in 1832, when he accompanied the Comte de Mornay on a diplomatic expedition to the Sultan of Morocco, that he actually experienced the "Orient," as the Islamic Mediterranean world was then known. While the expedition was proceeding from Tangier to Meknes, Delacroix recorded in his journal

an equestrian spectacle: "During their military exercises which consist of riding their horses at full speed and stopping them suddenly after firing their shot, it often happens that the horses carry away their riders and fight each other when they collide. . . ." Delacroix continued to draw from his North African experiences, as is illustrated by a painting executed twelve or thirteen years afterwards [14].

Although not a practicing Christian, Delacroix frequently turned to New Testament subjects, attracted by their drama and pathos. He was particularly interested in exploiting intense emotions evoked by the Crucifixion. In one of his earlier versions of this subject, Christ is portrayed at the ninth hour, the moment of his death, and is

14
Ferdinand Victor Eugène
Delacroix
French, 1798–1863
Collision of Moorish Horsemen,
1843/4
oil on canvas
32 × 39 in (81.3 × 99.1 cm)
purchased by William T.
Walters, 1883 (37.6)

15
Ferdinand Victor Eugène
Delacroix
French, 1798–1863
Christ on the Cross, 1846
oil on canvas
31 1/2 × 25 1/4 in (80 × 64.2 cm)
purchased by William T.
Walters, 1886 (37.62)

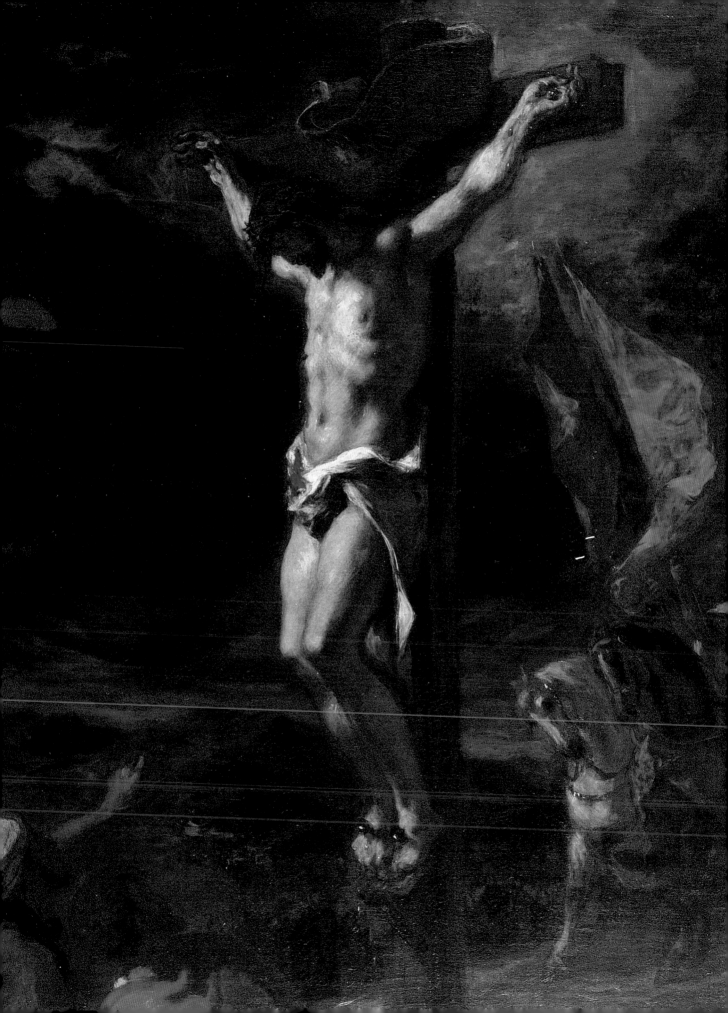

16

Ferdinand Victor Eugène Delacroix

French, 1798–1863

Christ on the Sea of Galilee, 1854

oil on canvas

23 9/16 × 28 7/8 in (59.8 × 73.3 cm)

purchased by William T. Walters, 1889 (37.186)

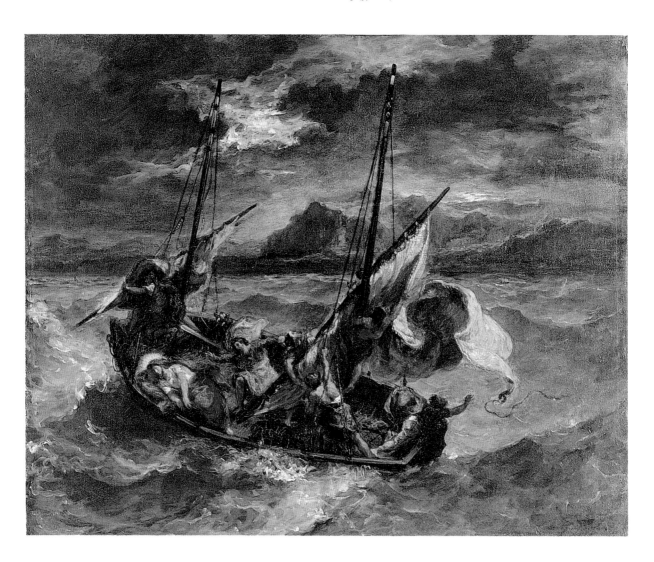

17

**Ferdinand Victor Eugène
Delacroix**

French, 1798–1863

Marphise, 1850/2

oil on canvas

32 $^5/_{16}$ × 39 $^3/_4$ in (82 × 101 cm)

purchased by Henry Walters,
1904 (37.10)

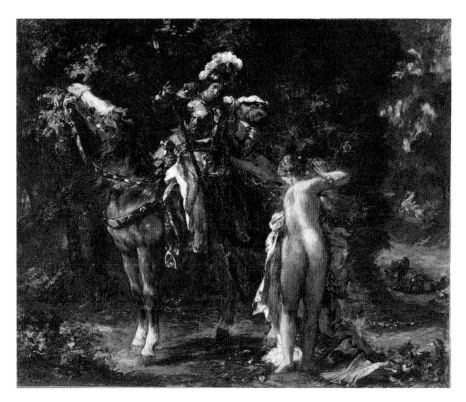

harshly illuminated against the darkened sky [15]. Among the witnesses are a couple of rudely gesticulating figures at the foot of the cross, two mounted Roman soldiers with billowing banners and a throng of spectators barely discernible in the mid-ground. When exhibited at the Paris Salon in 1847, this painting was enthusiastically received by critics who likened it to similar scenes by the Flemish seventeenth-century master Peter Paul Rubens.

Another New Testament theme which Delacroix repeatedly treated after 1840 was *Christ on the Sea of Galilee*. In the Walters version, a two-masted ship is floundering in a tumultuous sea [16]. As his comrades struggle to control the ship, a sailor reaches over to awaken Jesus,

who would then calm the waters. During visits to the coastal town of Dieppe in the early 1850s, Delacroix would sometimes contemplate the sea for three or four hours at a time, and he may have reflected his observations in the rendering of the waves and the ominous shoreline in this painting.

Cosmopolitan in outlook, Delacroix was well versed in British and German as well as French literature, and among his friends he counted the authors George Sand, Alexandre Dumas and Honoré de Balzac. Throughout his career, he selected subjects from the writings of Dante, Shakespeare, Lord Byron, Sir Walter Scott and Goethe. In his later years, he turned to the epic poetry of Renaissance

18
Antoine-Louis Barye
French, 1795–1875
The Bear Hunt, 1834/9
bronze
H: 18 ¹¹/₁₆ in (47.4 cm)
purchased by William T.
Walters, 1876 (27.183)

19
Antoine-Louis Barye
French, 1795–1875
The Elk Hunt, 1834/9
bronze
H: 20 ¹/₂ in (52 cm)
purchased by Henry Walters,
1899 (27.175)

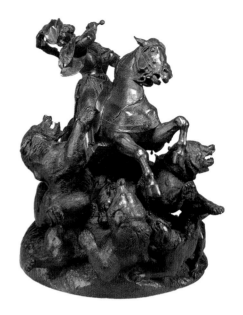

authors Ludovico Ariosto and Torquato Tasso. In *Marphise*, Delacroix depicts a scene from Ariosto's *Orlando Furioso* (XX, 108–116), in which a woman warrior, Marfisa, has unhorsed the knight Pinabello and compelled his lady to disrobe and exchange her finery for the rags of the old beggar woman [17]. The horse, apparently undisturbed by the drama, nonchalantly munches the leaves overhead.

Delacroix's renderings of animals were based on careful observations of both living creatures and their corpses. In October 1828, he wrote to his friend Antoine-Louis Barye: "The lion is dead—come at a gallop—it is time for us to begin—I am waiting for you—warmest regards." To observe the dissection of the animal from the Jardin des Plantes, the Paris zoo, was too rare an opportunity for either artist to miss.

Barye, the foremost French *animalier* of the nineteenth century, initially trained in fine metalwork. His early experiences working for the neoclassical sculptor François-Joseph Bosio and the romantic painter Antoine-Jean Gros may have contributed to a paradoxical aspect of his work. Although he both sculpted and painted, and sometimes dealt with human, figurative compositions, occasionally on a grand scale, Barye is primarily remembered for small sculptures of animals cast in bronze. He

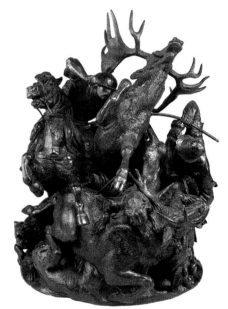

20
Antoine-Louis Barye
French, 1795–1875
The Wild Bull Hunt, 1834/9
bronze
H: 18 ⁷/₈ in (47.9 cm)
purchased by William T.
Walters, 1885 (27.178)

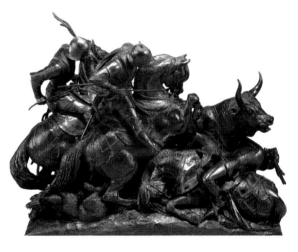

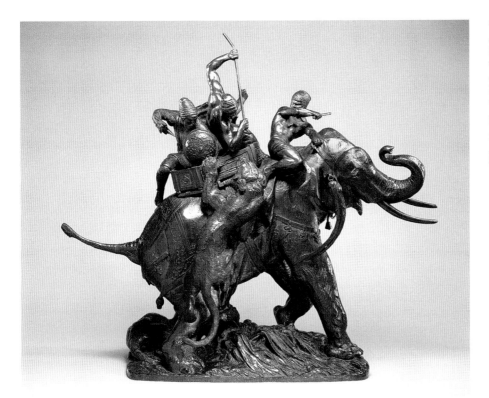

21
Antoine-Louis Barye
French, 1795–1875,
with the assistance of
Auguste-Louis-Marie Ottin
French, 1811–90
The Tiger Hunt, 1834/9
bronze
H: 27 ¹¹/₁₆ in (70.3 cm)
purchased by William T.
Walters, 1872 (27.176)

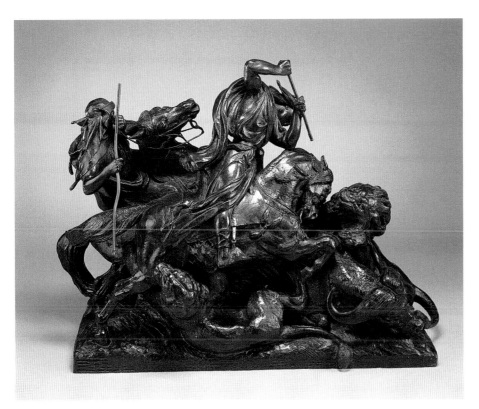

22
Antoine-Louis Barye
French, 1795–1875
The Lion Hunt, 1834/9
bronze
H: 17 ¹³/₁₆ in (45.2 cm)
purchased by Henry Walters,
1898 (27.174)

never traveled, relying instead on the Jardin des Plantes and various menageries for his exotic subjects. Sometimes he showed the animals alone and in repose, but often they were portrayed as predators and prey locked in mortal combat. Barye combined the scientific approach of detailed, sometimes annotated anatomical studies with a powerful, romantic imagination, imparting to his subjects intense emotions normally associated with humans.

During the reign of Louis-Philippe, Barye enjoyed royal patronage. The king's son, the Duc d'Orléans, commissioned a monumental *surtout de table*, or table centerpiece. It was one of the most ambitious decorative projects of the period and entailed contributions from many of the leading artists and artisans. The architect Aimé Chenavard was responsible for the overall design and Barye undertook the major sculptural components. These included five large hunts and four smaller animal combats, all cast in bronze and incorporated into a gilded architectural and vegetal setting decorated with precious stones and niello, or blackened silver, plaques.

The Tiger Hunt, supported in the center on a high triumphal arch, dominated the *surtout* [21]. Four Indians perched in a box-like seat fend off tigers on either side. In one of the lateral groups, *The Lion Hunt*, mounted Arabs attack a lion and lioness that have been devouring a water buffalo, and in the other, *The Wild Bull Hunt*, sixteenth-century Spanish soldiers rescue a companion whose horse has been killed by the bull [22, 20]. Finally, two circular groups, *The Bear Hunt* and *The Elk Hunt*, complete the *surtout* [18, 19]. The former is a German sixteenth-century subject and the latter a Mongolian theme. Of Barye's four smaller combat groups, only *Python Crushing the Gnu* was acquired by the Walters family.

When Barye submitted his models for the *surtout* to the Paris Salon in 1837, *The Bear Hunt* (and possibly *The Elk Hunt*) was dismissed by the jury as an industrial product. The sculptor finally cast and delivered the *surtout* to his patron in 1839. It adorned the duke's dining table on at least one occasion, the winter costume ball held three years later in the Marsan Pavilion of the Louvre. The hunt groups, which were mostly cast in the lost-wax technique rather than being sand-cast—the usual nineteenth-century method of production—have been ranked among the technical achievements of their time.

Barye was not only a sculptor, but, together with Delacroix, he participated in the early nineteenth-century revival of watercolors in France. This medium had long been popular in England because of such virtues as permitting rapid execution. Barye tended to treat the same subjects in watercolor that he had in sculpture, often

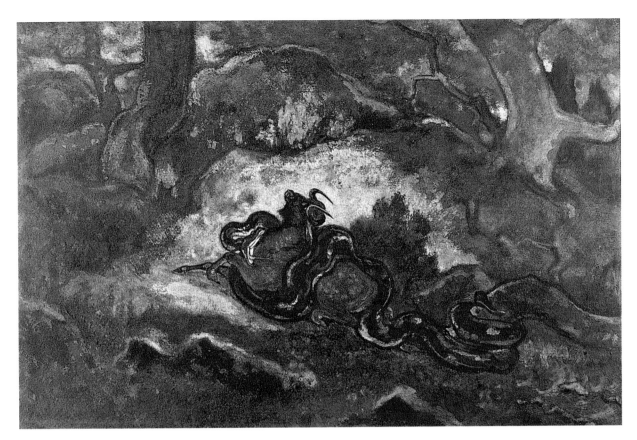

incorporating the animal combatants into forest settings based on the surroundings near his studio in the village of Barbizon. In *Python Crushing a Gnu*, he repeated the theme that he had used for one of the four combat groups in the Duc d'Orléans' *surtout* [23].

At the Exposition Universelle held in Paris in 1855, the romantic artist Alexandre-Gabriel Decamps shared with Ingres and Delacroix the distinction of being awarded a Grand Medal of Honor. He was essentially self-taught, a limitation that may have hindered him from fully realizing his high-minded goals as a history painter. Decamps

was primarily known for "Oriental" subjects based on travels he took in 1828 to Greece and Asia Minor, but he also painted realistic views of rural life in the vicinity of the forest of Fontainebleau. In an atypical work, *The Suicide*, Decamps treats a distinctly romantic theme, an unfortunate artist who, overcome by adversity, takes his life. In a dimly illuminated garret, the victim lies sprawled across a bed and, in the foreground, a pistol and note suggest the tragic sequence of events [24]. Decamps' rich earth tones and dense, pasty paint textures were subsequently adopted by such artists as Diaz de la Peña.

23
Antoine-Louis Barye
French, 1795–1875
Python Crushing a Gnu,
mid-nineteenth century
watercolor
$12\,^1/_4 \times 19\,^{11}/_{16}$ in (32.4 × 50 cm)
purchased by William T.
Walters (37.815)

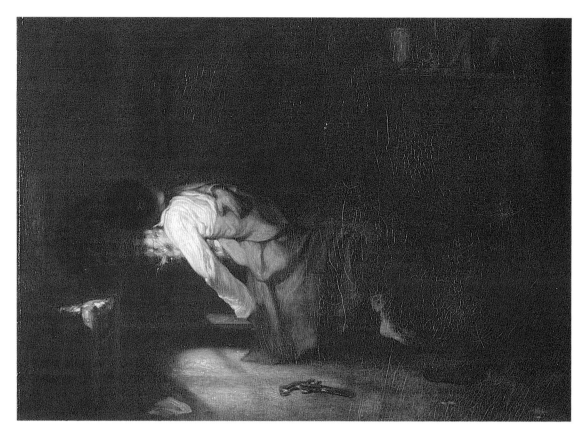

Louis-Philippe once characterized his policy for the nation's internal affairs as the *juste-milieu*, or course of moderation. This term was also applied to artists who, seeking a compromise, followed a middle road between the academic or classical camp and that of the romantics. Horace Vernet is frequently cited as the archetypal painter of the *juste-milieu*. Originally a confirmed Bonapartist, Vernet accepted commissions from the Bourbon monarchs after their restoration and later produced a number of battle scenes for the Duc d'Orléans. In *Italian Brigands Surprised by Papal Troops*, painted while he was director of the French Academy in Rome, Vernet portrays a contemporary rather than a historical subject [25]. However, his technique, with its precisely delineated forms and his reliance on bright local colors, recalls the classical works of Ingres.

In Great Britain, the classical traditions were less ingrained than in France, leaving Romanticism in the ascendancy. A dramatic example of English Romanticism is Sir George Hayter's *After the Storm* [26]. Several warriors or bandits are carrying an unconscious woman through the dark, inhospitable forest. The sky is turbulent

24
Alexandre-Gabriel Decamps
French, 1803–60
The Suicide, about 1836
oil on canvas
15 $^1/_4$ × 22 $^1/_{16}$ in (40 × 56 cm)
purchased by William T.
Walters, 1876/8 (37.42)

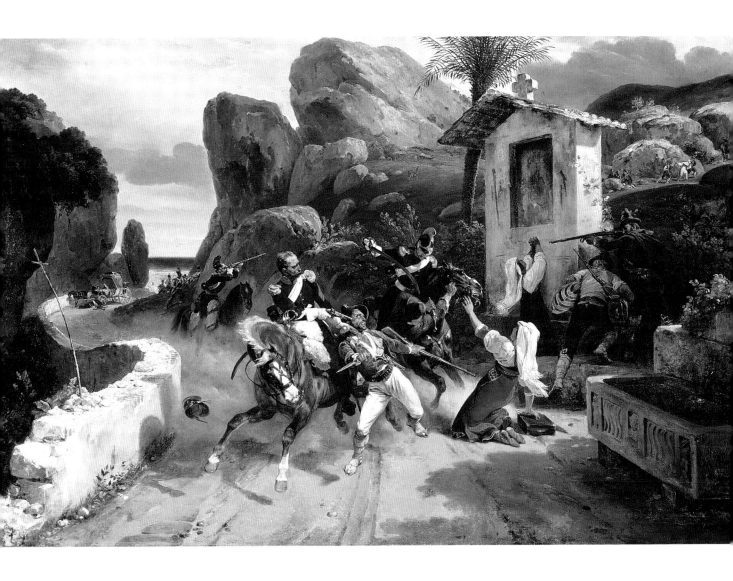

25

Emile-Jean-Horace Vernet

French, 1789–1863

*Italian Brigands Surprised by
Papal Troops*, 1831

oil on canvas

33 ¹¹/₁₆ × 51 ⁹/₁₆ in (85.6 × 131 cm)

purchased by William T.
Walters, 1876 (37.54)

26
Sir George Hayter
British, 1792–1871
After the Storm, 1833
oil on canvas
17 $^{15}/_{16}$ × 22 $^{3}/_{16}$ in (45.6 × 56.4 cm)
museum purchase, 1993
(37.2661)

27
Alfred Jacob Miller
American, 1810–74
Cavalcade, about 1858
watercolor on paper
$10^{7}/_{8} \times 14^{15}/_{16}$ in (27.6 × 38 cm)
commissioned by William T.
Walters, 1858/60 (37.1940.199)

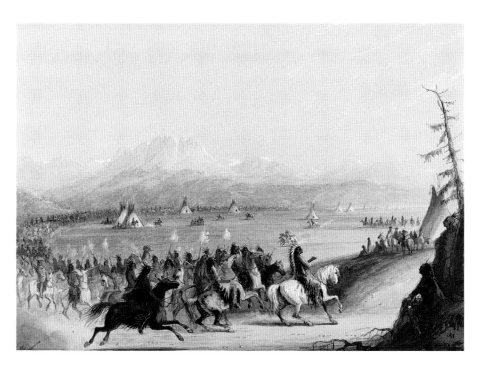

and the landscape is dominated by an immense, blasted tree trunk, a favorite motif of the seventeenth-century Italian master Salvator Rosa. For British viewers, Hayter's painting must have represented a visual counterpart to Lord Byron's romantic poetry.

In a text appended to his watercolor *Cavalcade*, the Baltimore artist Alfred Jacob Miller transcribed verses from Byron's *The Corsair* (1814) beginning:

> Ours the wild life,— in tumult still to range,
>
> From toil to rest and joy in every change, . . .

Just as the French government had commissioned Delacroix to record the Comte de Mornay's 1832 diplomatic mission to the Sultan of Morocco, the Scottish adventurer Captain William Drummond Stewart hired Alfred Jacob Miller to chronicle an expedition to the American fur-traders' rendezvous in the Green River Valley (western Wyoming) in 1837. Miller's "trail" sketches produced during the journey provided a basis for his subsequent paintings in watercolors and oils. *Cavalcade* shows the tumultuous arrival of 2,000 Snake Indians at the annual gathering at the foothills of the Rockies [27]. Miller lacked formal training but had benefited from studying in the museums and galleries of Paris and Rome in 1832/3 and had returned to America a confirmed romantic. He saw in the American Indians "a race of men equal in form and grace (if not superior) to the finest beau ideal ever dreamed of by the Greeks."

Romanticism dominated German art of this period. Andreas Achenbach, a major adherent of the Düsseldorf school of painting, received a first-class medal in Paris at

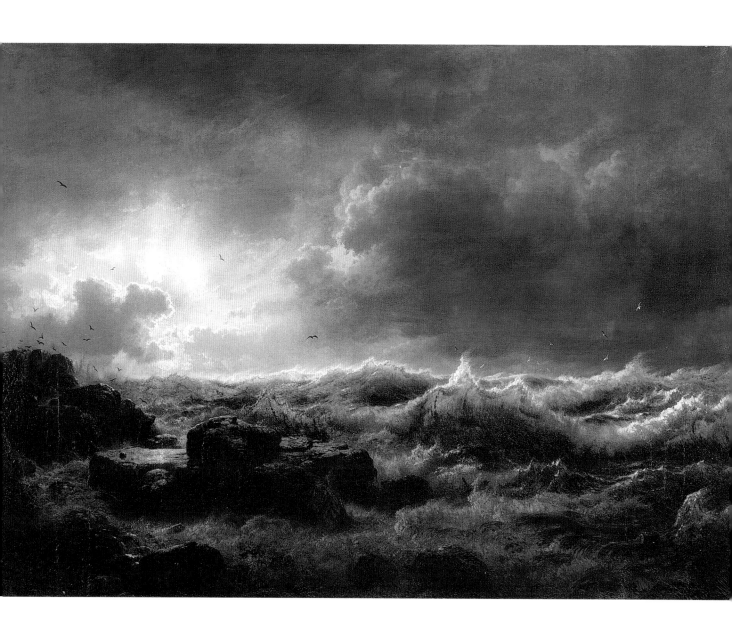

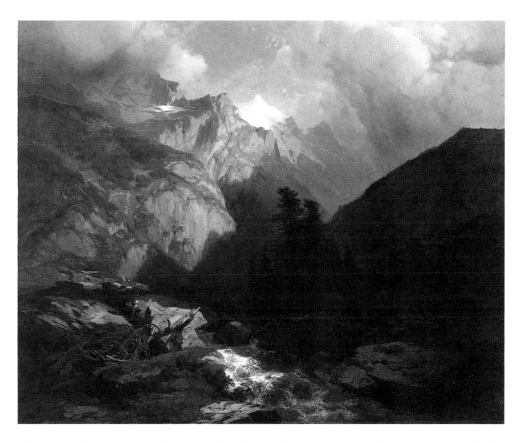

the Exposition Universelle of 1855. He was known for his dramatic, coastal scenes and marine paintings based on studies undertaken in the Netherlands, Scandinavia, Bavaria and Italy. In *Clearing-up, Coast of Sicily*, Achenbach shows the evening sunlight breaking through a stormy sky to illuminate the swelling sea [28]. Scarcely discernible amongst the flotsam and jetsam in the foreground is the only trace of man's presence, a tattered American flag flung against the rocks.

Not surprisingly, a Swiss artist, Alexandre Calame, was one of the first painters to transcribe the grandeur of the Alps [29]. A devout Protestant, Calame conveyed in his paintings the awe and religious fervor which the mountain peaks evoked in him. He described the site for *The Jungfrau, Switzerland* as "a lost corner which I know is really wonderful . . . as if God has delighted in assembling in one corner of the earth the greatest marvels of creation." The lone traveler struggling to ascend the rocky gorge serves to emphasize the scene's desolation and heightens the scale of the surroundings. Calame participated in international exhibitions receiving praise from conservative and progressive critics and colleagues alike.

28
Andreas Achenbach
German, 1815–1910
Clearing-up, Coast of Sicily, 1847
oil on canvas
$32^{1}/_{2} \times 45^{11}/_{16}$ in
(82.5 × 116.1 cm)
purchased by William T. Walters (37.116)

29
Alexandre Calame
Swiss, 1810–64
The Jungfrau, Switzerland, 1853/5
oil on canvas
$33^{9}/_{16} \times 41^{9}/_{16}$ in
(85.3 × 105.5 cm)
purchased by William T. Walters, 1867 (37.108)

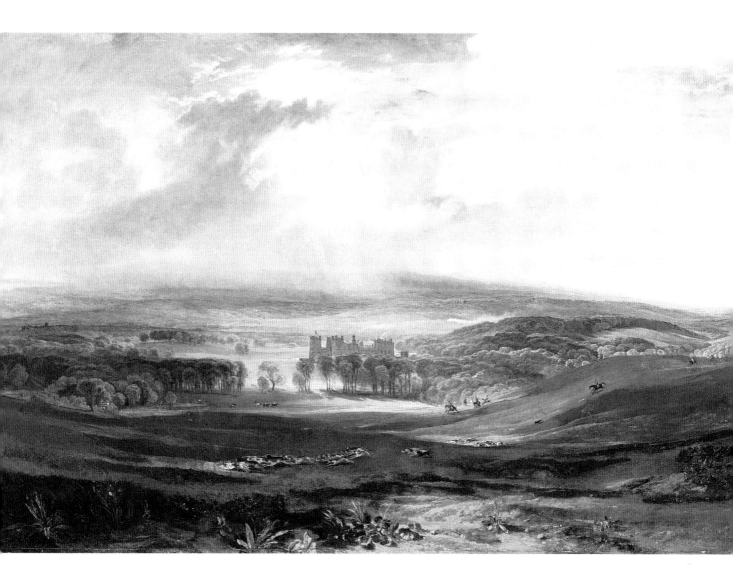

30

Joseph Mallord William Turner

English, 1755–1851

Raby Castle, the Seat of the Earl of Darlington, 1817

oil on canvas

46 ⁷/₈ × 71 ¹/₈ in (119 × 180.6 cm)

purchased by Henry Walters, after 1899 (37.41)

PERCEPTIONS OF
NATURE

J. M. W. Turner emerged from the late eighteenth-century English topographical tradition as one of the most innovative artists of the nineteenth century. Like his contemporary, John Constable, he sought to portray nature's drama, though he was less concerned with recording the elusive, transitory effects of the weather. Turner's panoramic view, *Raby Castle, the Seat of the Earl of Darlington*, represented one of his last "house-portraits," a category which had proven highly profitable for several generations of British artists [30]. In this autumnal scene set in County Durham, the fourteenth-century castle is illuminated by a shaft of sunlight penetrating the clouds. Already, particularly in the dramatic rendering of the expansive sky, Turner has demonstrated both his keen observation of light and his dedication to recording the elemental forces of nature, characteristics which would prove lifelong.

During the 1820s, progressively minded French landscape painters challenged the prevailing academic theories, questioning, in particular, the supremacy of history painting and faith in an idealized beauty. Technically, they rejected the traditional, smooth paint surfaces, emphasizing instead *facture*, or the manipulation of the pigments over the canvas for expressive effects.

Painting directly from nature became easier after 1840 when John G. Rand, an American artist working in London, patented a method of storing and selling paints in air-tight, collapsible metal tubes. Pigments were now protected from the deleterious effects of exposure to air and they could also be carried outdoors more readily.

Private collectors were beginning to supplant the state and church as influential art patrons. Understandably, the new, bourgeois clients were more attracted to familiar landscape views than to religious or historical subjects set in antiquity. Their tastes may also have been influenced by nostalgia for an agrarian life already threatened by urbanization and industrialization. In the course of the century, city dwellers came to appreciate the remarkable diversity of the French countryside as improvements in transportation facilitated travel: slow, uncomfortable coach travel gave way to a network of railroads linking even the most remote regions to the capital.

With the fall of Napoleon in 1814, the English Channel ceased to be an insurmountable barrier between Great Britain and France. As had so often been true over the centuries, cultural exchanges between the two countries again proved mutually beneficial. The sensation created by John Constable's *Hay Wain* (London, National Gallery) at the 1824 Paris Salon awakened French artists to recent developments in British landscape painting. Géricault and Delacroix, among others, visited London

31
Eugène Louis Gabriel Isabey
French, 1803–86
Fishing Boats, about 1836
watercolor on paper
10 $^1/_8$ × 14 $^7/_8$ in (25.7 × 37.7 cm)
purchased by William T.
Walters (37.889)

and, in return, British painters, including Turner, went to France.

Eugène Isabey, the son of Napoleon's miniaturist, Jean-Baptiste, first visited England in 1821 and returned four years later. In the late 1820s, he began to produce oils, watercolors and prints of Normandy coastal scenes. *Fishing Boats*, a tranquil port scene, shows a couple of fishing boats stranded by the receding tide and the small, weathered houses of the fishermen [31]. In the broad, loose handling of his pigments and washes, particularly in the sky, Isabey reflected his contact with English artists.

The now highly prized Dutch seventeenth-century landscape paintings provided another source of inspiration for French painters. Artists of northern Holland had recorded various aspects of their land under changing conditions of weather and light. Through views of tree-lined roads, flat fields and canals and rivers, they had endeavored to demonstrate God's bounty. Georges Michel was among the early nineteenth-century French artists to respond to the Dutch naturalistic traditions. He supplemented his limited formal training by copying Dutch masters in the Louvre Museum where he was briefly employed restoring works by Rembrandt, Ruisdael and Hobbema. Michel restricted his own painting to the environs of Paris, depicting Montmartre, then still dotted with windmills,

the plains of St-Denis and the surrounding villages which were soon to be absorbed by the city. The *Gathering Storm*, with its expansive view of the plain and its stormy sky, and the broad, thick brushwork, typifies his work [32]. Michel is now recognized as an immediate precursor of the landscape painters of the 1830s and 1840s.

Camille Corot's long career overlapped several generations of French artists ranging from the romantics to the impressionists. He received a formal training and never fully abandoned idealized, historical landscapes, continuing to incorporate biblical and literary motifs into many of his compositions. Corot studied in Rome from 1825 to 1828 and visited again in 1834 and 1843, thoroughly steeping himself in the classical tradition. However, while in Italy, he painted directly from nature some remarkably fresh and vivid studies. Initially, Corot adhered to the prevailing practice of preparing oil studies out of doors during the summer, which he then used to develop "exhibition" pieces in his studio during the winter. Gradually, he broke with tradition in de-emphasizing the distinction between the preparatory study and the "finished" painting.

At various times throughout his career, Corot undertook figurative subjects as well as landscapes. A small study of two Italian models, now thought to date from his 1843 Italian sojourn, illustrates the vigor of his style at this

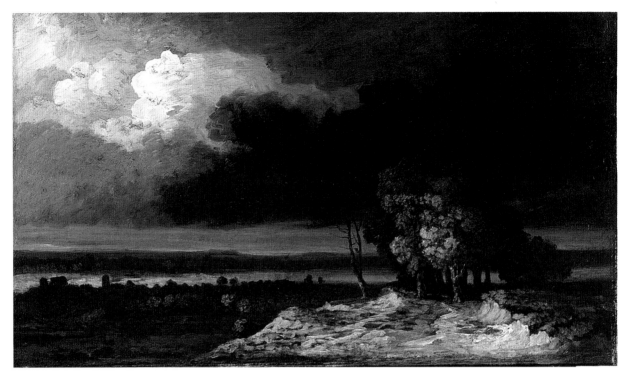

time [33]. Corot entered one of his largest and most ambitious paintings, *St Sebastian Succored by Holy Women*, in the Paris Salon of 1853, and after reworking it he exhibited it again at the Exposition Universelle of 1867 [34]. Before donating the monumental work to a lottery held in 1874 for the benefit of war orphans, Corot altered the composition once more, replacing a curved top with the present right-angled format. The subject has been identified as a metaphor for charity. St Irene and her companion attend to the dying Sebastian, withdrawing the arrows from his wounds, while overhead hover two small angels, one bearing a wreath and the other a martyr's palm frond. The executioners, the Emperor Diocletian's archers, ride over a hill into the distance. In keeping with the tragic subject, it

is twilight and only a few rays of light break through the foliage to illuminate the angels, Sebastian's body and Irene's companion.

The elegiac qualities of Corot's mature works are demonstrated in *The Evening Star* [35]. While visiting the artist's studio in 1864, William Walters had been so profoundly impressed by a painting then in progress, *L'Étoile de Berger* (Toulouse, Musée Augustins), that he commissioned this replica for himself. It is dusk, and a woman standing next to a leafless tree beside a body of water gestures toward a bright star as the sunlight wanes. To the right, a shepherd follows his flock homewards. Corot declined his client's request to delineate the sheep more clearly and produced this painting, which apart from its

32
Georges Michel
French, 1763–1843
Gathering Storm, early
nineteenth century
oil on canvas
16⅝ × 28⅝ in (42.2 × 72.6 cm)
museum purchase, part of the
George A. Lucas Collection at
the Walters Art Gallery, 1997
(37.1991)

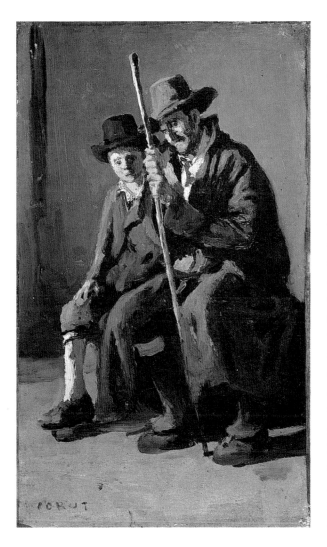

reduced size nearly replicates the original version. The artist had been inspired to record the scene after listening to a Swiss friend sing the following lines from Alfred de Musset's poem of 1830, *The Willow: Fragment*:

> Pale star of the evening, distant messenger,
> Whose countenance is brilliant like the rays of sunset,
> From your azure palace to the depths of the firmament,
> What are you looking at on the plain?

Corot is frequently associated with a younger generation of painters known as the Barbizon school. Its adherents shared a disdain for modern, urban life and rooted their art in the countryside. They initially worked in the vicinity of Paris—the forests of Compiègne and Fontainebleau and the Parc St Cloud—but gradually they ventured farther afield, assembling during the summers in "colonies" often located along the Atlantic and Normandy coasts. Generally, however, they were associated with Barbizon on the edge of the Fontainebleau forest. Not only was the village readily accessible to Paris, but it offered a varied terrain ranging from the flat plain of Chailly to dense woodlands, and to swamps and sandy areas studded with immense sandstone boulders. A major attraction was the Auberge Ganne and its congenial innkeeper who extended credit to his customers, accepting paintings in lieu of cash. Although it is occasionally difficult to distinguish each

33
Jean-Baptiste-Camille Corot
French, 1796–1875
Two Italian Peasants, 1843?
oil on canvas
11 5/8 × 7 in (29.5 × 17.8 cm)
purchased by Henry Walters, 1908 (37.201)

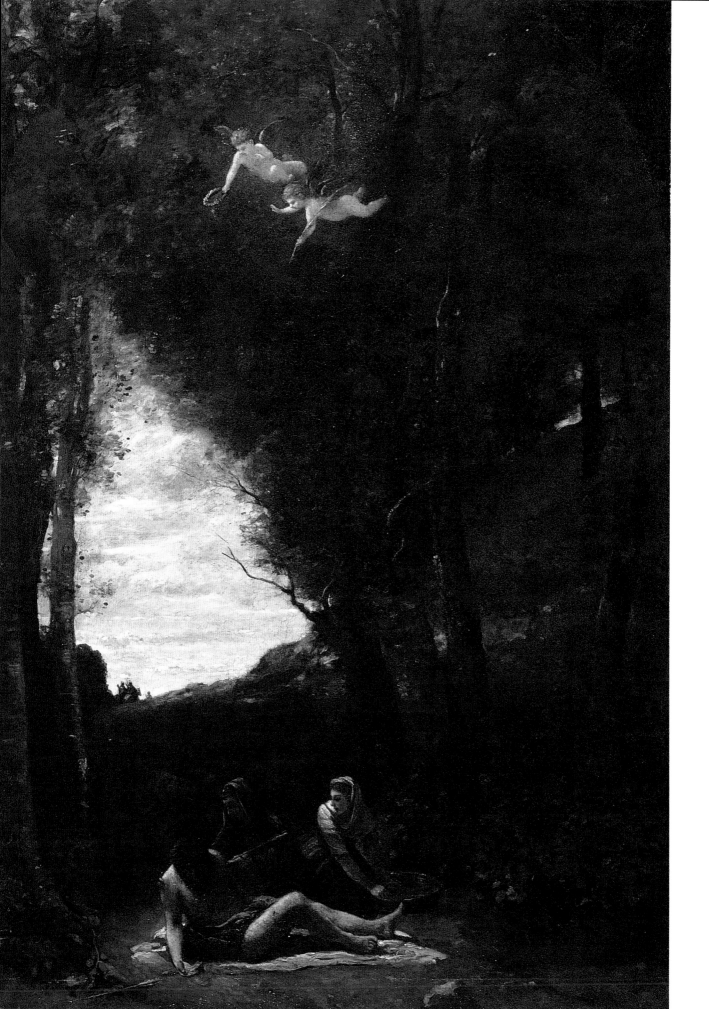

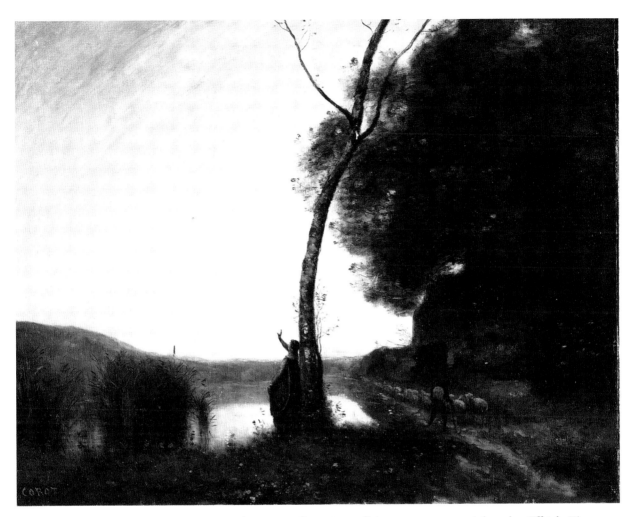

artist's work, each brought to his paintings his own individual interests.

Théodore Rousseau, for example, was regarded as the foremost specialist in pure landscapes. Finding formal training of little help, he taught himself by copying the works of the seventeenth-century masters Claude Lorrain, the Van de Velde brothers and Karel Dujardin.

One of his most controversial works, *Effet de Givre*, was executed while he shared quarters with a colleague, Jules Dupré, at L'Isle-Adam on the Oise River during the winter of 1845/6 [36]. In this pivotal painting, Rousseau conveys the warm golden light breaking through the cloud cover to illuminate the hoarfrost glistening on the rocky terrain. Working at the site for only a week, he completed this

34
Jean-Baptiste-Camille Corot
French, 1796–1875
*St Sebastian Succored by Holy
Women*, 1851/3
oil on canvas
101 5/$_8$ × 66 15/$_{16}$ in (258 × 170 cm)
purchased by William T.
Walters, 1883 (37.192)

35
Jean-Baptiste-Camille Corot
French, 1796–1875
The Evening Star, 1864
oil on canvas
27 15/$_{16}$ × 35 7/$_{16}$ in (71 × 90 cm)
commissioned by William T.
Walters, 1864 (37.154)

36
**Pierre Étienne Théodore
Rousseau**
French, 1812–67
Effet de Givre, 1845
oil on canvas
25 × 38 ⅝ in (63.5 × 98 cm)
purchased by William T.
Walters, 1882 (37.25)

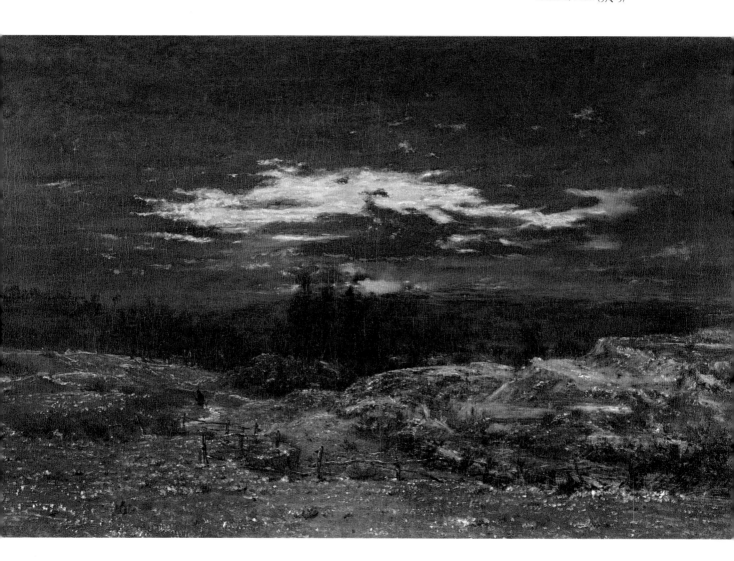

37
Pierre Étienne Théodore Rousseau
French, 1812–67
Landscape with Cottage
pencil, crayon and watercolor on paper
12 ¹/₈ × 14 ³/₄ in (32.2 × 37.5 cm)
purchased by William T. Walters, 1867 (37.966)

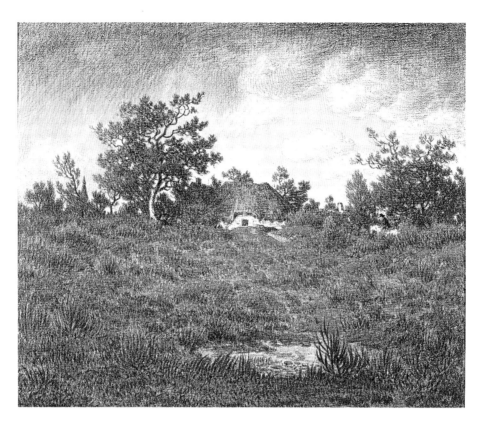

painting, which has been heralded as a harbinger of Impressionism.

Rousseau toured various regions of the country—Franche-Comté, the Auvergne and the Alps and the Jura Mountains—but returned to the Fontainebleau forest, renting a studio in Barbizon, where he would eventually spend much of his time. In a drawing, *Landscape with Cottage*, showing a peasant's thatched house on a rise in the swampy region of the forest, he demonstrated his commitment to recording his actual observations [37].

Like his friend Rousseau, Jules Dupré had been deeply impressed by paintings of the Dutch masters, particularly those of Hobbema, Ruisdael and Van Ostade, and he had also familiarized himself with British art during a visit to England in 1831. The impact of John Constable is apparent in *A Bright Day*, a landscape with a low horizon and expansive, cloud-strewn sky [38]. In 1849, Dupré argued with Rousseau; and although he later befriended Millet, he increasingly worked in isolation, having little immediate contact with his colleagues in Barbizon.

Dupré's uncle, Arsène Gillet, operated the porcelain factory where Diaz de la Peña, the orphaned son of Spanish refugees, first found employment. In 1830, Diaz left the factory to devote his energies to landscape

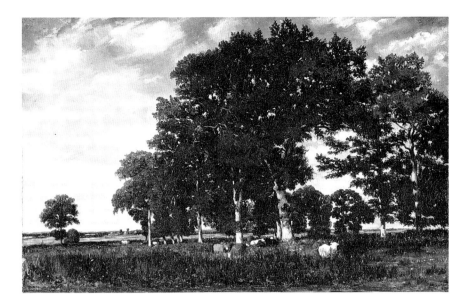

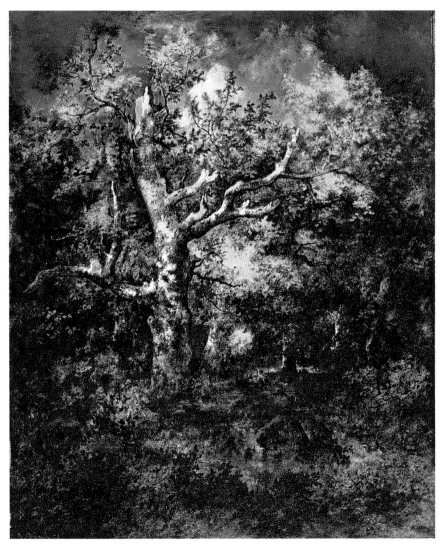

38
Jules-Louis Dupré
French, 1811–89
A Bright Day, 1835/40
oil on canvas
11 1/4 × 17 11/16 in (28.5 × 45 cm)
purchased by William T.
Walters, 1883 (37.38)

39
**Virgile Narcisse Diaz de la
Peña**
French, 1807–76
*Forest of Fontainebleau,
Autumn*, 1871
oil on panel
30 1/4 × 25 1/2 in (78 × 64.7 cm)
purchased by William T.
Walters, 1884/7 (37.64)

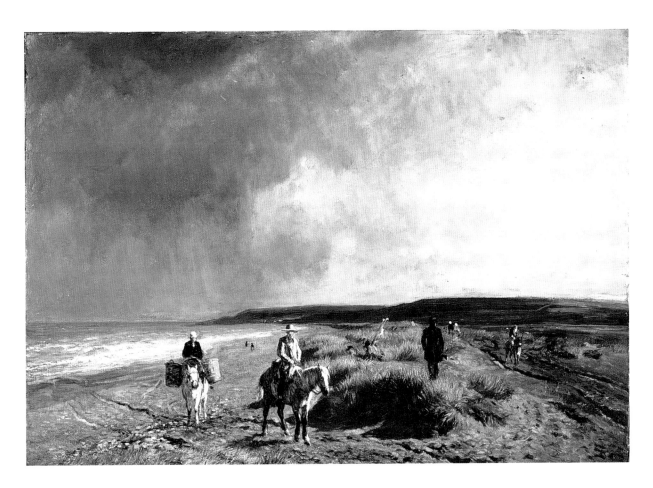

painting, though throughout his career he frequently introduced into his compositions figurative motifs—Dianas and Venuses or Spanish gypsies—often painted in a manner recalling the eighteenth-century rococo style. He first stayed in Barbizon in 1835, and despite occasional visits to Etretat and Honfleur on the coast, he remained inexorably linked with the Fontainebleau village. He painted densely wooded scenes viewed from the depths of the forest. A congenial individual, Diaz attracted a number of young admirers, among them the future impressionists Monet, Renoir, Bazille and Sisley. His reputation as the outstanding colorist of the Barbizon school is confirmed by a painting of an old tree with broken limbs, *Forest of Fountainebleau, Autumn* [39]. By scumbling the russets, ochres, golden yellows and the various greens and grays, he achieved the effect of a tapestry.

At the suggestion of his friend Dupré, Constant Troyon joined the gatherings at the Auberge Ganne in

40
Constant Troyon
French, 1810–65
Coast near Villers, about 1859
oil on canvas
26 $\frac{1}{2}$ × 37 $\frac{11}{16}$ in (67.4 × 95.7 cm)
purchased by William T.
Walters, 1903 (37.993)

41
Jean-François Millet
French, 1814–75
The Sheepfold at Moonlight,
1856/60
oil on panel
17⁷/₈ × 24¹⁵/₁₆ in (45.3 × 63.4 cm)
purchased by William T.
Walters, 1884/7 (37.30)

Barbizon. After visiting Normandy in 1841, where he worked with the animal specialist J. R. Brascassat, Troyon began to insert animals into his landscapes. Six years later, this practice was reinforced by a visit to the Netherlands and Belgium where he saw the animal subjects of the Dutch seventeenth-century painters Paulus Potter and Albertus Cuyp. In *Coast near Villers*, Troyon presents a dramatic view of the beach as a storm approaches [40]. Ominously silhouetted against the horizon is an estuary lost in shadow, and discernible among the figures in the foreground are a peasant couple

mounted on ponies, a sportsman and hunters with fowling nets.

Ironically, the artist most frequently associated with the Barbizon school, Jean-François Millet, excelled in figurative rather than landscape painting. Born into a relatively prosperous peasant family, he received a stipend in 1837 enabling him to leave Normandy for Paris to enroll in the studio of Paul Delaroche, an experience that proved of little consequence. While in Paris, however, Millet befriended his future colleagues Rousseau, Troyon, Diaz, Barye and Daumier. When cholera threatened the city in 1849,

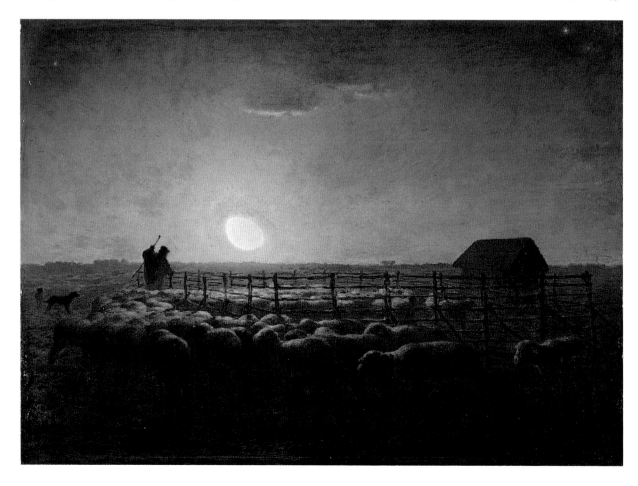

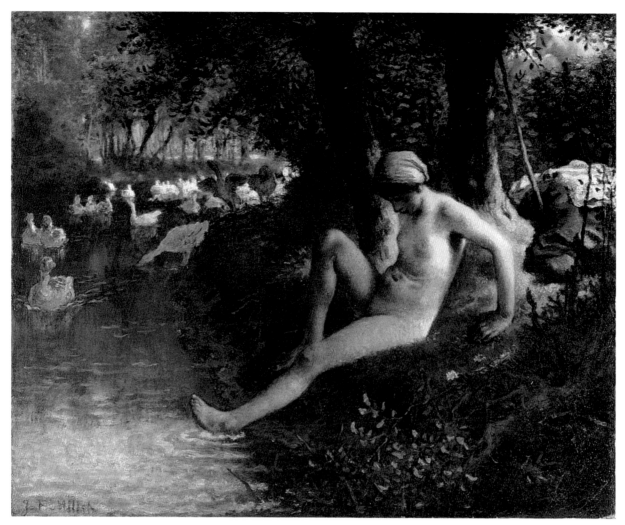

Millet and his family moved to Barbizon where he would remain throughout the year for most of his career.

In *The Sheepfold at Moonlight*, a nocturnal scene in which a solitary shepherd and his dogs tend a flock on the plain extending between the villages of Barbizon and Chailly, Millet conveys a sense of timelessness, the unknown and the infinite [41]. A sense of mystery is imparted to the scene by the waning, gibbous moon (seen with more than half but not all of the apparent disk illuminated), which the artist recorded so precisely that astronomers taking into consideration Barbizon's latitude and longitude have been able to conjecture that the time

42
Jean-François Millet
French, 1814–75
The Goose Girl, 1863
oil on canvas
14 ¹⁵/₁₆ × 18 ⁵/₁₆ in (38 × 46.4 cm)
purchased by Henry Walters,
1905 (37.153)

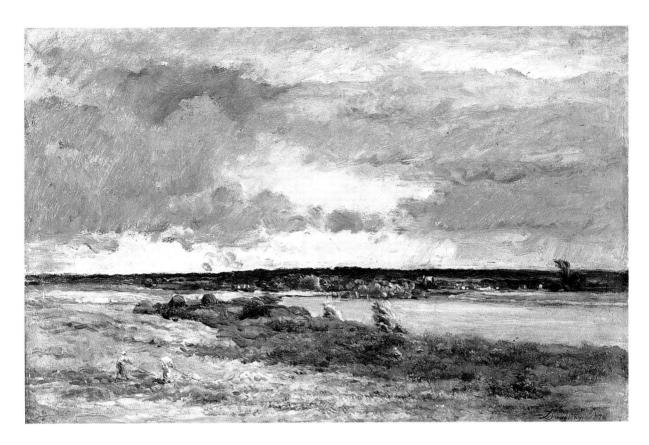

and approximate date of the scene is near 10 pm in mid-January. Millet was misunderstood by many of his contemporaries who failed to recognize in his paintings an expression of the brutal reality of agrarian life and, instead, interpreted them as manifestations of faith in either religion or socialism. In actuality, Millet was too much of an agnostic and fatalist to have been drawn to either credo.

As conditions improved in his later years, Millet may have mellowed. One of his most benign subjects is the goose girl bathing in a brook alone except for her gaggle of geese and a grazing cow [42]. Millet increasingly exploited

color, and in *The Goose Girl*, the sunlight gleaming through the foliage illuminates and intensifies the colors in the undergrowth.

A younger artist linked with the Barbizon school, although he was not an habitué of the village, Charles Daubigny helped to bridge the gulf between his colleagues and the younger impressionists. He traveled extensively in France, converting a small boat, "Le Botin," into a floating studio in which he cruised the French rivers. His close friend Corot was designated honorary admiral, Daubigny was the captain and his son Karl served as cabin boy.

43
Charles-François Daubigny
French, 1817–78
The Coming Storm, Early Spring,
1874
oil on panel
17 1/2 × 27 15/16 in (44.4 × 70.9 cm)
purchased by William T. or
Henry Walters, 1887/95
(37.163)

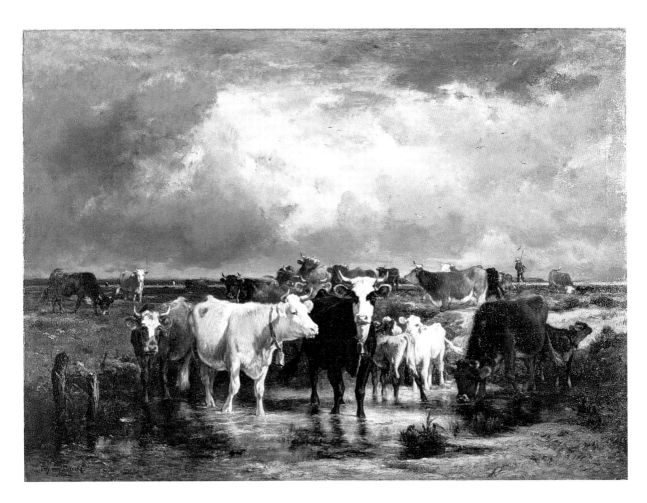

Painting with loose, seemingly spontaneous brush-strokes, he incurred the wrath of critics, including Théophile Gautier, who accused him of painting merely "impressions." His vividly colored landscape *The Coming Storm, Early Spring* dates from 1874, the year of the first impressionist exhibition [43].

Émile Van Marcke was tangentially connected to the Barbizon school. He had been introduced to sketching directly from nature by his friend and mentor, Constant Troyon. Van Marcke explored the countryside looking for agrarian, usually bovine subjects. *The Approach of a Storm* is typical of his large Salon paintings which brought him official recognition and popular success, especially among American buyers [44]. The cowherd mounted on stilts denotes the setting as the swampy terrain in the Landes region of southwestern France.

44
Émile-Lecummen Van Marcke
French, 1827–90
The Approach of a Storm
oil on canvas
57 1/2 × 79 1/8 in (146 × 201 cm)
purchased by William T.
Walters, 1872 (37.77)

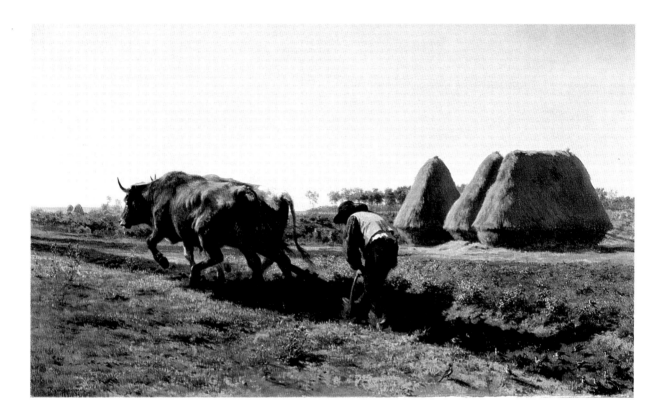

Another animal specialist, Rosa Bonheur, main-tained a menagerie for her subjects at a château in By, a hamlet near Barbizon. Her international reputation was established by the monumental *Horse Fair* (New York, The Metropolitan Museum of Art) exhibited at the Salon in 1853. In *Ploughing Scene*, which shows a peasant plough-ing with a yoke of oxen, she exhibits great sensitivity to the effects of the light falling across the field and casting long shadows [45].

Some landscape painters of this period lacked access to artists' studios and art schools. For them, the experience of decorating porcelain with figurative or landscape subjects often provided an alternative opportunity to learn their craft. Both Dupré and Diaz initially worked for private factories, whereas Troyon and Van Marcke found employment at the state-owned Sèvres Manufactory. Characteristic of the Sèvres wares of this period is a large vase decorated with a view of the Château de St-Cloud and a woodland vignette [46]. Auguste Renoir, who was himself a porcelain decorator at the outset of his career, attributed the decline of the art to the introduction of transfer-printed decoration.

Although Gustave Doré is ranked as one of the great-est illustrators of the nineteenth century, he wanted to be

45
Marie-Rose Bonheur
French, 1822–99
Ploughing Scene, 1854
oil on canvas
19¹/₂ × 31³/₄ in (49.5 × 80.5 cm)
purchased by Henry Walters,
after 1929 (37.836)

remembered for his monumental canvases. A native of Alsace in eastern France, he fell outside the mainstream of French landscape painting and perhaps should best be classified as a late-romantic artist. Doré enjoyed travel, especially to remote, undeveloped regions. During a visit to the Scottish Highlands in 1873, ostensibly to fish for salmon, he prepared a number of sketches which, over the next eight years, would serve as the basis for his canvases. In *Landscape in Scotland* he presents a grandiose, sweeping view of a valley [47]. Light streams through a tumultuous sky to illuminate a vast valley partially obscured by the clouds rolling over the mountains.

Americans were less encumbered than Europeans by the concept of a hierarchy in categories of painting. During the first half of the nineteenth century, landscapes and genre paintings vied with portraiture as popular art forms. A number of artists centered in New York, who would later be categorized as the Hudson River school, regarded the North American wilderness as a manifestation of Nature in its unsullied, primeval state. By the 1850s, they had abandoned the idealized, Claudian traditions originating in Europe for a more empirical approach. Their leader, Asher B. Durand, interpreted nature as an intimation of a higher reality in which man's spirit played an integral role, and urged them to execute oil studies and

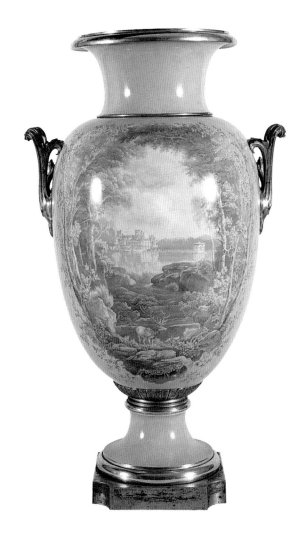

46
Large Vase, produced in 1863
and decorated in 1865
Sèvres Porcelain Manufactory
porcelain, gilt-bronze
H: 38 in (96.5 cm)
purchased by William T.
Walters (48.1799)

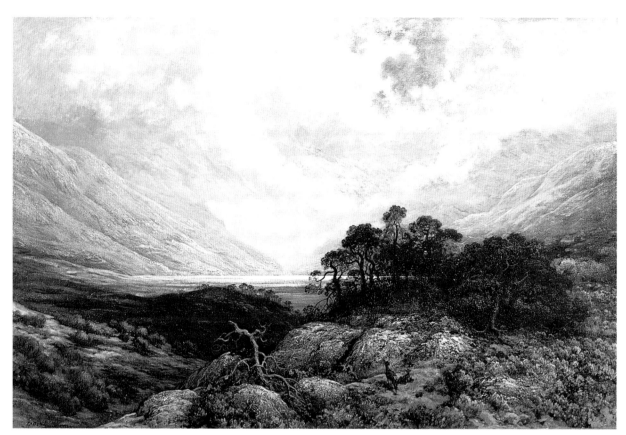

pencil sketches out of doors. Such exercises, he maintained, would enhance their knowledge of nature as well as provide a basis for their studio paintings. *The Catskills* presents a view recalling the Plaaterkill Cove in the Catskill Mountains [48]. Two large, partially moss-covered trees, a black birch and a sycamore, dominate the foreground. First falling over a rocky precipice, a stream then winds through the valley toward the sunny plain in the distance. The only sign of life, a squirrel crouching on a rock in the foreground, serves to emphasize the loneliness and grandeur of the setting.

Still life subjects remained a secondary category of art, except in cities such as Lyons where floral designs were required for the silk-weaving industry. At mid-century, however, in both Europe and America, still life and landscape traditions coalesced to create *natures vivantes* in which living plants were faithfully depicted, as opposed to still lifes or *natures mortes* composed of plant arrangements. Such an approach was advocated by the influential English critic John Ruskin, who stressed that "the most beautiful position in which flowers can be seen is precisely the most natural one." Taking this advice to heart, the

47
Gustave Doré
French, 1832–82
Landscape in Scotland, about 1878
oil on canvas
51⁷/₈ × 77³/₁₆ in (131 × 196 cm)
museum purchase, W. Alton Jones Acquisition Fund, 1986 (37.2625)

48
Asher B. Durand
American, 1796–1886
The Catskills, 1859
oil on canvas
62³/₈ × 50¹/₈ in (158 × 128 cm)
commissioned by William T. Walters, 1858 (37.122)

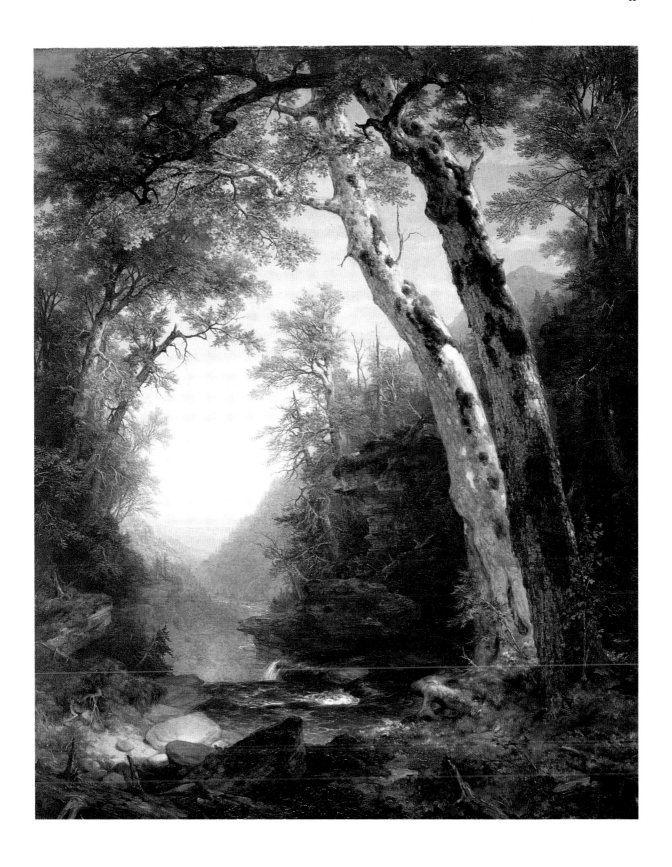

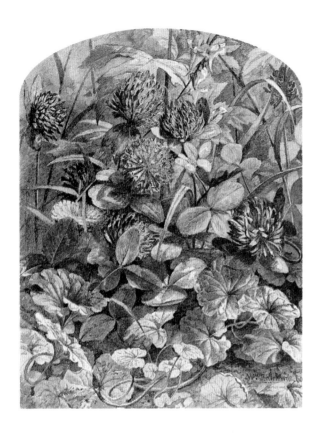

49
William Trost Richards
American, 1833–1905
*Red Clover, Butter-and-eggs and
Ground Ivy*, 1860
pencil and watercolor on paper
$6^{11}/_{16} \times 5^{5}/_{16}$ in (17.3 × 13.5 cm)
purchased by William T.
Walters, before 1862 (37.1564)

American painter William Trost Richards produced some remarkable drawings and watercolors showing plants growing in their natural settings [49].

An Irish topographical painter, Andrew Nicholl, juxtaposed clusters of plants against panoramic landscapes. In doing so, he might have been following a precedent set by botanical artists such as Robert Thornton, who used similar spatial arrangements for his famous publication, *The Temple of Flora*. In Nicholl's *Wildflowers with a View of Dublin from Dunleary*, a magnificent stand of poppies, daisies and other wild flowers are set against a view of Dublin Bay [50].

50
Andrew Nicholl, R.H.A.
Irish, 1804–86
*Wildflowers with a View of
Dublin from Dunleary*
watercolor on paper
$16^{1}/_{4} \times 26^{7}/_{8}$ in (41.2 × 68.2 cm)
gift of the Honorable Francis
D. Murnaghan, Jr, 1987
(37.2628)

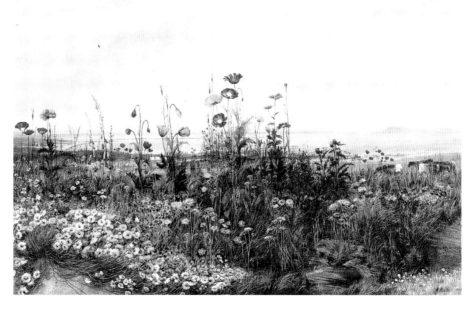

51
Léon Bonvin
French, 1834–66
*Vase of Flowers near an Open
Window*, 1864
watercolor on paper, mounted
on cardboard
9¹/₂ × 7⁵/₁₆ in (24.2 × 18.5 cm)
purchased by William T.
Walters (37.1660)

Léon Bonvin devoted his brief career to painting in watercolors both still lifes and *natures vivantes.* Unlike his half-brother, François, who attained success in Paris as a realist genre painter, Léon remained in relative obscurity at his family's inn in Vaugirard, a village absorbed by the capital in 1860. He confined his painting to the early mornings and evenings, depicting flowers and vegetables from his own garden or showing them growing in the fields surrounding the inn. In *Vase of Flowers near an Open Window* he combines both approaches, showing a vase of flowers with wilted petals realistically lying on the sill and, outside, a view of the Vaugirard countryside [51].

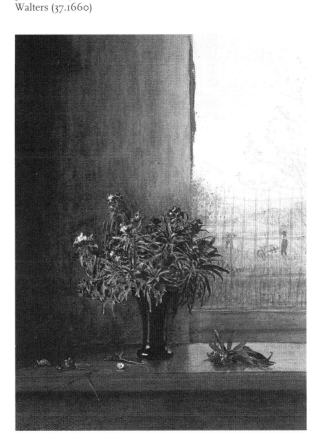

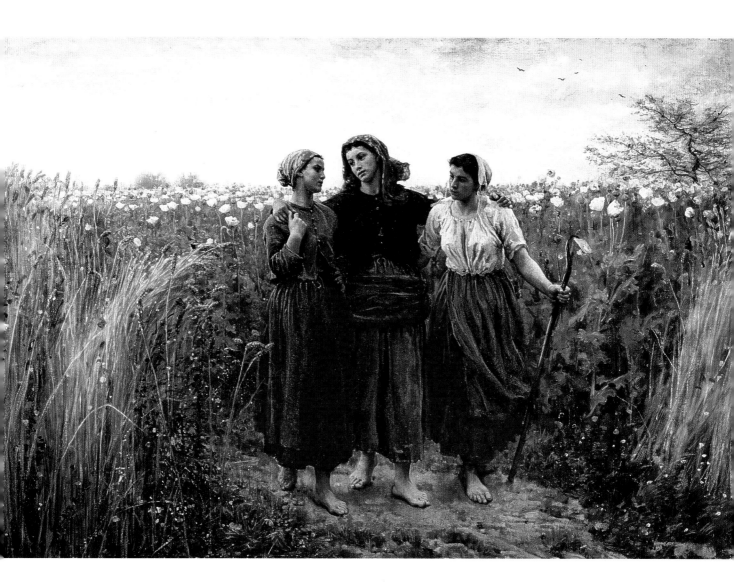

52
**Jules-Adolphe-Aimé-Louis
Breton**
French, 1827–1906
Returning from the Fields, 1871
oil on canvas
27 ³/₈ × 41 in (69.5 × 104 cm)
purchased by William T.
Walters, 1886 (37.58)

SOCIAL REALISM AND GENRE PAINTING

Realistic tendencies had permeated French art since the beginning of the century, as demonstrated by the starkly honest portrayal of an elderly woman attributed to David [9]. At mid-century, the term "Realism" was generally reserved for artists who broke with academic conventions to portray objectively contemporary subjects, without distorting or idealizing them. Realism did not represent a slavish imitation of nature, but rather the artist's sincere, though inevitably subjective endeavor to record the external world. It was a democratic, even socialist movement which dealt with subjects previously dismissed as artistically insignificant. Realism was manifested in literature as well as the visual arts, as demonstrated in the writings and art criticism of Champfleury (Jules Husson), Charles Baudelaire and Émile Zola.

In 1849/50, Gustave Courbet established his reputation as the principal spokesman for Realism with his vast canvas, *A Burial at Ornans* (Paris, Musée d'Orsay), which he painted on a scale usually associated with historical subjects. Courbet treated in realistic, highly palpable terms a relatively mundane subject, a village funeral. After his entries had been rejected from the Paris Exposition Universelle in 1855, Courbet showed them independently outside the exhibition grounds in his "Pavilion of Realism."

Another leading exponent of Realism, Millet recorded the arduous, seemingly endless labors of the peasants. He gained notoriety with *The Sower,* shown at the Paris Salon of 1850/1 [53]. This composition, repeated a number of times, also in pastels, illustrates the endless cycle of planting and harvesting, a theme that can be traced in French art to the Middle Ages. A peasant sowing seeds dominates the foreground while in the distance another plows the field. A sense of futility is imparted to the scene by the droves of crows descending to devour the freshly sown seeds. The same spirit prevails in a small painting, *Breaking Flax*, in which Millet presents a monumental, even iconic image of a woman alone in a murky interior crushing a sheaf of flax with a beetle and block [54]. During the 1850s, as he drew closer to Rousseau, Millet increasingly incorporated his figurative subjects into landscape settings. Peasants toil in the plain between the villages of Barbizon and Chailly in *The Potato Harvest*, one of nine works which drew international acclaim at the Exposition Universelle in 1867 [55]. In this work, where Millet again treats the theme of the peasants' struggle for survival, he employs paste-like pigments densely applied over a coarsely textured canvas, a technique appropriate for the rustic subject.

A comparison between Millet's peasant subjects and those of Jules Breton proves instructive. Like Millet,

53
Jean-François Millet
French, 1814–75
The Sower
pastel and crayon on paper
16¼ × 20 in (41.2 × 50.8 cm)
purchased by William T.
Walters, 1884 (37.905)

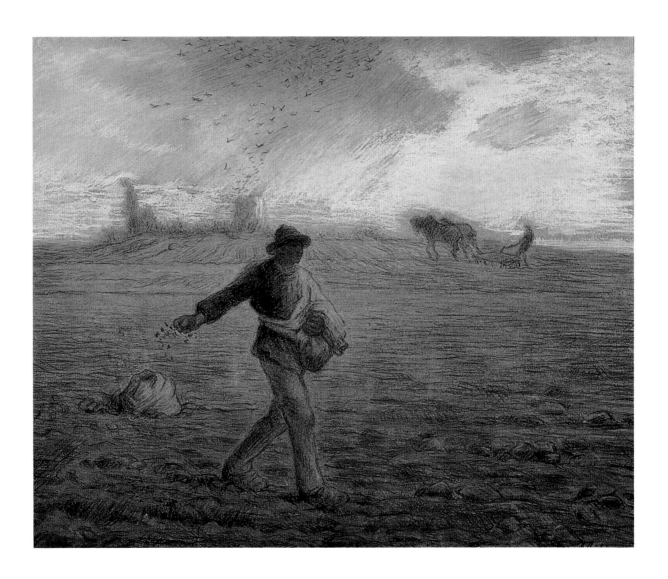

54
Jean-François Millet
French, 1814–75
Breaking Flax, 1850/1
oil on canvas
18^1/$_{16}$ × 14^5/$_8$ in (45.85 × 37.2 cm)
purchased by William T.
Walters, prior to 1878

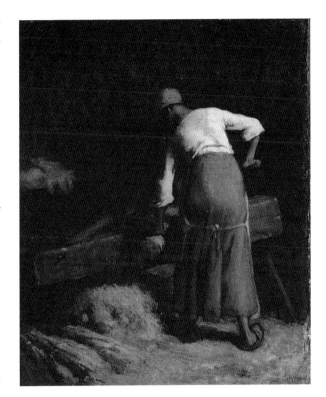

Breton came from a rural background and spent much of his career in his native town of Courrières in the north of France. Breton painted scenes similar to those in Millet's works, but worked in an academic style, presenting highly idealized views of peasant life. In *Returning from the Fields*, three barefoot young women, returning to the village, stroll through a field of wheat and poppies tired but contented after their day of toil [52].

Honoré Daumier, in contrast, explored urban subjects. In illustrations for a number of journals, including *Le Charivari*, he demonstrated an extraordinary power of observation and a biting wit. His ardent republican and anti-monarchist sentiments, expressed in caricatures lampooning King Louis-Philippe, landed him in jail in 1832. After the French revolution of 1848, he returned to political cartoons which were now focused on the regime of Louis-Napoleon, the prince-president. In his sculpture *Ratapoil*, modeled in 1850/1, but only cast posthumously, Daumier satirizes the unscrupulous political thug who ensured Napoleon's rise to power [56]. The swaggering scoundrel is depicted leaning on the cudgel that he used to bully voters.

During his later years Daumier found a private clientele for drawings and watercolors, treating many of the themes that had also appeared in his journal illustrations:

55
Jean-François Millet
French, 1814–75
The Potato Harvest, 1855
oil on canvas
21¼ × 25⅞ in (54 × 65.2 cm)
purchased by William T.
Walters, before 1878 (37.115)

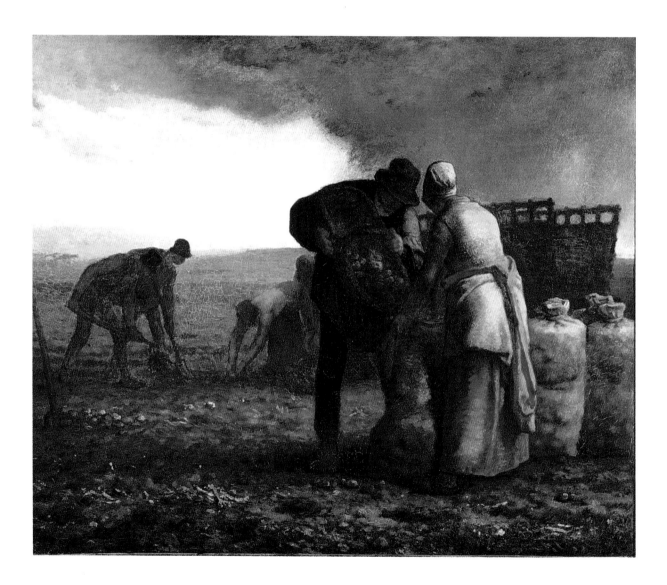

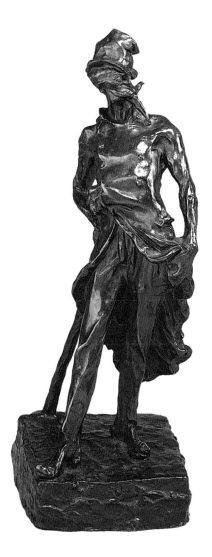

56
Honoré Daumier
French, 1808–79
Ratapoil, 1850/1
bronze (cast by Siot-Decauville, Paris)
H: 17 ⁱⁱ/₁₆ in (45 cm)
purchased by George A. Lucas, 1891,
part of the George A. Lucas Collection
at the Walters Art Gallery, 1997
(27.497)

travel for the rich and poor. In *The First Class Carriage*, four well-dressed figures, all absorbed in their own thoughts, ride comfortably in an upholstered compartment [57]. Their postures and facial expressions reveal varying degrees of self-contentment. *The Second Class Carriage* nearly replicates a wood-engraving published two years earlier entitled *Pleasure Train: Ten degrees of Boredom and Bad Humor* [58]. The caption leaves no doubt as to the state of mind of travelers in this bitter, winter scene. Daumier reserves his sympathies for the passengers riding in the undivided coach in *The Third Class Carriage*, a subject which he repeated in two oil paintings (New York, The Metropolitan Museum of Art, and Ottawa, National Gallery of Canada) [59]. On the banquette in the foreground, a woman with features recalling those of Millet's peasants gazes downwards with an expression of resignation. She is flanked by a mother nursing her child, and a sleeping boy.

William Walters may have been prompted to commission these carriage scenes after either he or his adviser, George A. Lucas, had noticed a wood-engraving, *L'intérieur d'un omnibus*, published in *Le monde illustré* in January 1862. The newspaper print provided a basis for the watercolor *The Omnibus*. In this work, Daumier has brought to bear a gentle sense of humor. A plump peasant

ordinary individuals victimized by abuses of authority, urban dwellers going about their daily chores and artists and patrons interacting with each other. Travel and its vicissitudes provided an endless source of subjects for his keen humor. In a series of three watercolor drawings commissioned in 1864, Daumier describes the distinctions in

57

Honoré Daumier

French, 1808–79

The First Class Carriage, 1864

ink, watercolor and litho-
graphic crayon on paper

8 ¹¹/₁₆ × 11 ¹³/₁₆ in (20.5 × 30 cm)

commissioned by George A.
Lucas for William T. Walters,
1864 (37.1225)

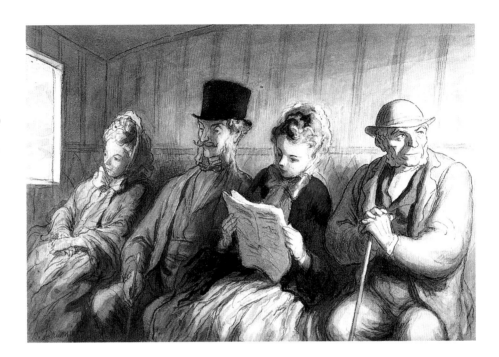

58

Honoré Daumier

French, 1808–79

The Second Class Carriage, 1864

ink, watercolor and lithographic
pencil on paper

8 × 11 ⁷/₈ in (20.5 × 30.1 cm)

commissioned by George A.
Lucas for William T. Walters,
1864 (37.1224)

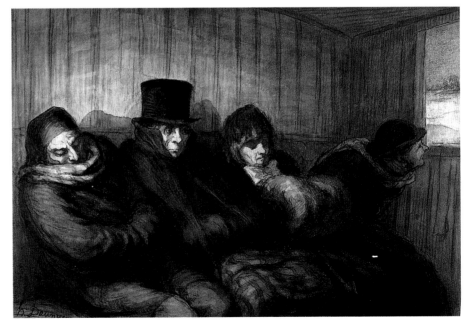

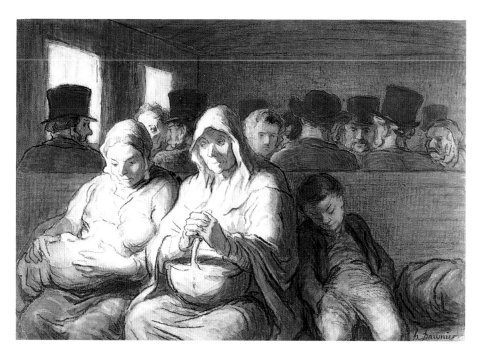

59
Honoré Daumier
French, 1808–79
The Third Class Carriage, 1864
ink, watercolor and litho-
graphic crayon on paper
8 $^1/_{16}$ × 11 $^7/_8$ in (20.5 × 30.1 cm)
commissioned by George A.
Lucas for William T. Walters,
1864 (37.1226)

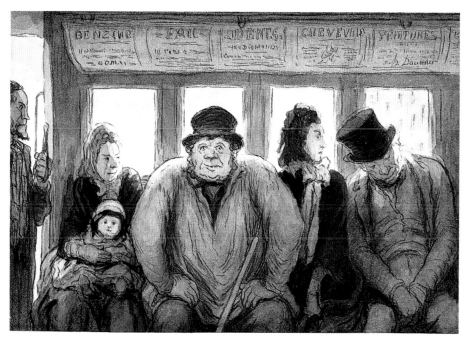

60
Honoré Daumier
French, 1808–79
The Omnibus, 1864
ink, watercolor and litho-
graphic crayon on paper
8 $^3/_8$ × 11 $^7/_8$ in (21.2 × 30.2 cm)
commissioned by George A.
Lucas for William T. Walters,
1864 (37.1227)

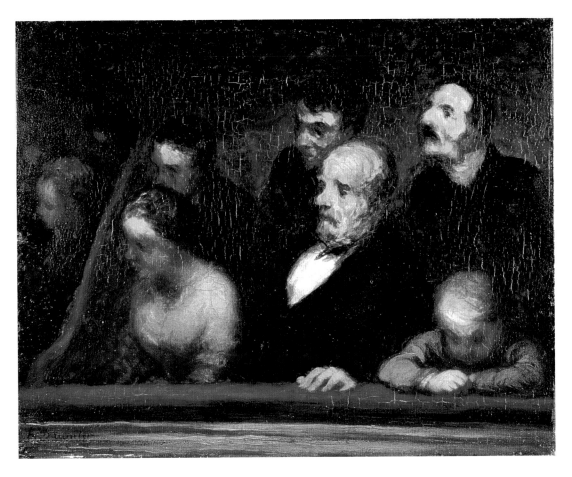

gazes nonchalantly at the viewer, apparently oblivious to both the mother and child cringing in the corner and to the prim woman with the frosty expression wedged between him and the dozing, elderly gentleman [60]. Mounted overhead are advertisements for benzine, paste, teeth, hair and paintings, the last bearing the signature: "h. Daumier."

Throughout his career, Daumier painted in oils, but he seldom exhibited his canvases, which often remained unfinished. During the 1850s and 1860s, he specialized in small, intimate scenes showing many subjects similar to those that had appeared in his illustrations. In *The Loge*, an audience is deeply absorbed in a theatrical production. His treatment, in this instance, is marked by a sense of compassion and pathos rather than wit [61].

Daumier's contemporary, the caricaturist Hippolyte-Guillaume-Sulpice Chevalier adopted the pen-name "Paul Gavarni" (after the valley of Gavarnie in the Pyrenees).

61

Honoré Daumier
French, 1808–79
The Loge, 1854/7
oil on panel
9 1/2 × 12 1/16 in (24.1 × 30.7 cm)
purchased by George A. Lucas, 1881, part of the George A. Lucas Collection at the Walters Art Gallery, 1996 (37.1988)

62
Paul Gavarni
French, 1804–66
"At age 15, me, I wasn't yet formed"
watercolor and ink on paper
12 $^{15}/_{16}$ × 7 $^{7}/_{8}$ in (32.5 × 20 cm)
purchased by William T. Walters, after 1868 (37.1459)

Like Daumier, Gavarni produced lithographs for *Le Charivari* and other journals, but after a visit to England in the early 1850s, he turned to painting in watercolor. In a work inscribed "*à quinze ans, moi, j'étais pas 'core formée*" ("at age fifteen, me, I wasn't yet formed") he presents a poignant image of a woman broken by labor and bereft of hope for the future [62].

During the late 1840s, François Bonvin, Léon's half-brother, joined Courbet's circle of realist artists and writers at the Brasserie Andler. François' earliest genre scenes reflected the influence of the French seventeenth- and eighteenth-century realists, the Le Nain brothers and Chardin, but after a visit to the Netherlands in 1867, he drew increasingly on Dutch seventeenth-century genre painting. His composition, *Interior of a Tavern*, showing the interior of the family inn in Vaugirard, is adapted from Pieter de Hooch's *The Cardplayers* (Paris, Musée du Louvre) [63]. A placard hanging on the wall inscribed "Goodwin" provides a cryptic allusion to the name of the family inn, "Le Bon Vin."

Following the precedent set by Courbet's Pavilion of Realism, Bonvin organized in his studio a small exhibition of works rejected by the 1859 Salon jury. Among the avant-garde, realist artists he represented were Théodule-Augustin Ribot and James McNeill Whistler. Ribot

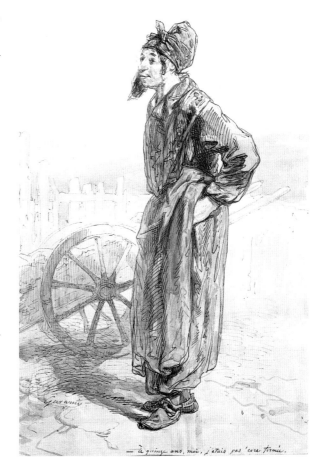

— à quinze ans, moi, j'étais pas 'core formée.

62

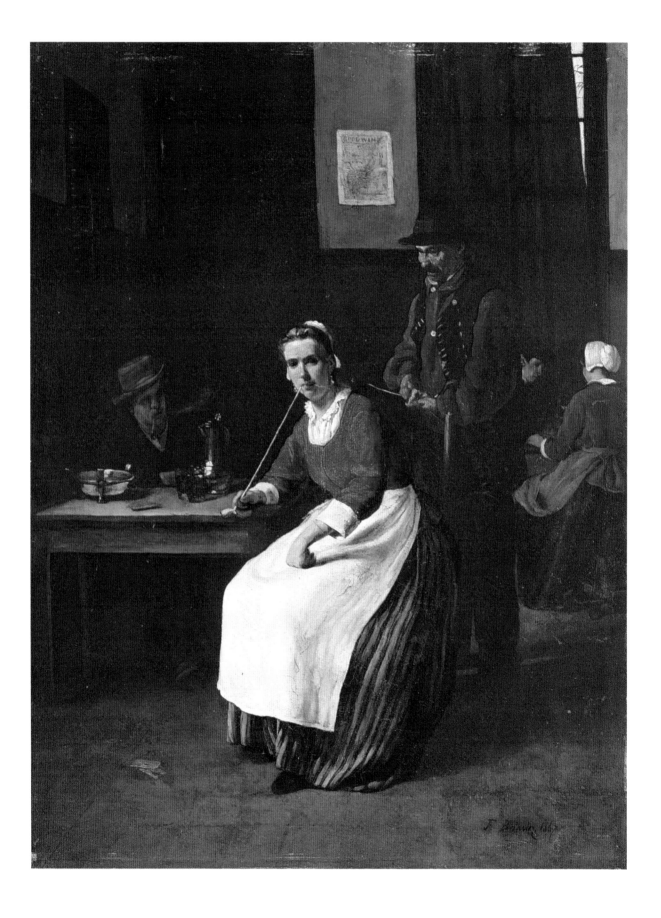

63
François Bonvin
French, 1817–87
Interior of a Tavern, 1867
oil on panel
19 ¼ × 14 ⅝ in (50.1 × 37.2 cm)
purchased by Henry Walters,
1910 (37.837)

64
Théodoule-Augustin Ribot
French, 1823–91
The Young Cook
oil on canvas
13 ¼ × 10 ¹³/₁₆ in (35 × 27.5 cm)
purchased by Henry Walters,
1908 (37.3)

specialized in small genre scenes, often of kitchen interiors. In *The Young Cook*, a butcher boy tempts a cat with a piece of meat [64]. The limited palette and dramatic contrast in light and shadow recall the use of chiaroscuro by the seventeenth-century Spanish masters Ribera and Velázquez.

Many artists, declining to comment on society's ills, produced genre paintings which assuaged rather than provoked middle-class clients' sensibilities. Edouard Frère's small canvases presenting a microcosm of life in Ecouen, a village north of Paris, proved exceptionally popular among British and American patrons. Invariably, he depicted children engaged in daily activities. These sentimental subjects stirred the English art critic John Ruskin to rhapsodize: "Who would have believed it possible to unite the depth of Wordsworth, the grace of Reynolds, and the holiness of Raphael" [65].

The English painter Charles Green, likewise, illustrated scenes from daily life. In a large watercolor, *The Derby, Here They Come! Here They Come!*, exhibited at the 1878 Paris Exposition Universelle, he explored the physiognomies of characters ranging from society nobs to the hoi polloi, who still come together once a year for one of the most popular events in British social life, the Derby, the horse race run at Epsom Downs. In doing so, Green capitalized on the renown of William P. Frith's treatment of

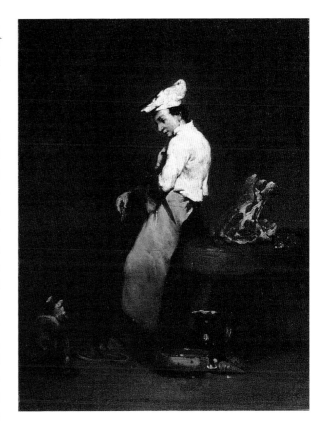

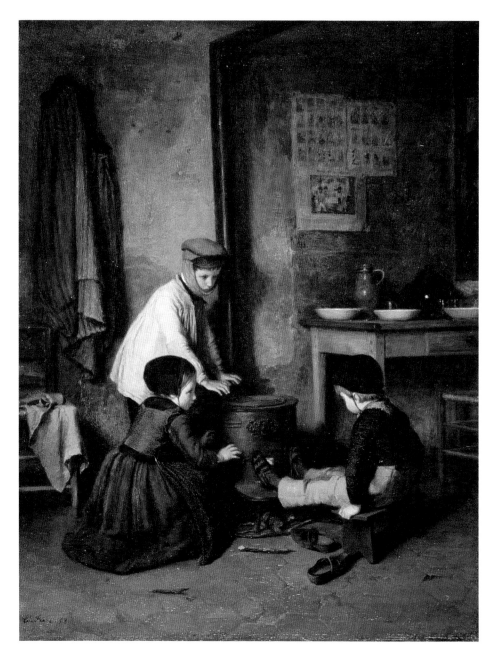

65
Pierre-Edouard Frère
French, 1819–86
The Cold Day, 1858
oil on panel
16 ¼ × 12 ½ in
(41.3 × 31.8 cm)
purchased by William T.
Walters, 1860 (37.29)

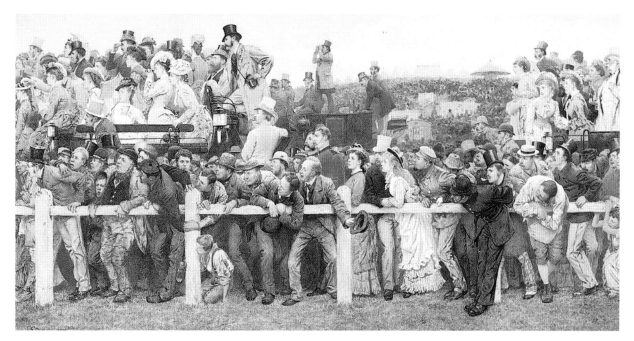

the same theme a decade earlier, *Derby Day* (London, Tate Gallery) [66].

In the United States at mid-century, naturalistically rendered views of daily life rivaled landscape painting in popularity. Most often, American genre painters depicted anecdotal, often humorous, scenes of rural life. An exception was Richard Caton Woodville who specialized in urban subjects. He spent most of his brief career abroad, initially in the German town of Düsseldorf and later in Paris, specializing in scenes recalling his youth in Baltimore. In *The Sailor's Wedding*, a justice of the peace scowls angrily at the proud groom and his demure bride as the wedding party intrudes upon his dinner of roast chicken [67]. Working from memory, Woodville defined the time and setting of the scene by including such details as a map of the eastern United States and the *Franklin*

Almanac. Visible beyond the black and white onlookers standing in the doorway is a view of the typical Baltimore brick house.

As Americans traveled more extensively and grew increasingly sophisticated, their taste for such genre paintings waned. Eastman Johnson's *The Nantucket School of Philosophy* represents a late phase of the tradition [68]. Johnson, like Woodville, trained in Düsseldorf, but he continued his studies in The Hague where he familiarized himself with Dutch seventeenth-century art. This experience led him to abandon the tight, detailed style associated with the German academy in favor of a looser, more fluid technique. He also enrolled briefly in the studio of the noted French academic teacher, Thomas Couture. Back in America, he specialized in scenes of daily life, often of individuals engaged in outdoor activities or, in contrast,

66
Charles Green
English, 1840–98
The Derby, Here They Come! Here They Come!, 1877
watercolor on paper
15 1/2 × 30 1/8 in (39.4 × 76.3 cm)
purchased by William T. Walters, 1878/84 (37.950)

67
Richard Caton Woodville
American, 1825–55
The Sailor's Wedding, 1852
oil on canvas
18 ¹/₂ × 22 in (47 × 55.9 cm)
purchased by William T.
Walters (37.142)

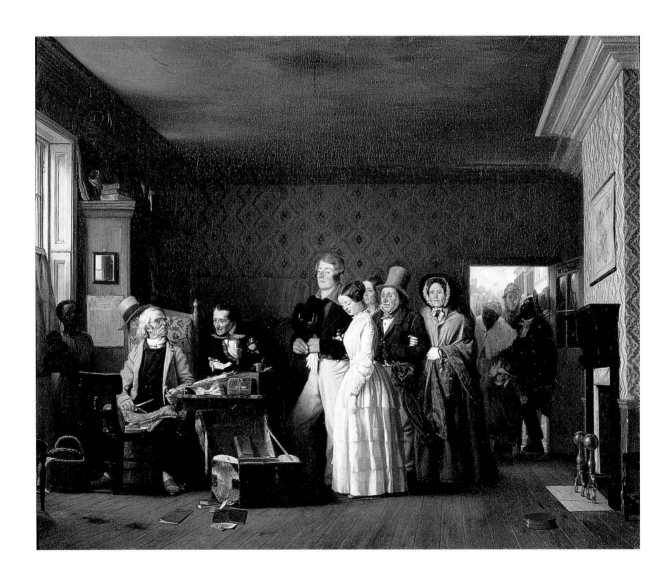

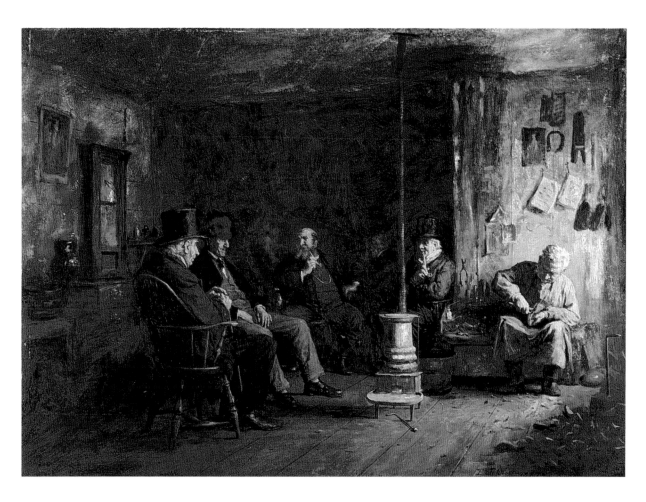

posed in elaborate interiors. In 1870, Johnson began to spend the summer and autumn months on Nantucket, Massachussetts, where he depicted the islanders' daily activities. In *The Nantucket School of Philosophy*, several elderly men, seated around a stove, enjoy their pipes while reminiscing. The suffused side-lighting of the interior and the low-keyed palette may reflect Johnson's knowledge of the Dutch seventeenth-century masters. In 1889, only two years after the work was completed, the artist identified the subjects as Captain Haggerty (the shoemaker), Captain Moore (the talker) and Captain Ray (the individual resting his head on his hand) and reported that the other "captains" had since died. After the completion of this work, Johnson devoted himself solely to portraiture.

68
Eastman Johnson
American, 1824–1906
The Nantucket School of Philosophy, 1887
oil on panel
23 1/4 × 31 3/4 in (59 × 80.5 cm)
purchased by Henry Walters, 1924 (37.311)

69
Jean-Léon Gérôme
French, 1824–1904
The Duel after the Masquerade,
1857/9
oil on canvas
15 5/8 × 22 3/16 in (39.1 × 56.3 cm)
purchased by William T.
Walters, 1859 (37.51)

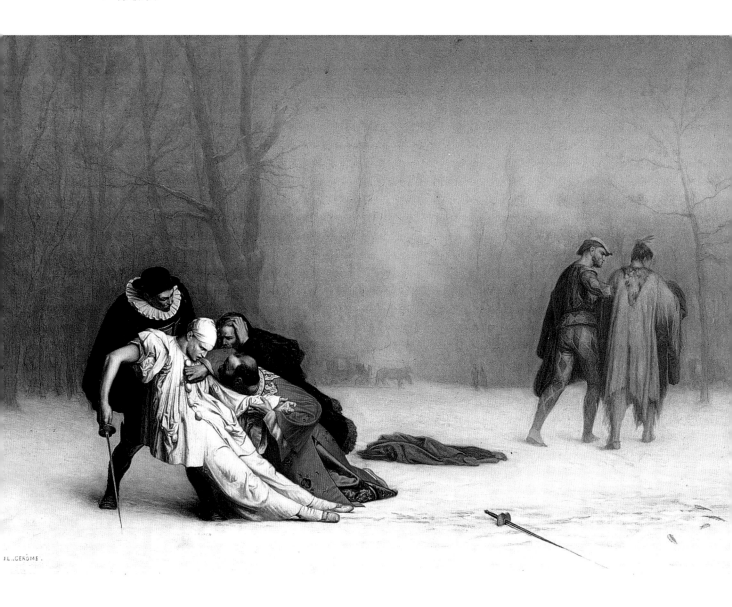

THE ACADEMIC
TRADITION

The first modern academies were established in Italy during the sixteenth century. They enshrined the fundamental humanist beliefs that the human figure provided the key to the divine order and that knowledge of pure beauty could only be derived through the study of ancient Greek and Roman statuary. In Paris, the Académie Royale de Peinture et de Sculpture opened in 1648. It was intended to free artists from the restraints of the medieval craft guilds, thereby ensuring a supply of talent to meet the demands of the state. Similar institutions followed in Vienna (1692), Berlin (1697), Naples (1755) and St Petersburg (1757). The Royal Academy of Arts, founded in London in 1768, differed in that it was operated by and for artists and was independent of government control. In North America, the earliest institution of its kind, the Académia de las Nobles Artes de San Carlos, opened in Mexico City in 1783, and during the first half of the nineteenth century, academies were established in various

cities in the United States including Philadelphia (The Pennsylvania Academy of the Fine Arts, 1805) and New York (The National Academy of Design, 1825).

During the French Revolution, the Académie Royale was disbanded and government sponsorship of the arts was reassigned to the recently created Institut de France. One branch of the Institut, subsequently known as the Académie des Beaux-Arts, was given control of the official exhibitions or Salons (named after the Salon Carré of the Louvre) which, until 1863, provided artists with opportunities for their principal exposure to the public. The Académie also maintained the Académie de France in Rome and sponsored the contests for the highly coveted Prix de Rome entitling recipients to an extended stay in Rome at the government's expense.

Art instruction, however, was left to the École des Beaux-Arts or to various regional schools. In addition to teaching drawing, these schools offered lectures in

70
Jean Auguste Marc
French, 1818–86
Hémicycle of the École des Beaux-Arts
engraving on paper
19 3/16 × 12 1/2 in (48.6 × 32 cm)
purchased by William T. Walters (93.112)

71

Hippolyte (Paul) Delaroche

French, 1797–1856

The Hémicycle, 1853

oil on canvas

16 3/8 × 101 5/16 in
(41.6 × 257.3 cm)

purchased by William T.
Walters, 1872 (37.83)

71

Detail of 71

Centre section

72

Detail of 71

Left section showing the great
sculptors and the painters who
had distinguished themselves
as colorists and naturalists.
Readily distinguishable are
Titian, shown in profile facing
Rembrandt, and the seated
Van Dyck.

73

Detail of 71

On the right side of the mural
are the architects, two
engravers and the painters who
were known for their design
and draughtsmanship. Among
the last are Leonardo da Vinci
seated on the marble bench,
Raphael shown standing and
facing left and Michelangelo
resting on a fragment of a
sarcophagus lid.

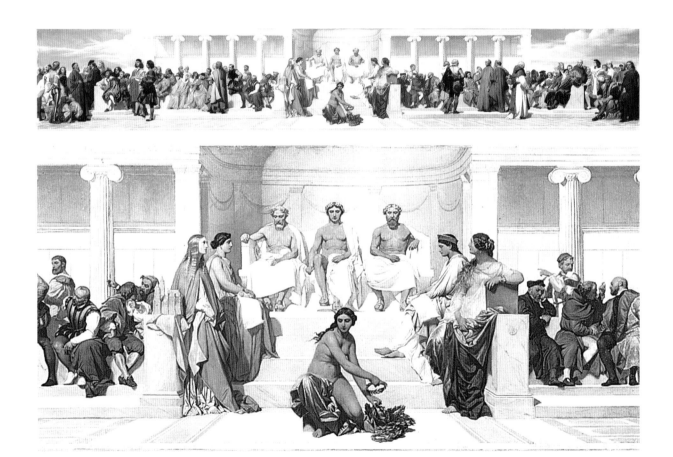

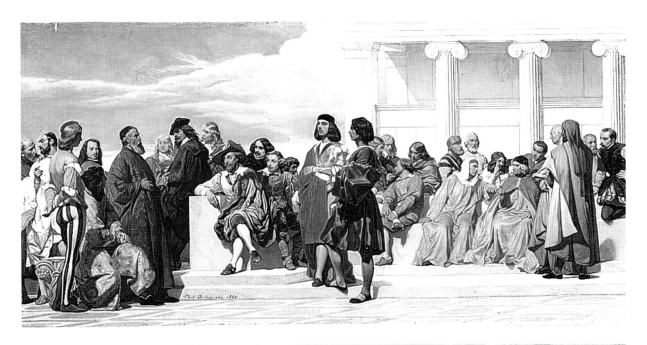

anatomy, perspective and ancient history. Until the École des Beaux-Arts was reformed in 1863, students received their practical training in painting in ateliers, or teaching studios, run by established artists.

Paul Delaroche became the youngest member of the Institut in 1832 and the following year he was appointed professor at the École des Beaux-Arts. In addition, in 1835, he assumed responsibility for the atelier that had been started by David. Over the next eight years, more than 355 pupils would pass through it.

As a painter, Delaroche can be likened to his father-in-law, Horace Vernet, who followed a middle course between the neoclassicists and the romantics, recreating with convincing verisimilitude incidents from post-classical history. Between 1836 and 1841, Delaroche labored over *The Hémicycle*, a monumental, panoramic mural painted on walls of the Salle de Prix of the École des Beaux-Arts [70]. It was in this amphitheater that the fortunate recipients received their awards. The theme of the mural was the continuity between the great masters of the past and the artists of the present day. Presiding over the scene, seated on the raised dais, are the "Immortals of Antiquity," Ictinus, the architect of the Parthenon, Apelles, the painter, and the sculptor, Phidias [71]. They are flanked by female personifications of Greek, Gothic,

Roman and Renaissance (or Modern) art and on the sides are groups of the most eminent artists from the thirteenth through the seventeenth centuries. The "Genius of Fame" appears to protrude through the picture plane to distribute laurel wreaths to the prize winners seated below, thereby providing a link between the past masters and their potential successors [72, 73].

Delaroche's mural was acclaimed as one of the *chefs-d'œuvre* of the century. Its international fame, however, owed much to reproductions, including Henriquel-Dupont's engravings, which were published in France and abroad. A reduced replica of the mural, painted in 1853, enabled the engraver to complete his work.

In 1843, Delaroche transferred control of his atelier to Charles Gleyre and left Paris for Rome. Gleyre, a Swiss artist, had studied in Rome and in 1834/5 had accompanied the Bostonian John Lowell on a tour of the eastern Mediterranean. At the 1843 Salon, Gleyre received wide acclaim for *The Evening* (Paris, Musée du Louvre), a painting recalling a vision he had experienced one evening while resting on the banks of the Nile near Abydos. With the assistance of his pupil, Léon Dussart, Gleyre undertook a replica of the celebrated work now also known as *Lost Illusions* [74]. It is a melancholic scene, rendered in subdued tones, in which an aging poet, resigned in his

74
Marc-Charles-Gabriel Gleyre
Swiss, 1806–74
The Evening (Lost Illusions),
1865/7
oil on canvas
34 1/4 × 59 1/4 in (86.5 × 150.5 cm)
commissioned by William T.
Walters, 1865 (37.184)

reveries, watches as a mysterious "bark" drifts downstream carrying away his youthful illusions and dreams, which are personified by the music-making maidens and a cupid strewing flowers.

Although he adhered to academic traditions in his own painting, Gleyre proved to be a liberal teacher who encouraged students to pursue their individual goals. His pupils ranged from the conservative Jean-Léon Gérôme to such avant-garde artists as Claude Monet, Alfred Sisley, Auguste Renoir and James McNeill Whistler.

After over two years in Delaroche's atelier, a year of study in Rome and several months with Gleyre, Gérôme emerged as a talented draughtsman with a flair for composition and a keen sense of drama. One of his few contemporary European subjects, *Departure from a Masked Ball* (Chantilly, Musée Condé), was so favorably received at the 1857 Salon that he painted two replicas, one for a Russian collector (St Petersburg, Hermitage Museum) and another, known as *The Duel after the Masquerade*, which was exhibited in London [69]. Following a dispute at a costume ball the previous evening, the protagonists, dressed as characters from the eighteenth-century theater, have engaged in a fatal duel: as Pierrot succumbs in the arms of the Duc de Guise, the Venetian Doge examines his wound and Domino clasps his brow in grief. In the mid-ground,

Harlequin leads away the victor, the American Indian. Several recent duels may have prompted this subject, or Gérôme could have been following a current literary tradition in which Pierrot was depicted as a tragic figure.

Thomas Couture falls uneasily within the academic camp. Although a pupil of David's follower Baron Gros, and also of Delaroche, he owes more to the great Venetian seventeenth-century colorists, specifically Veronese. Throughout his career, he emphasized the primacy of line, but masked the deliberate, highly controlled nature of his work with vivid colors, minimal use of half-tones, and rich, variegated paint surfaces. Couture drew subjects from contemporary life, usually imbuing them with moral overtones. Like the caricaturist Daumier, he aspired to emulate the satiric wit of the great seventeenth-century dramatist Molière. In *Lawyer Going to Court*, a jurist, burdened by the weight of his legal briefs, trudges along a road in the artist's hometown of Senlis [75]. Despite the title of this work, the lawyer appears to be approaching his residence, indicated by the notary's shields suspended over the gate. The turkey cock and the fowl pecking in the dirt introduce a profane note to the setting.

Delaroche's devoted disciple, Charles-François Jalabert, accompanied his master to Rome in 1843. He remained there for a year and then returned to France to

75
Thomas Couture
French, 1818–79
Lawyer Going to Court, 1859/60
oil on canvas
15 × 18 3/16 in (38 × 46.2 cm)
purchased by Henry Walters
(37.1204)

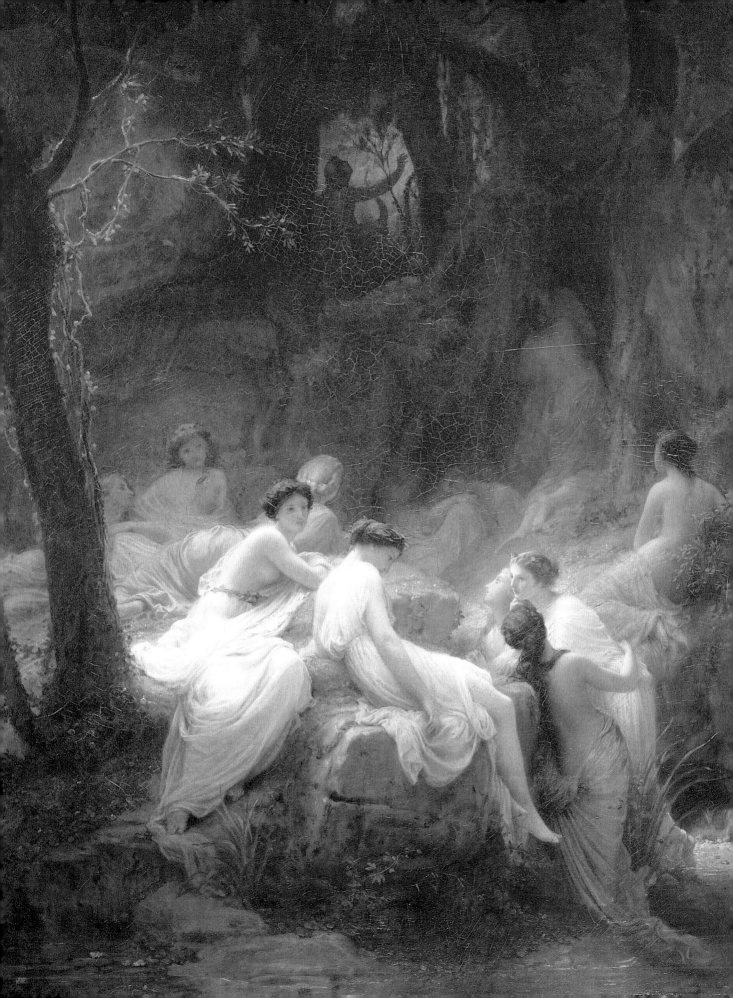

76
Charles-François Jalabert
French, 1819–1901
*Nymphs Listening to the Songs of
Orpheus*, 1853
oil on canvas
44 × 36 ⅛ in (111.8 × 91.8 cm)
purchased by William T.
Walters, before 1878 (37.37)

77
Alexandre Cabanel
French, 1823–89
Napoleon III, about 1865
oil on panel
16 ⅛ × 12 ⅝ in (41 × 32 cm)
purchased by William T.
Walters, 1887/93 (37.146)

pursue a successful career at the salons exhibiting genre
and religious paintings as well as portraits. Jalabert devel-
oped a distinctly lyrical, almost feminine style, as is clearly
apparent in one of his entries for 1853 in which dryads,
oreads and other nymphs are depicted reclining in a wood-
land glade listening to the music of Orpheus. This subject
may have been inspired by Hector Berlioz's presentation
of Gluck's *L'Orphée* at the Théâtre-Lyrique in Paris in
1859 [76].

One of the most far-reaching reforms in the adminis-
tration of the École des Beaux-Arts in 1863 was the
appointment of three faculty members to teach painting
techniques: Alexandre Cabanel, Gérôme and Isidore
Pils. A pre-eminent painter of the Second Empire
(1852–70), Cabanel was received and patronized by the
imperial family and by the aristocracy and wealthy
financiers of the period. His style was grounded in the art
of the Italian High Renaissance as well as in that of
France's seventeenth-century past. In 1865, Cabanel exe-
cuted a life-size portrait of Napoleon III for the Empress
Eugénie's apartments in the Tuileries palace. The present
whereabouts of this portrait remains unknown, but the
image has survived in a small replica painted by the artist
[77]. It is a flattering likeness showing the emperor in
court attire and wearing the grand cordon of the Légion

d'honneur and various medals. In such details as the placement of the crown on the desk and the ermine-lined robe of office, this painting recalls Hyacinthe Rigaud's court portraits of the Bourbon monarchs (Versailles, Musée de Versailles).

Both the opulence and the *retardetaire* tastes of Napoleon III's court may be surmised from an image of Eugénie painted by her Puerto Rico-born miniaturist, Pierre Paul Emmanuel de Pommayrac [78]. The empress, who was renowned for her beauty as well as for her pearls, remained devoted to the memory of her predecessor,

Marie-Antoinette, and sought to rekindle at her court the allure of the *ancien régime*. She wears a diamond and emerald diadem, a brooch and a necklace of extraordinary pearls and a pair of earrings of pear-shaped pearls known as the "Tears of Venus."

In the later nineteenth century, progressive critics dismissed paintings by conservative adherents to official and academic precepts as "Pompier Art" (*pompier*: "fireman;" alluding to metal helmets worn by firemen and the soldiers of antiquity, as well as to pomposity). These works tended to be monumental in scale, frequently classical or biblical in content and often of an allegorical nature. Among the artists frequently cited in this context was William Bouguereau, a painter of religious, classical and genre subjects and the recipient of numerous state and church commissions. In 1875, Bouguereau returned to a theme that he had first explored while a student in Rome over 21 years earlier, *The Flagellation of Christ*. The painting, completed in 1881, now hangs in the cathedral of La Rochelle, the artist's native city. A drawing related to this project illustrates Bouguereau's skills in delineating form, his attention to such details as facial expressions and gestures and his preference for restrained, highly controlled compositions [79].

During the 1860s and 1870s, Hugues Merle rivaled Bouguereau as a painter of large-scale, emotionally

78
Pierre Paul Emmanuel de Pommayrac
French/Puerto Rican, about 1810–80
The Empress Eugénie
watercolor on ivory
5 1/4 × 4 in (13.3 × 10.2 cm)
purchased by Henry Walters, 1895 (38.102)

79
William-Adolphe Bouguereau
French, 1825–1905
The Flagellation of Christ, about 1881
charcoal on gray paper
17 × 11 3/4 in (43.2 × 29.9 cm)
purchased by William T. Walters from the artist, 1883 (37.1348)

charged, figurative paintings. In *The Scarlet Letter*, he por-trays Hester Prynne, the heroine in Nathaniel Hawthorne's famous novel of 1850, clutching Pearl to her breast. The baby sleeps with her thumb resting on the insignia of her mother's shame, the embroidered scarlet "A" [80].

Ernest Meissonier, who enjoyed one of the most lucrative careers in nineteenth-century French art, is gen-erally ranked among the academic painters, even though he had received little formal education and avoided classi-cal subjects in favor of objectively realistic genre scenes. Not only was he the first artist to receive the state's highest award, the grand-croix of the Légion d'honneur, but he twice served as president of the Académie des Beaux-Arts. Meissonier specialized in small, meticulously rendered scenes largely inspired by Dutch and Flemish seven-teenth-century precedents. Perhaps drawing on the popu-larity of such literary works as *The Three Musketeers* (1844) by Alexandre Dumas *père*, he produced a number of seven-teenth-century cavalier scenes. In *The End of the Game of Cards*, he chose a stage-like interior, actually his studio, as the setting for a fatal quarrel following a game of tarot [81]. This painting illustrates his mastery of foreshortening, a remarkable ability to express dramatic action in miniature scale and an exceptional attention to detail in matters of costume and furnishings.

Before moving to Paris in 1844, Alfred Stevens received classical training from David's Belgian follower, François-Louis Navez. He continued his studies under the academician Camille Roqueplan and with Ingres. About 1855, Stevens abandoned historical and social-realist subjects for views of elegantly clad women posed in fash-ionable interiors, a genre for which he became famous. In *The Painter and his Model*, he depicted a popular subject throughout much of the century, the artist in his studio. A pretty model leans over the shoulder of the painter, presumably Stevens himself, to admire a work in progress [82]. As is usual in such settings, a number of props appear in the background, including a Flemish tapestry showing *The Adoration*.

Given the universality of the academic system, artists could readily participate in foreign exhibitions. Ludwig Knaus, a native of the Duchy of Nassau, trained at the Düsseldorf academy, traveled extensively and then settled in France for seven years. In 1853, the year of his arrival, he won a gold medal at the Salon. His sentimental, idealized views of peasant life were widely popular among foreign collectors. Later, Knaus returned to Düsseldorf to teach at the academy and eventually he transferred to the Berlin academy. He advocated a naturalistic approach to painting which he based on the direct observation of nature, as

80
Hugues Merle
French, 1823–81
The Scarlet Letter, 1861
oil on canvas
39 5/16 × 31 15/16 in (94.9 × 81.1 cm)
commissioned by William T. Walters, 1861 (37.172)

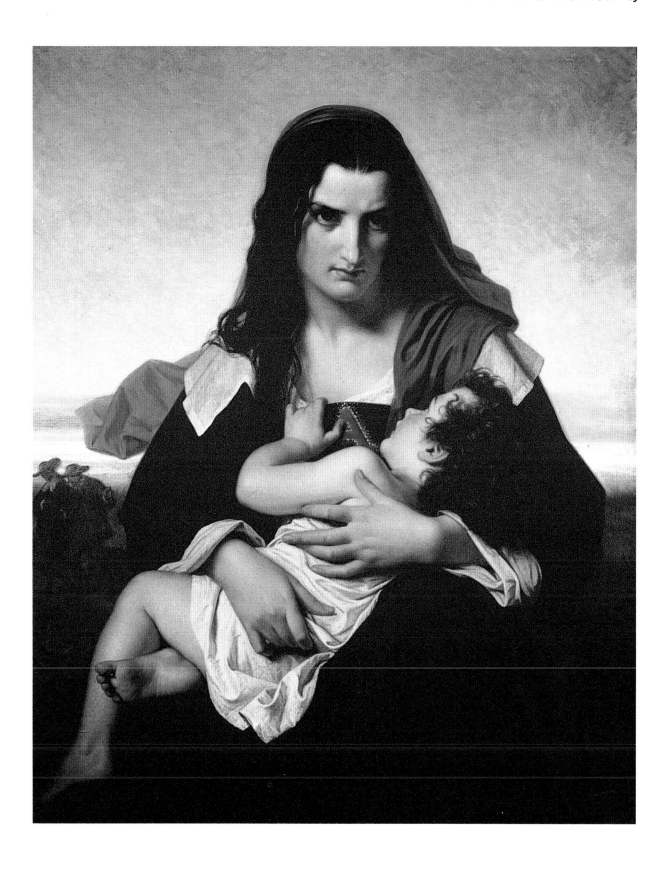

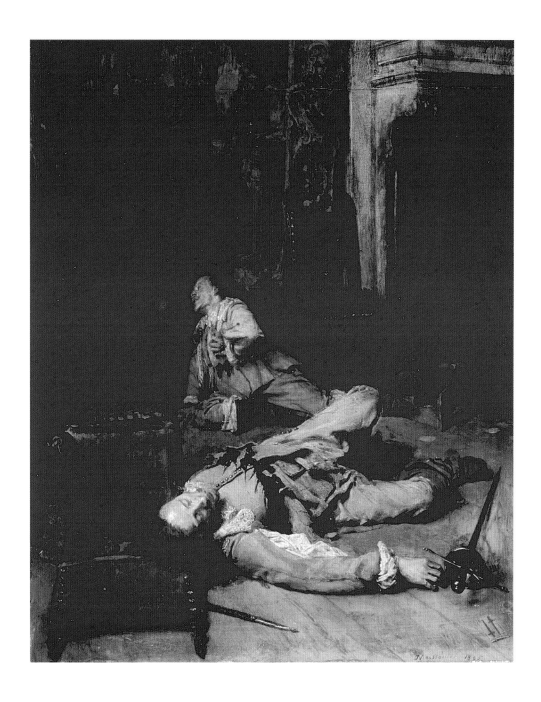

81
Jean-Louis-Ernest Meissonier
French, 1815–91
The End of the Game of Cards,
1865
oil on panel
8 3/4 × 7 1/8 in (22.2 × 18 cm)
purchased by Henry Walters,
1898 (37.149)

82
Alfred Stevens
Belgian, 1823–1906
The Painter and his Model, 1855
oil on canvas
36 3/8 × 29 in (92.4 × 73.7 cm)
purchased by Henry Walters,
1908 (37.322)

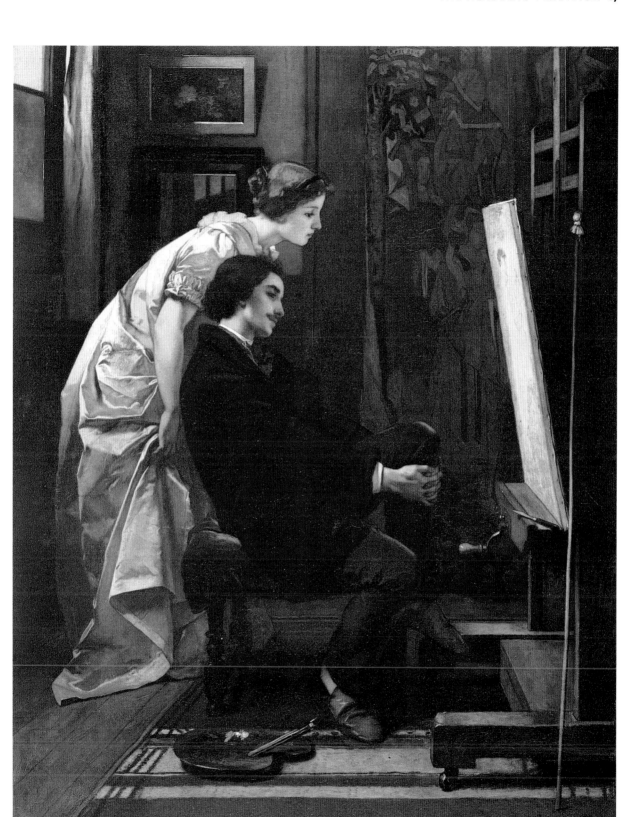

83
Ludwig Knaus
German, 1829–1910
Mud Pies, 1873
oil on canvas
25 3/8 × 43 1/16 in
(64.4 × 109.4 cm)
purchased by William T.
Walters, 1878 (37.21)

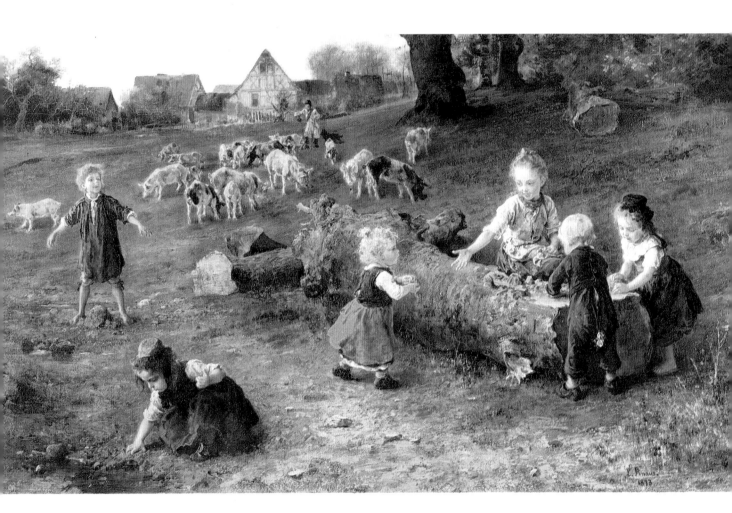

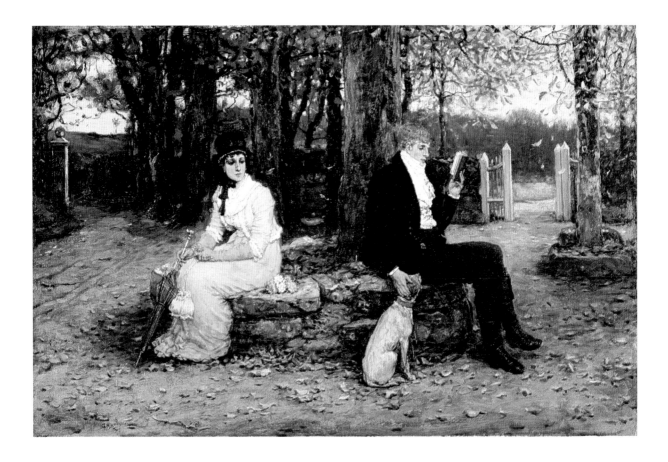

is demonstrated in a painting of children making mud pies [83].

The English-born, American-trained George H. Boughton exhibited his works in New York, at the National Academy of Design, as well as in London, at the Royal Academy of Arts. His entry in London in 1878, *The Waning Honeymoon*, portrays a recently married couple sitting under a chestnut tree [84]. The groom is absorbed in a book and pats his dog while the bride looks on forlornly. The autumnal chill and the diverging pathways in the background bode ill for the marriage. Engravings of such anecdotal subjects found a ready market abroad. The young Vincent Van Gogh was enamored with this particular image.

84
George Henry Boughton
English, 1833–1905
The Waning Honeymoon, 1878
oil on canvas
20^1/$_{16}$ × 30^1/$_8$ in (51 × 76.5 cm)
purchased by William T. Walters, about 1878 (37.129)

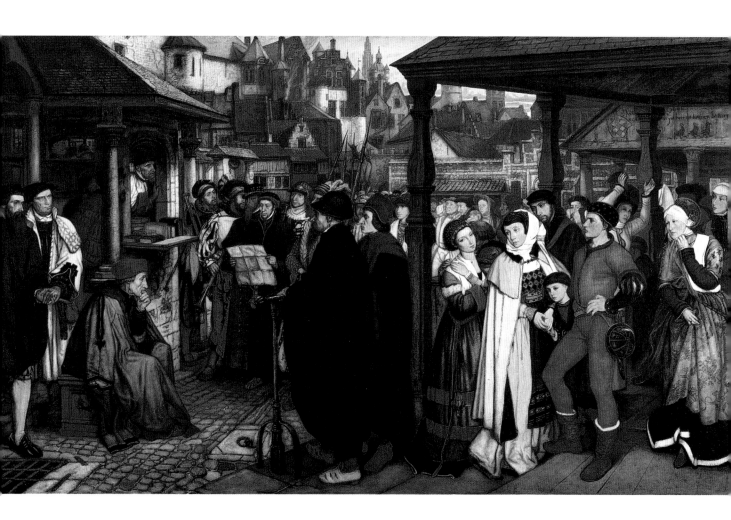

85
Baron Hendrik Jan Augustyn Leys
Belgian, 1815–69
The Edict of Charles V, about 1861
oil on panel
54 5/16 × 96 7/16 in (138 × 245 cm)
purchased by William T. Walters, 1873 (37.123)

HISTORICISM

During the third quarter of the nineteenth century, many artists began to evaluate their relationship to past traditions. Adopting an eclectic approach, they reworked early subjects and reinterpreted historical styles. History painting continued to be extolled in academic circles, but in practice it was transformed into anecdotal or genre painting, usually devoid of the edifying or symbolic content once associated with it. Many artists, with their more informed historical perspectives, now created convincingly realistic scenes, even when interpreting classical or biblical themes. Others, responding to nationalistic sentiments, looked to the histories of their own countries, often portraying incidents from the Middle Ages or the Renaissance.

In *The Edict of Charles V*, Hendrik Leys, Belgium's most acclaimed mid-century painter, recreated an event from Antwerp's turbulent, sixteenth-century past [85]. Between 1520 and 1550, Charles V of Spain issued eleven edicts proscribing Protestantism in the Netherlands. Leys shows the emperor's herald reading a decree to the populace. The setting, appropriately, is the book-sellers' quarter in the city, long noted for its humanistic studies. Leys imparts a sense of verisimilitude to this view by accurately rendering such details as the iron leaning-rail, the coats of arms on the market gables and the famous spire of

Antwerp's cathedral. For the figures' poses and physiognomies, he studied paintings by sixteenth-century German masters, Albrecht Dürer, Hans Holbein the Younger and the Cranachs. A bold innovation adopted by the artist was the deliberate use of archaisms such as the subdued, uniform lighting, the avoidance of linear perspective and the meticulous rendering of detail, all of which were intended to recall sixteenth-century Northern European painting.

The public's interest in classical archaeology was whetted by the ongoing excavations of Herculaneum and Pompeii, the two Roman cities buried by the eruption of Mt Vesuvius in A.D. 79, and by such remarkable findings as the *Victory of Samothrace* (Paris, Musée du Louvre) and the *Augustus of Primaporta* (Rome, Musei Vaticani), both in 1863, and of Priam's Treasury at Troy in 1873.

Jean-Léon Gérôme captured the public's imagination with a number of dramatic compositions which were widely distributed as engraved reproductions. For one of his most popular works, *The Death of Caesar*, recreating the events of the Ides of March 44 B.C., he consulted early literary sources, notably Plutarch's *Lives*, as well as current archaeological publications [86]. A master of narrative, Gérôme depicts the immediate aftermath of the assassination rather than the event itself. In a brilliant exercise

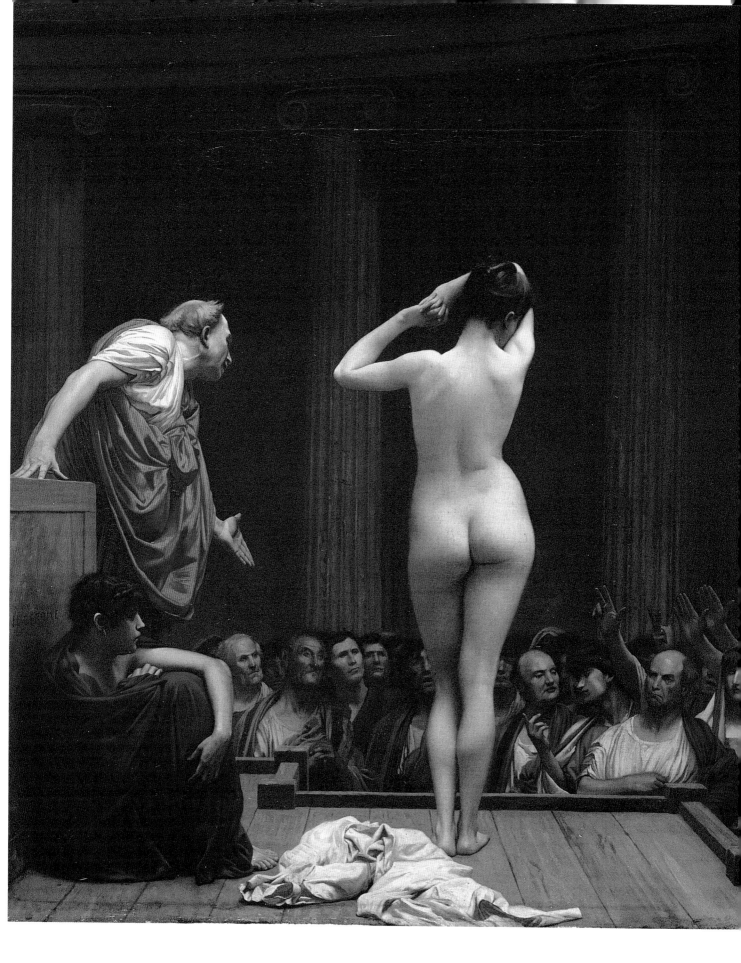

animals. It was earlier, during Nero's reign, that the Christians were burned alive, and again not in the Circus Maximus but in an amphitheater standing on the site of St Peter's basilica. Likewise, the hill with the colossal statue and temple looming in the background more closely resembles the Athenian Acropolis than it does Rome's Palatine Hill.

Exploiting a demand for slave-market scenes recalling inhuman practices of the past and, at the same time, titillating viewers' prurient instincts, Gérôme painted *The Roman Slave Market* [88]. An auctioneer barks the bids as a sensuously delineated nude slave, seen from the back, is offered for sale. As a *tour de force* in composition, the artist painted another view of the same event, showing it from the opposite vantage point. In his *Slave Market at Rome* (St Petersburg, Hermitage Museum), which is represented in Baltimore by a preliminary drawing, the artist dwelt more on the piteous plight of the slave who is exposed frontally [89].

Gérôme did not confine himself to recreations of antiquity, but occasionally looked to the less remote past. *The Tulip Folly* illustrates an incident from the "tulipmania" which swept the Low Countries from 1634 to 1637 [90]. When the bulb market suddenly collapsed leaving many speculators bankrupt in its wake, the government intervened by forcibly reducing the supply of bulbs. As

88
Jean-Léon Gérôme
French, 1824–1904
The Roman Slave Market, about 1884
oil on canvas
25 1/4 × 22 3/8 in (64.1 × 56.9 cm)
purchased by Henry Walters, 1917 (37.885)

89
Jean-Léon Gérôme
French, 1824–1904
Study for *Slave Market at Rome*, about 1884
pencil on paper
7 1/4 × 7 1/4 in (19.5 × 18.3 cm)
gift of Mrs E.T. Mudge in memory of her late husband, E.T. Mudge III, 1985 (37.2620)

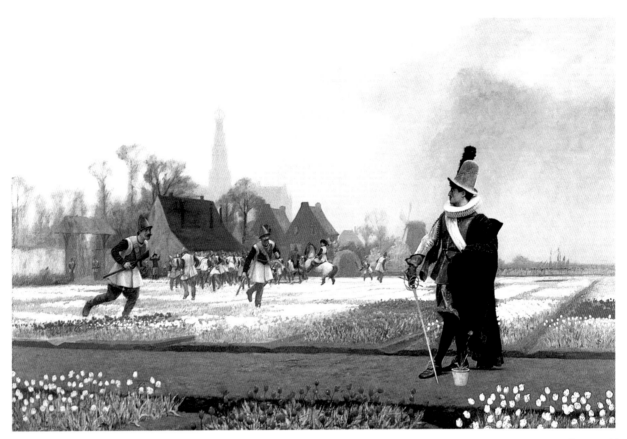

soldiers approach, trampling the beds of blossoms, a nobleman prepares to defend his prize specimen.

Lawrence Alma-Tadema, a Dutch artist, was apprenticed for three years in Hendrik Leys' Antwerp studio before moving to London in 1869. He pursued a highly successful career painting scenes from antiquity, usually set in the late Roman Empire. His wealthy, upper-bourgeois clientele undoubtedly drew parallels between the British and Roman empires and identified themselves with their ancient counterparts. Alma-Tadema was following in the footsteps of his literary counterpart, E. G.

Bulwer-Lytton, the author of *The Last Days of Pompeii* (1839), who visited Pompeii and expressed a wish "to people once more those deserted streets, to repair those graceful ruins, to reanimate the bones which were yet spared to his survey." As sources of reference, the artist had at his disposal a library of over 4,000 books as well as a comprehensive collection of prints, drawings and photographs of Roman and Greek antiquities. Although his subjects were sometimes similar to those of Gérôme, he treated them very differently. The high drama found in the French artist's *The Death of Caesar* was replaced by one of banal,

90
Jean-Léon Gérôme
French, 1824–1904
The Tulip Folly, 1882
oil on canvas
25 ³/₈ × 39 ³/₈ in (65.4 × 100 cm)
gift of Mrs Cyril W. Keene,
1983 (37.2612)

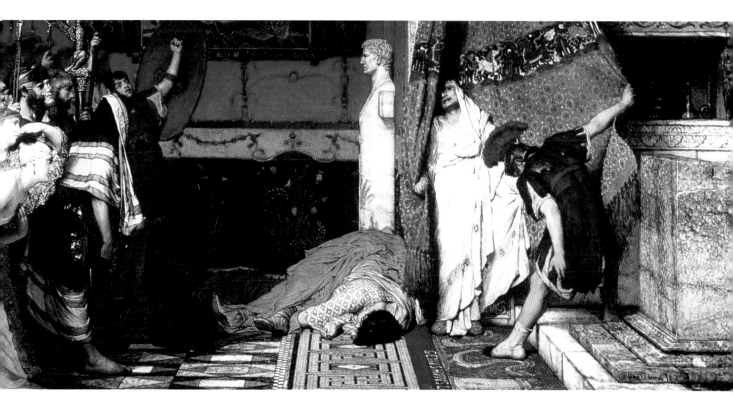

human frailty in Alma-Tadema's *A Roman Emperor—Claudius* [91]. As described by the early authors Suetonius and Josephus, a band of conspirators murdered Caligula and his family on 24 January A.D. 41. Caligula's successor, Claudius, was discovered cowering behind a curtain and was taken to the praetorian guard's camp where he was proclaimed emperor. The setting, a palace apartment known as the Hermaeum, is decorated in the Pompeian Second Style. The artist has lavished attention on such archaeological details as the polyptych showing the Battle of Actium and the mosaic pavement bearing an image of a serpent and an inscription: "GENIUS HUI(US) LOC(I)" ("guardian spirit of the place"), both copied from

publications pertaining to Pompeii. The blood stains on the herm with the head of Augustus, Claudius' great-uncle, might well have been inspired by those appearing on the base of the statue of Pompey in Gérôme's *The Death of Julius Caesar*, a painting which Alma-Tadema probably saw at the Paris Exposition Universelle of 1867. Known for his raucous humor, Alma-Tadema probably placed the Aztec carving of a rattlesnake on the altar as a prank.

For *Sappho and Alcaeus*, a scene set on the Greek island of Lesbos (Mytilene) in the late seventh century B.C., Alma-Tadema lacked archaeological sources. Sappho, her daughter Kleis and several companions listen intently as Alcaeus, who is yearning with love for the poetess, plays

91
Sir Lawrence Alma-Tadema, R.A.
Dutch/British, 1836–1912
A Roman Emperor—Claudius, 1881
oil on canvas
33⁷/₈ × 68⁵/₈ in (86 × 174.3 cm)
purchased by William T. Walters, 1882 (37.165)

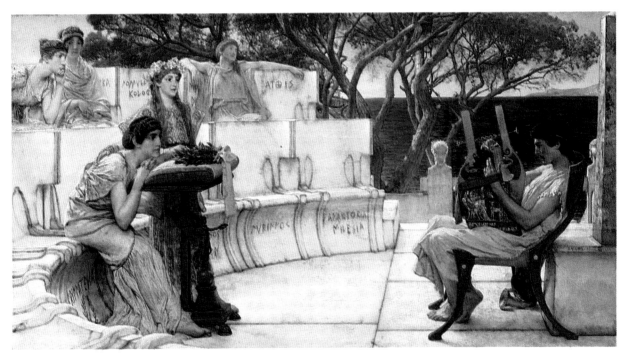

his kithara [92]. Alma-Tadema, who prided himself on being a painter of marbles, renders the gradations in the stone's color with great subtlety. In this instance, the semi-circular exedra is based on the seats of honor in the Theater of Dionysus in Athens, although the names of members of Sappho's sorority, written in archaic Greek, have been substituted for those of the officials inscribed on the back and base of his Athenian prototype. For the lectern, he ingeniously combined two elements found in Pompeii, a bronze lamp stand and a statuette of Victory poised on a globe.

Alma-Tadema explained to William T. Walters that *The Triumph of Titus—The Flavians* represents Titus and his family returning from the Palatine Hill (in actuality, it was the Capitoline Hill) after depositing at the temple of

Jupiter Victor spoils taken from the temple of Jerusalem in A.D. 79 [93]. The aging Vespasian leads the procession, followed by Titus, identified by his gold cuirass. He holds the hand of his daughter Julia who, in turn, glances back at her uncle Domitian, of whom she is "inordinately fond." Behind the imperial family follow five officers who had distinguished themselves in battle, and visible on the temple steps are priests and musicians as well as the spoils captured in Jerusalem. The cropping of the lictors or officers bearing *fasces* (bundles of rods and axes symbolizing their authority) in the immediate foreground is a remarkable compositional innovation which may reflect the artist's interest in photography.

Eclecticism was a common thread which ran through the European decorative arts as well as painting of this

92
Sir Lawrence Alma-Tadema, R.A.
Dutch/British, 1836–1912
Sappho and Alcaeus, 1881
oil on panel
26 × 48 ¹/₁₆ in (66 × 122 cm)
purchased by William T. Walters, 1883 (37.159)

93
Sir Lawrence Alma-Tadema, R.A.
Dutch/British, 1836–1912
The Triumph of Titus—The Flavians, 1885
oil on panel
17 ¹/₂ × 11 ¹/₂ in (44.5 × 29 cm)
commissioned by William T. Walters, 1881 (37.31)

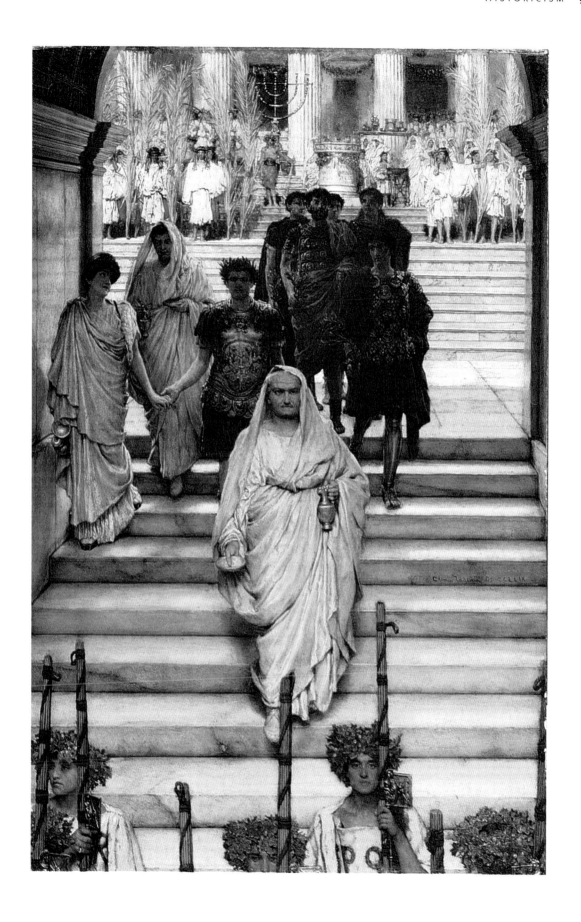

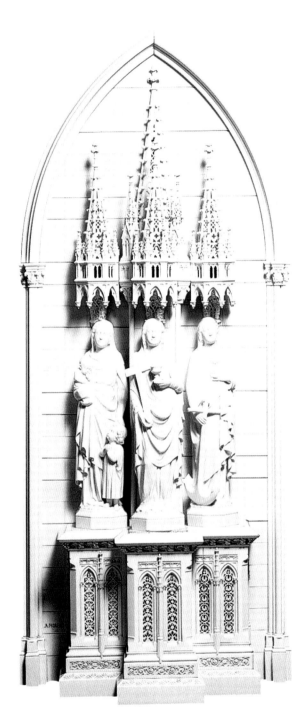

94
Augustin-Jean Moreau
(known as **Moreau-Vauthier**)
French, 1831–93
The Three Theological Virtues,
1855
ivory
H: 35 in (89 cm)
purchased by Henry Walters
(71.584)

period. Artists and craftsmen adopted at will various historical styles. The Gothic, for example, lent itself to ecclesiastical art whether it was church architecture or liturgical objects. At the Paris Salon in 1857, Moreau-Vauthier, a specialist in ivory carving, exhibited his first major work, a large tabernacle containing statuettes of the three theological virtues, Charity (with children), Faith (holding a cross and chalice) and Hope (with an anchor) [94]. Admiring the delicate openwork carving of the archi-tectural setting, one critic enthused that "the tabernacle directed the imagination towards the thirteenth century, to Pierre de Montereau, the architect of the Ste Chapelle."

While in Rome, the English poets Robert and Elizabeth Browning frequented the Castellani family's jewelry shop. So intrigued was Robert by the firm's "archaeological" jewelry that he began his epic poem *The Ring and the Book* (1859):

> Do you see this Ring?
> 'Tis Rome-work, mad to match
> (By Castellane's imitative craft)
> Etrurian circlets found, some happy morn, . . .

Perhaps the ultimate manifestation of the classical revival in the decorative arts, "archaeological" jewelry entailed the introduction of granulation and filigree techniques simu-lating those employed by ancient goldsmiths. The firm

95
Castellani
Bracelet
Italian, about 1860
gold, agate cameo
museum purchase, 1971
(57.1993)

founded in Rome by Fortunato Pio Castellani in the 1820s gained renown twenty years later for its "classical," especially "Etruscan" work which would remain fashionable until the end of the century and was widely imitated by other jewelers in Italy and abroad. Castellani's exquisite goldsmithing is illustrated in the looped chains and wire decoration of a bracelet mounted with an agate cameo of a helmeted warrior [95].

A range of wares was marketed to visitors in Italy during the second half of the century. In addition to gold jewelry, the tourists purchased shell and stone cameos, coral and lava products, reproductions of ancient metal artifacts and mosaics. The Vatican School of Mosaic specialized in micromosaics rendered with minute glass tesserae which frequently replicated paintings in the Vatican Museum or depicted views of Roman ruins. Set in the lid of a gold box in the Walters collection is a fine mosaic of a majestic, striding lion executed in scarcely discernible tesserae, which evokes rather than imitates an image from an ancient Roman wall painting or floor mosaic [96].

96
The Vatican School of Mosaic
Rome, mid-nineteenth century
Mosaic of a lion
gold, glass tesserae
D: 2 ⅞ in (7.3 cm)
gift of Miss Katharine Kosmak and George Kosmak in memory of their father, George W. Kosmak, M.D. (43.32)

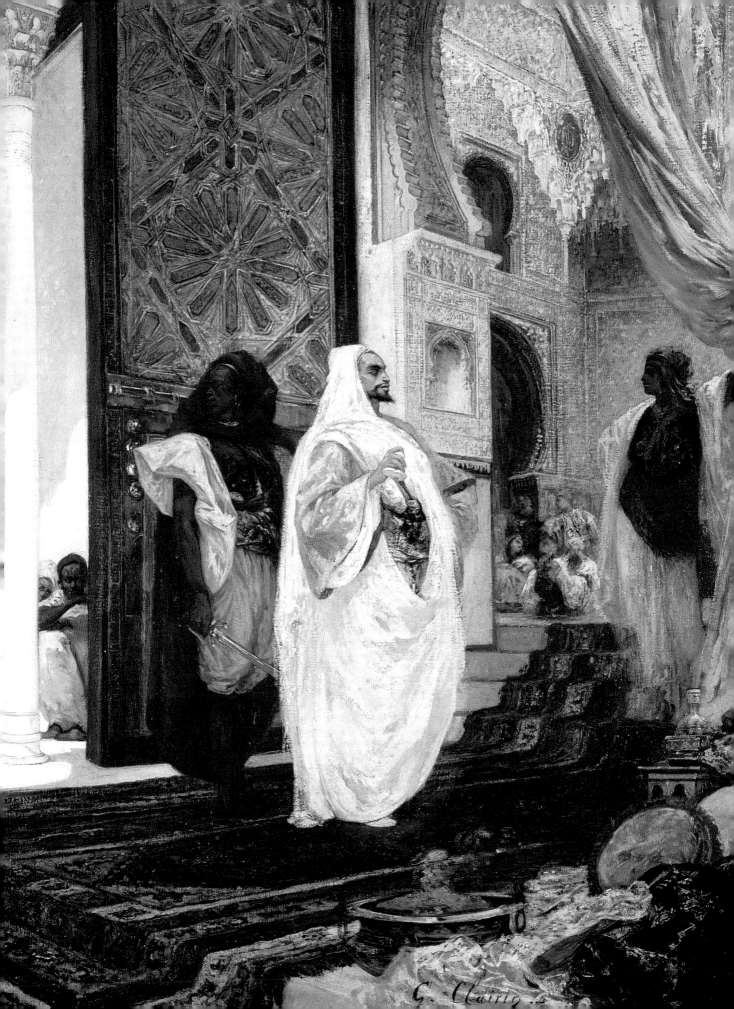

ORIENTALISM AND EXOTICISM

The nineteenth century witnessed confrontations between Europe's industrialized countries and the less technologically developed societies of Africa, Asia and the Americas. It was an era marked by imperial expansion and colonization, and travel facilitated by the introduction of steam power and the staging of the great international exhibitions. As the world's frontiers contracted, Europeans responded with reactions ranging from curiosity and awe to condescension and exploitation.

The term "Orientalism" is derived from the French *orientalisme* designating the study of languages, literature and customs, both modern and past, of peoples living outside the sphere of occidental Europe. Since the Renaissance, artists had occasionally explored non-European subjects, but in France the term orientalism was not generally applied to the visual arts until 1857, the year the realist critic Jules Castagnary deplored the influx of Islamic subjects at the Paris Salon. Artists who borrowed themes and decorative motifs from the Islamic world, extending from Moorish Spain to Mogul India, came to be known as "orientalistes." For collectors who might otherwise have regarded their lives as drab, humdrum and urban-bound, orientalist paintings provided avenues of escape, transporting their viewers to harems where unbridled passions held sway, to bazaars brimming with exotic bric-à-brac and to vast expanses of desert unremittingly scorched by the harsh sun.

The orientalists followed in the footsteps of Delacroix, Ingres and the other romantics who had already explored Islamic subjects, both real and imagined. Their way had also been paved by numerous writers. In France, for example, François René Chateaubriand, Victor Hugo, Gustave Flaubert and Théophile Gautier all explored oriental themes, whereas in England, Lord Byron, who died in the cause of Greek freedom at Missolonghi in 1824, evoked in his poetry images of pashas, sultanas and giaours (infidel slaves). His vision of a mysterious, sometimes cruel East was rekindled by Edward FitzGerald in his adaptation of a fourteenth-century Persian poet's quatrains known as the *Rubáiyát of Omar Khayyám* (1859) and by Robert Louis Stevenson in *The New Arabian Nights* (1880). Johann Wolfgang von Goethe initiated German orientalism with his influential *Der West-östlicher Divan* (1819).

With the invasion of Egypt (1798) and conquest of Algeria (1830–48), France acquired vested interests in the Near East and North Africa. French artists pioneered as orientalists, but colleagues from other countries soon followed them.

The influential writer and painter Eugène Fromentin stayed in Algeria on three occasions, the first starting in

98
Eugène Fromentin
French, 1820–76
*An Encampment in the Atlas
Mountains,* about 1865
oil on canvas
41 ⅛ × 56 ½ in (105 × 143.3 cm)
purchased by William T.
Walters, 1878/84 (37.195)

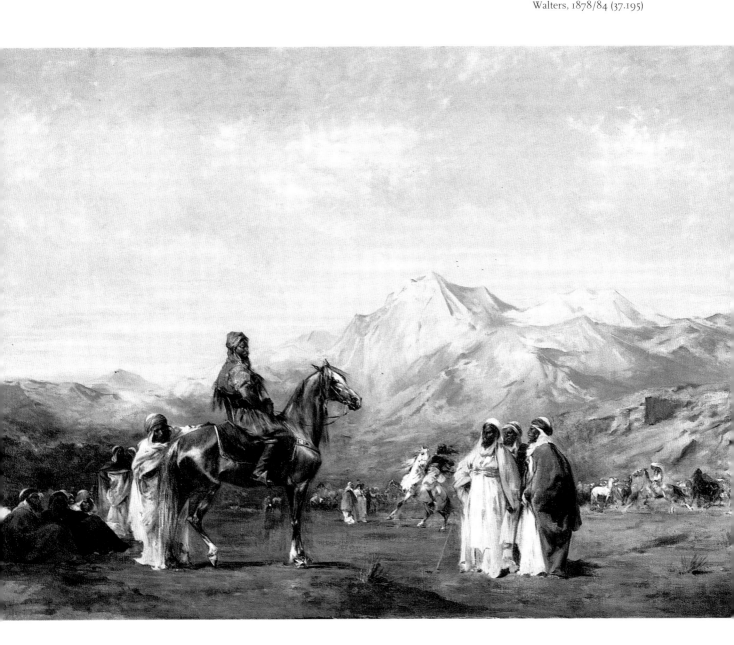

1846. On one of these, his honeymoon in 1852/3, he resided for almost a year in the towns along the coast and in the oasis of Laghouat farther inland. Subsequently, he published two accounts of his Algerian experiences, *A Summer in the Sahara* (1857) and *A Year in the Sahel* (1858). In the intense sunlight and expansive spaces of the Algerian landscape, Fromentin found a beauty unlike anything he had known in France. His subjects, as in *An Encampment in the Atlas Mountains*, were usually Berber nomads and their horses [98].

For over 50 years, Charles Frère, the brother of Pierre-Edouard Frère, specialized in orientalist watercolors and oil paintings which were remarkable for the intensity of their colors and for the subtle renditions of the sky at different times of the day [99]. Although based in Paris,

Frère also maintained a studio in Cairo where, as the recipient of the honorary title of "bey," he mingled with the local population.

Many artists exploited Orientalism as an opportunity to give free rein to their imaginations in treating subjects of sensuality and cruelty. A former pupil of Delacroix, Alexandre Bida, first journeyed to Venice, Constantinople (known since 1930 as Istanbul) and Syria in 1843 and seven years later he resided in Egypt. Subsequent travels took him as far as the Crimea and the Holy Land. In *The Ceremony of Dosseh*, Bida portrays an event recounted by the writer Maxime du Camp in *The Nile: Egypt and Nubia* (1854) [100]. The dervishes, in their religious fervor, throw themselves on the ground to be trampled by their leader mounted on horseback. At the Paris Salon in 1855, the

99
Charles-Théodore Frère
French, 1814–88
Arab at Prayer
watercolor on paper
6 3/8 × 8 7/16 in (16.2 × 21.4 cm)
purchased by William T.
Walters, after 1863 (37.1289)

100

Alexandre Bida
French, 1823–95
The Ceremony of Dosseh, 1855
black crayon heightened with
white on paper
23 ⁵/₈ × 35 ³/₁₆ in (60 × 89.4 cm)
purchased by William T.
Walters (37.901)

critic Théophile Gautier commented that this drawing represented "in admirable depth the fatalist quietude of Islam."

Gérôme, one of the most cosmopolitan travelers of his generation, visited Greece and Turkey in 1854, sailed up the Nile in 1857 and later returned to the Near East on a number of occasions, sketching and taking photographs. He devoted much of his career to orientalist paintings, usually set in either Cairo or Constantinople. As in his Roman archaeological reconstructions, Gérôme displayed a remarkable attention to descriptive detail, thereby imparting a sense of veracity to his subjects. He delighted in portraying various races, their habits and their dress. In *Bashi-Bazouk Singing*, one of the Turkish irregular soldiers, who were renowned for their ferocity, entertains his companions by playing a lute-like stringed instrument known as an oud [101]. Introducing a humorous note of cacophony, a pet raven caws in accompaniment. Three of

101
Jean-Léon Gérôme
French, 1824–1904
Bashi-Bazouk Singing, 1868
oil on canvas
18 3/16 × 26 in (46.3 × 66 cm)
purchased by Henry Walters,
1917 (37.883)

the figures can be identified by their white pleated skirts as Arnauts of Greek or Albanian heritage.

The sculptor Charles Cordier made a career of "exploring different types of the native human race." In 1848, he aroused attention at the Paris Salon with a plaster model for a bust of an African visitor who was later identified as Saïd Abdullah of the Mayac, Kingdom of Darfur (Sudan). Three years later, he sculpted a young Senegalese model as a companion-piece for Saïd Abdullah and exhibited them as a pair cast in bronze [102]. By producing such noble and dignified images, Cordier expressed his abhor-

rence of slavery and at the same time contributed to the emerging science of ethnography.

Louis-Ernest Barrias, like Gérôme, worked alternately in classical and orientalist modes. In 1870, he exhibited a marble of a Greek maiden spinning wool entitled *The Young Girl of Megara* (Paris, Musée d'Orsay). Twenty years later, inspired by *The Wool Carder of Bou-Saâda* (Rouen, Musée des Beaux-Arts) painted by his friend Gustave Guillaumet (1840–87), the sculptor rendered the composition in orientalist terms and exhibited it as a wax model in the Salon of 1890. Now showing a Berber girl

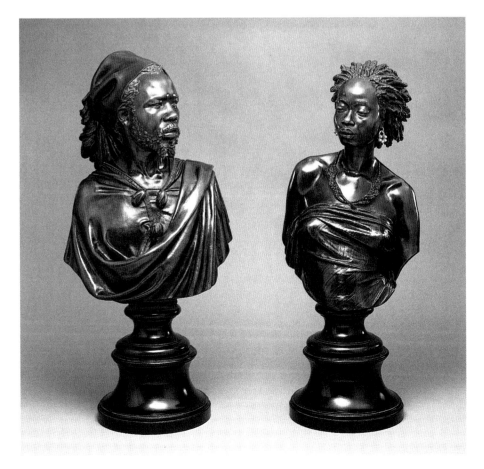

102
Charles-Henri-Joseph Cordier
French, 1827–1905
Saïd Abdullah of the Mayac, Kingdom of Darfur
(modelled in 1848) and
African Venus
(modelled in 1851)
bronze
H: 16 $^1/_2$ in (42 cm) and 15 $^1/_2$ in (39.40 cm)
museum purchase, 1991
(54.2664/5)

strewing flowers, *The Young Girl of Bou Saâda* was destined to become the Guillaumet's tomb monument in Montmartre.

By the end of the century it had become a common practice for foundries to issue editions of sculptures in various sizes and media. The Susse Frères foundry produced a marvelously exotic version of Barrias' sculpture in chryselephantine, an ivory and metal combination, that had been inspired by accounts of ancient statuary, notably of

Phidias' lost ivory and gold masterpiece, the *Athena Parthenos* [103].

In the late 1860s, a number of French orientalists turned from the contemporary Near Eastern life to thirteenth- and fourteenth-century Moorish Spain and Morocco. Georges Clairin and his companion, Henri Regnault, participated in the 1868 republican uprising against Queen Isabella II of Spain before proceeding to Morocco. Both artists were overcome by the beauty of the

103
Louis-Ernest Barrias
French, 1841–1905
The Young Girl of Bou Saâda,
about 1900
founder: Susse Frères
ivory, silvered bronze, wood,
mother-of-pearl and turquoise
H: 12 5/16 in (31.2 cm)
purchased by Henry Walters,
1900 (71.430)

104
Mariano Fortuny y Marsal
Spanish, 1838–74
Arab Fantasia, 1866/7
oil on canvas
20¹/₂ × 26³/₈ in (52 × 67 cm)
purchased by Henry Walters,
1898 (37.191)

105
Mariano Fortuny y Marsal
Spanish, 1838–74
Café of the Swallows, 1867/8
watercolor on paper
19³/₈ × 15³/₈ in (49.4 × 38.7 cm)
purchased by Henry Walters,
1898 (37.968)

Mudéjar architecture of Granada and Seville, which they began to incorporate in their paintings. In *Entering the Harem*, Clairin portrays a popular orientalist subject, a harem. As a haughty, imposing sheikh draws near the steps, an attendant draws aside a curtain to reveal the hidden pleasures awaiting him [97]. The richness of the interior, particularly the elaborately inlaid door and the honeycombed vaulting of the ceiling, recall a specific site, the entrance to the Hall of the Two Sisters at the Alhambra Palace in Granada.

Spain produced its own orientalists. Principal among them was the Catalán painter Mariano Fortuny y Marsal whose brief, meteoric career was divided between Rome, Paris, Naples and Granada. His name came to be associated with a virtuoso style, *fortunismo*, characterized by spontaneous brushstrokes and vibrant colors. Inspired by a precedent set by Meissonier, an artist whom he much admired and whose *The End of the Game of Cards* [81] he had once borrowed for close examination, Fortuny worked in small scale, the only notable exception being a vast scene, *The Battle of Wad Ras* (Barcelona, Museu d'Art Modern), which he never fully completed. In preparation for this project, he returned to Morocco in 1862, two years after the key engagement in the Spanish-Moroccan War, and undertook a number of brilliant studies for his panoramic canvas. These would provide a basis for his later orientalist paintings, including the *Arab Fantasia* in which he shows a ritual that he had observed in Tangiers in 1862 [104]. Fortuny's watercolors also received international acclaim and undoubtedly contributed to

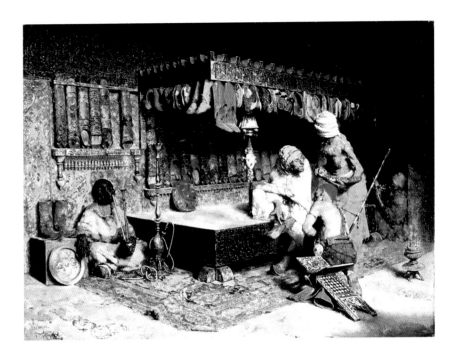

the renewed interest in the medium which resulted in the founding of the Society of French Aquarellistes in 1879. The subtlety and luminosity of his watercolors are apparent in *Café of the Swallows* [105].

Many American collectors also turned to José Villegas y Cordero of Seville for exotic North African scenes. Though his palette was similar to Fortuny's, he concerned himself less with the ephemeral qualities of light and, instead, relied on a profusion of bric-à-brac to create exotic effects. The *narghilah* (water-pipe), Koran stand, brazier and embossed copper bowl appearing in *The Slipper Merchant* are all accessories which might have been seen in any cluttered nineteenth-century studio [106].

An invitation issued in 1855 to accompany the French diplomat Prosper Bourée on a mission to Teheran launched the career of Alberto Pasini, an orientalist from Parma. The journey took them through Egypt, Saudi Arabia, Yemen and the Persian Gulf. In Iran, the artist explored the countryside, often accompanied by the Shah, Nâssar-al-Din. A dedicated traveler, Pasini would later visit Istanbul, Asia Minor, Syria, Lebanon and Spain, painting sun-drenched town scenes usually incorporating well-defined renderings of architecture as well as equestrian motifs [107]. Pasini resided in Paris where he was regarded as one of the foremost foreign orientalists.

The expatriate Bostonian Edwin Lord Weeks must be ranked among the most adventuresome of the artist-travelers. He roamed the Florida Keys, Surinaam and the jungles of South America in 1869 before embarking for

106
José Villegas y Cordero
Spanish, 1848–1921
The Slipper Merchant, 1872
oil on canvas
19 × 25 ⅝ in (48.3 × 65 cm)
purchased by William T.
Walters, before 1876 (37.105)

Paris to study with the portraitist Léon Bonnat. Within months of his arrival in Europe he departed for Egypt and Iran, and during travels over the next three decades which would take him to Morocco and eventually to India, Weeks withstood the perils of famine, violence and disease. In 1905, during the liquidation of Week's estate, the cataloguer identified the subject of *Interior of the Mosque at Cordova* as follows: "Preaching the holy war against the Christians, the old Moor holds aloft the green flag of Mohammed, while he curses the "dogs of Christians" with true religious fervor, and calls on Mohammed to drive them out of Spain." Most likely, Weeks undertook this painting in 1880 while he was residing in Granada in a studio formerly occupied by Fortuny [108].

Josef Brandt, a Polish artist, trained in Paris and later studied in Munich, where he opened a studio that served as a focal point for his countrymen working in the German city. During the summers he returned to his property at Oronsko, south of Warsaw, and from there he traveled eastward to the Ukraine and the European portion of Turkey, usually painting equestrian scenes. In *On Reconnaissance*, a troupe of Tartar horsemen is proceeding across a plain. Just why their leader has abruptly halted and is warily cautioning his followers is left to the viewer's imagination [109].

107
Alberto Pasini
Italian, 1826–99
Damascus, 1880
oil on canvas
16 3/4 × 12 13/16 in (42.6 × 32.6 cm)
purchased by William T. Walters, before 1884 (37.193)

Exotic subjects could sometimes be found closer to home. In 1851, August von Pettenkofen began to stay in Szolnok, a town on the Theiss River about 100 kilometers southeast of Budapest. After a visit to Paris, he adopted Meissonier's practice of rendering clearly defined forms in minute scale. Working out of doors, von Pettenkofen depicted gypsy market scenes often shown in dramatic weather conditions [110]. Colleagues of various nationalities followed him to Szolnok and established a realist school of painting.

108
Edwin Lord Weeks
American, 1849–1903
Interior of the Mosque at Cordova, about 1880
oil on canvas
56 × 72 ⅝ in (142.2 × 184.3 cm)
purchased by Henry Walters, 1905 (37.169)

109
Josef Brandt
Polish, 1841–1915
On Reconnaissance, 1876
oil on canvas
19 ¹/₈ × 44 ¹/₈ in (48.5 × 112 cm)
gift of Mr and Mrs L. Whiting
Farinholt, 1980 (37.2569)

110
**August Xaver Karl von
Pettenkofen**
Austrian, 1822–89
The Market at Szolnok, Hungary
oil on panel
11 ¹/₄ × 18 ³/₄ in (28.5 × 47.6 cm)
purchased by William T.
Walters, 1878 (37.53)

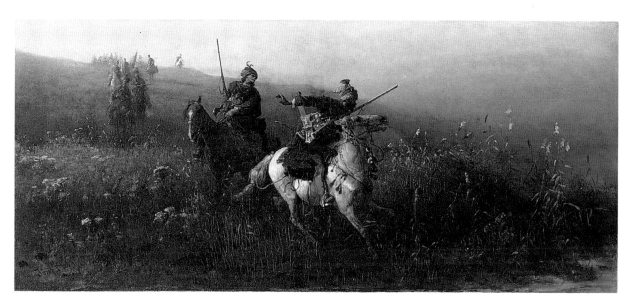

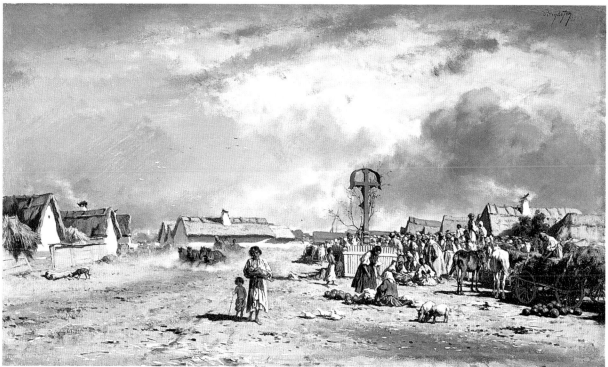

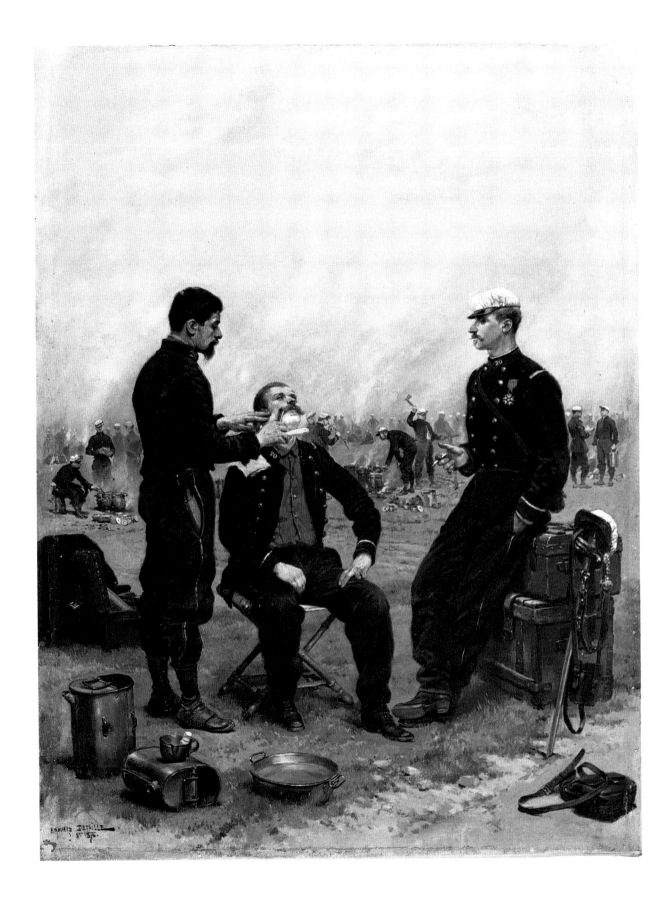

MODERN LIFE

Throughout the nineteenth century a strong realist vein resurfaced intermittently in various guises in European art. During the 1870s and 1880s, many painters, without abandoning the precepts of their academic training, broke with convention to select subjects which were either current or from the near past. Unlike Daumier or Millet, they were less concerned with social issues than with factually recording daily life. They strove for contemporaneity of vision comparable to that found in illustrations in the popular press.

A call to arms provided artists with opportunities to portray recent events, but after Napoleon's defeat in 1814 few occasions arose for French military painters to hone their skills. Though J. L. E. Meissonier documented Napoleon III's role in the Austro-Italian War of 1859, he is usually remembered for a cycle of historical works glorifying Napoleon I. Although entitled simply *1814*, this painting, commissioned by Prince Napoleon Bonaparte, the subject's nephew, has traditionally been said to represent the emperor mounted on his white horse, Marie, on the heights of Vitry just after the Battle of Arcis-sur-Aube (1814) [112]. The desolate setting and cloud-laden sky impart a note of foreboding to the scene.

When Napoleon III was lured into declaring war on Prussia in July 1870, opportunities for French artists to

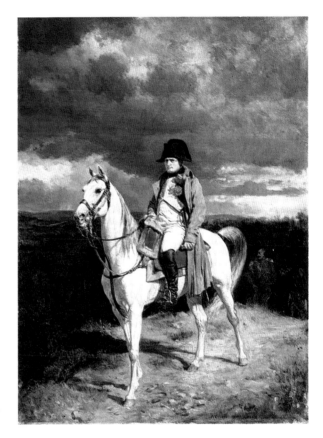

111
Jean-Baptiste-Edouard Detaille
French, 1848–1912
The Camp Barber, 1876
oil on canvas
14 × 10 3/4 in (35.5 × 27.5 cm)
purchased by Henry Walters, 1906 (37.190)

112
Jean-Louis-Ernest Meissonier
French, 1815–91
1814, 1862
oil on panel
12 3/4 × 9 1/2 in (32.4 × 24.2 cm)
purchased by William T. Walters, 1886 (37.52)

113
Alphonse-Marie-Adolphe de Neuville
French, 1835–85
The Attack at Dawn, 1877
oil on canvas
57 ¹¹/₁₆ × 87 ³/₈ in (146.5 × 222 cm)
purchased by William T. Walters, before 1878 (37.40)

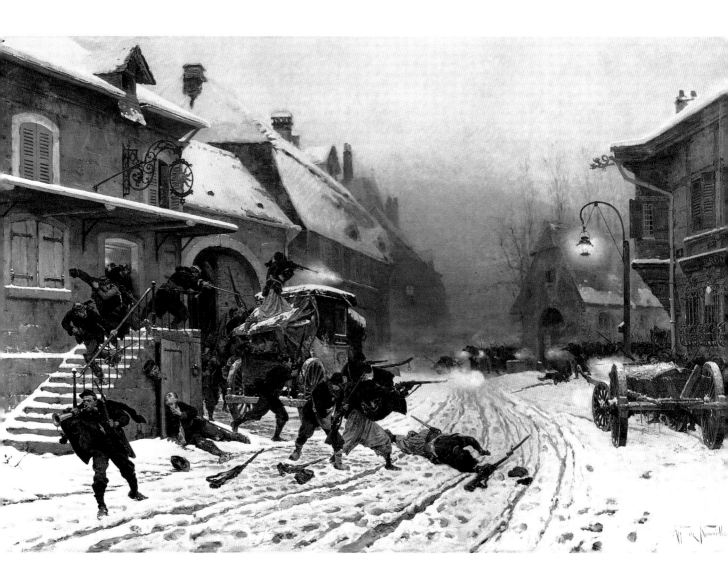

114
John Everett Millais, Bart.,
P.R.A., D.C.L.
English, 1829–96
News from Home, 1856/7
oil on panel
14 × 9⁷/₈ in (35.5 × 25 cm)
purchased by William T.
Walters, 1880 (37.85)

experience military action first-hand were brought painfully home. Among those who responded to the call to arms was Meissonier, who commanded a corps of artists which included in its ranks Edouard Manet. Without victories to commemorate, the French military painters devoted their energies to glorifying the defenders' heroism.

Alphonse de Neuville, a largely self-taught artist, served as an officer in the Auxillary Sappers and later as aide-de-camp to General Callier. Drawing from his own experiences and from a thorough study of battle sites and weaponry, de Neuville has recreated in exacting detail a Prussian assault on a village in *The Attack at Dawn* [113]. A bugler sounds the alarm as French troops rush from an inn to defend themselves. Their uniforms identify them as *turcos* (Algerian riflemen) and *mobiles* (members of the Garde Mobile). A mountain silhouetted in the background locates the setting as a village in the Jura Mountains near the Swiss border where General Bourbaki's Army of the East had withdrawn rather than surrender to the Prussians.

Alternately fighting and sketching, Edouard Detaille participated in many of the key conflicts of the war, developing a lifelong commitment to military subjects. One of his last government commissions, with unfortunate consequences, was to assist in designing the colorful red and

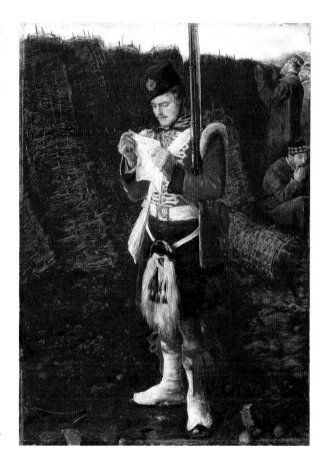

115

Pascal-Adolphe-Jean Dagnan-Bouveret

French, 1852–1929

An Accident, 1879

oil on canvas

35 5/8 × 51 1/2 in
(90.7 × 130.8 cm)

purchased by William T. Walters, before 1884 (37.49)

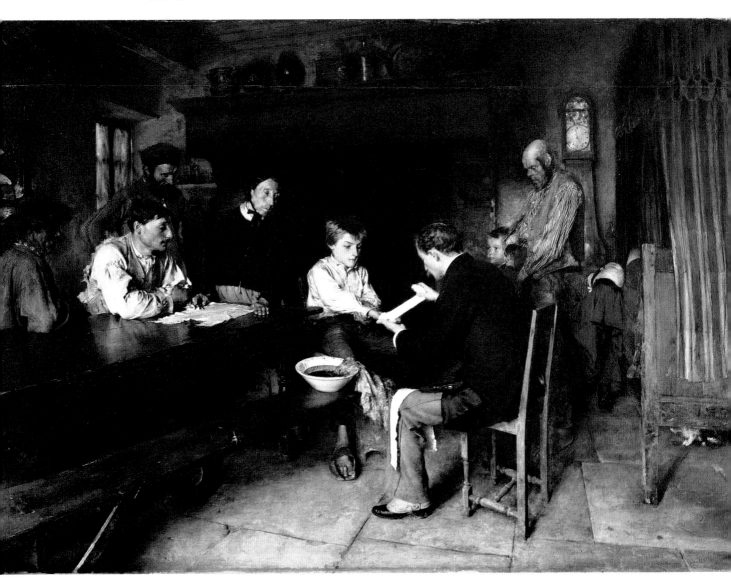

blue army uniforms which provided such easy marks for the German riflemen in 1914. While serving as a sub-lieutenant in the reserve of the 20th Battalion of the Chasseurs à Pied in 1876, Detaille participated in manœuvers on the plains of the Eure. In *The Camp Barber*, he shows a routine scene of army life during this exercise [111]. A soldier is being shaved while others prepare breakfast. The figure smoking a cigarette at the right has been identified as the artist.

In contrast to Detaille's and de Neuville's earthy Realism, the English artist John Everett Millais, who had never personally experienced combat, presented a sanitized view of life in the trenches during the Crimean War (1854–6). *News from Home* shows an immaculately clad soldier of the 42nd Highlanders, the famed Black Watch regiment, reading a letter [114]. The redoubtable critic John Ruskin, who was by no means a disinterested party—his Scottish wife, Effie, having recently abandoned him for Millais—ridiculed this work, noting:

> We will pass this [*News from Home*] for the present; merely asking whether Millais supposes this to be the generally bright aspect of a Highlander on a campaign? or whether he imagines that Highlanders at the Crimea had dress portmanteaus as well as knapsacks, and always put on new uniforms to read letters from home in.

Other artists drew their subjects from their own daily experiences. Initially, P. A. J. Dagnan-Bouveret explored provincial life in the Franche-Comté region, but later he turned to Brittany. His training with Cabanel and Gérôme resulted in a naturalistic style combining superb draughtsmanship and a keen eye for realistic detail. In *An Accident*, Dagnan-Bouveret recalls an incident he had witnessed while visiting an inn in the village of Mélecey accompanied by a doctor-friend [115]. Peasant onlookers watch with varying degrees of consternation as a doctor bandages the hand of a twelve-year-old boy. Accentuating the drama of the situation are the patient's pale face and the blood-stained water in the bowl.

The Hungarian painter Mihály von Munkácsy illustrated newspapers in Budapest and studied painting in Budapest, Vienna and Munich before eventually enrolling in Ludwig Knaus' studio in Düsseldorf. His realist inclinations were reinforced by a visit to the Paris Exposition Universelle in 1867 where he was captivated by both Courbet's second one-man show as well as by the works of the Barbizon masters. He settled in France in 1871 and initially divided his time between Paris and Barbizon. His paintings, rendered in a distinctive, vigorous technique involving freely applied, fluid brushstrokes and a somber palette, soon brought him success and an international

116
Mihály von Munkácsy
Hungarian, 1844–1909
The Story of the Battle, about
1875
oil on canvas
40 ¹/₄ × 55 ¹/₈ in
(104.5 × 152.4 cm)
purchased by William T.
Walters, 1878/84 (37.60)

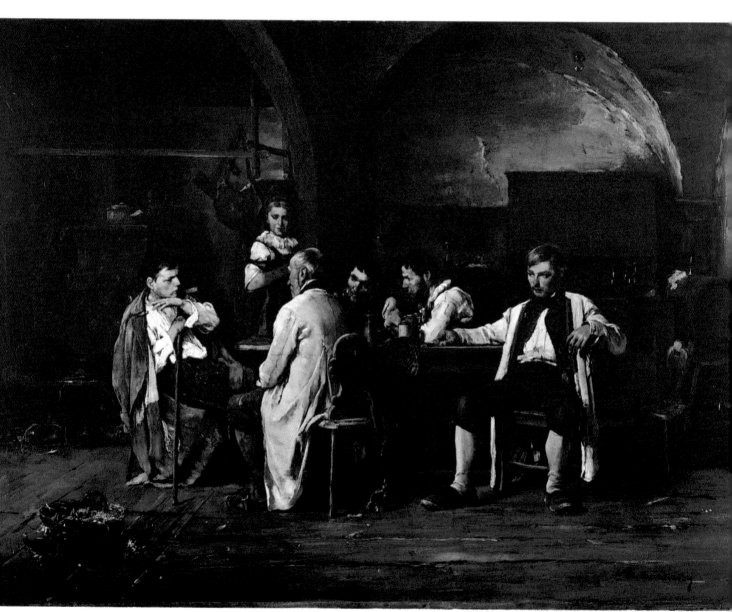

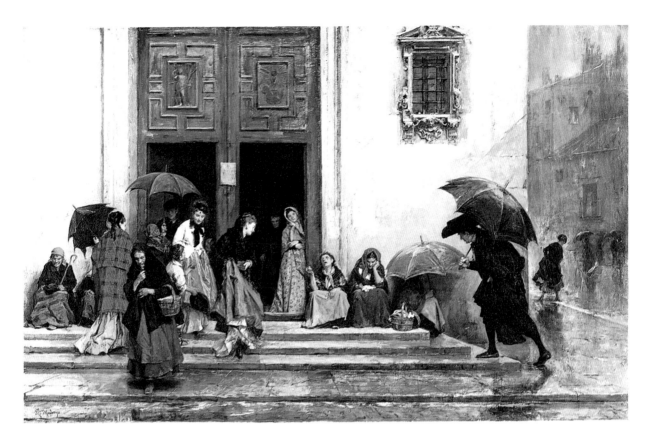

following. In *The Story of the Battle*, Munkácsy portrays an incident dating from his infancy, yet he imbues it with a strong sense of immediacy [116]. In a country inn, a wan, young veteran, leaning on a crutch, recounts to his companions his experiences in the 1848 Hungarian uprising against Habsburg rule.

Though a member of the third generation of Madrid's most eminent family of painters, Raimondo de Madrazo y Garreta resided for most of his career in Paris. He delighted patrons with a dash of Realism in such works as *Coming Out of Church* in which he contrasted the finely attired parishioners leaving church with the beggars huddled on the steps [117]. His flair for color and his mastery of atmospheric effects owe much to the influence of his brother-in-law, Mariano Fortuny y Marsal.

Léon Bonnat, the quasi-official portrait painter of the early Third Republic (1870–1940), was a native of Bayonne in southwestern France. Before moving to Paris, he studied in Madrid with José de Madrazo y Agudo and Federico Madrazo y Künst, Raimondo's grandfather and father. During the 1870s, Bonnat abandoned his earlier genre and religious subjects for portraiture. Employing a

117
Raimondo de Madrazo y Garreta
Spanish, 1841–1920
Coming Out of Church, before 1875
oil on canvas
25 1/4 × 39 1/8 in (64 × 100 cm)
purchased on behalf of William T. Walters by Samuel P. Avery, 1892 (37.48)

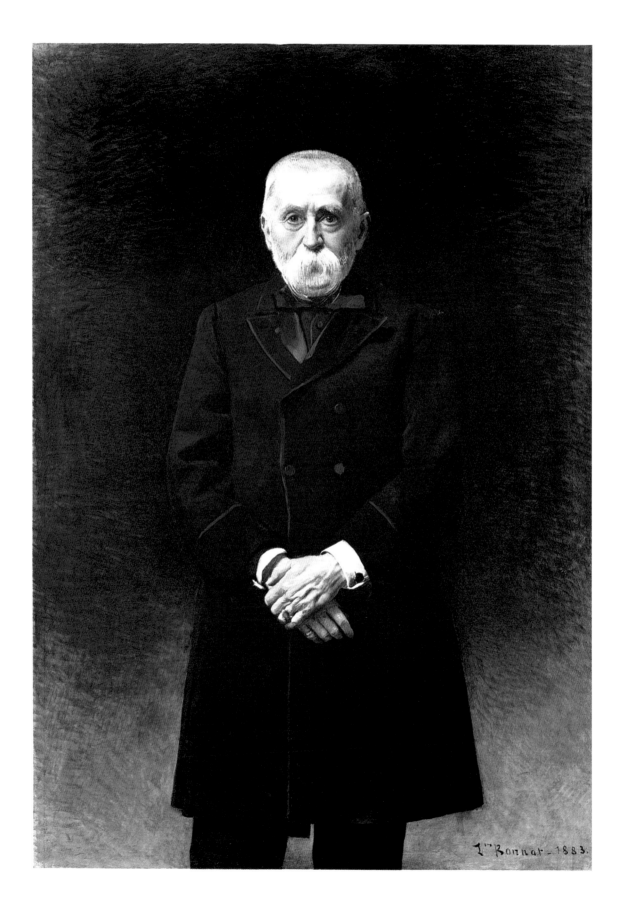

118
Léon-Joseph-Florentin Bonnat
French, 1833–1922
Portrait of William T. Walters,
1883
oil on canvas
56 1/2 × 40 9/16 in
(143.5 × 103 cm)
commissioned from the artist,
1883 (37.758)

119
Jean Béraud
French, 1849–1936
Paris Kiosk, early 1880s
oil on canvas
13 15/16 × 10 7/16 in
(35.5 × 26.5 cm)
purchased by Henry Walters,
1901 (37.1055)

style reminiscent of Ribera, Titian, Velázquez and Van Dyck, masters whose works he had admired in the Prado Museum, Bonnat produced powerful images characterized by bold chiaroscuro, harsh lighting and neutral backgrounds, as demonstrated in the portrait of William T. Walters [118].

Bonnat's pupil, Jean Béraud, was born to French parents in St Petersburg, Russia. Following his father's death in 1853, he moved to Paris to study law, which he eventually rejected in favor of painting. He began with portraiture, but turned to realistic genre scenes of high society. Working from a carriage which he converted into a mobile studio, Béraud recorded life on the grand boulevards that had recently been carved through the city. In *Paris Kiosk,* an elegant lady and a debonair gentleman are both engaged in reading posters affixed to a Morris column [119]. Because of the artist's meticulous attention to detail, it is possible to read an advertisement for Franz von Suppé's comic opera *Fatinitza* which opened at the Théâtre de Nouveauté in 1879. A window sign in the background, "[GR]AND CAFÉ," identifies an establishment on the Boulevard des Capucines.

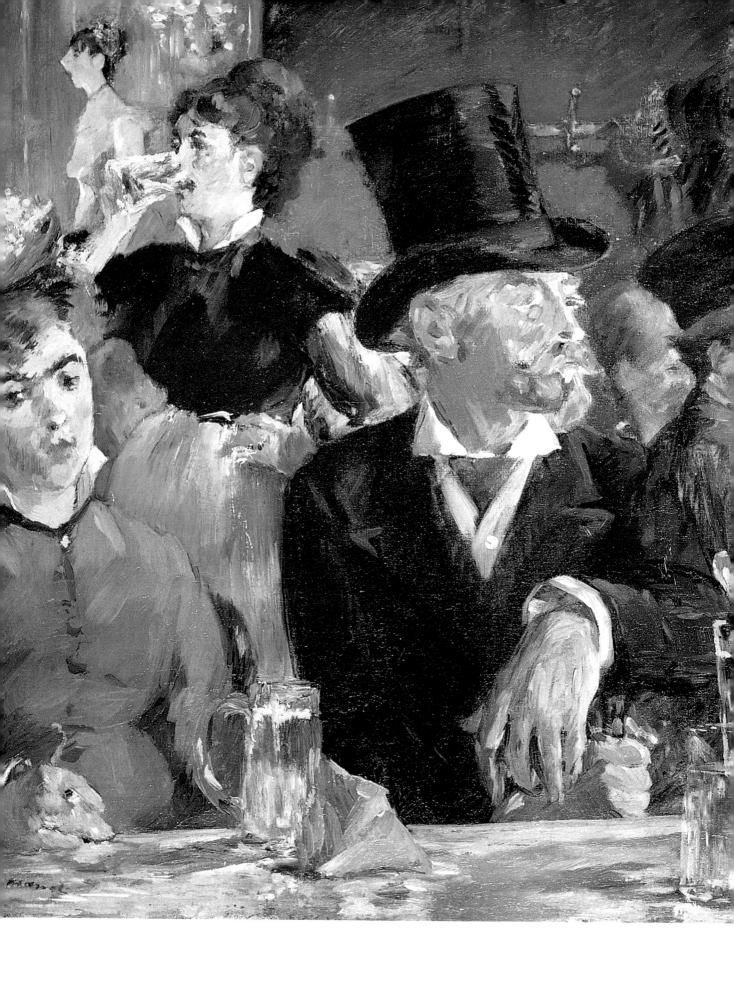

THE IMPRESSIONISTS AND THE AVANT-GARDE

During the 1860s, the Café Guerbois on the rue des Batignolles in Montmartre was frequented by the young artists Edouard Manet, Edgar Degas, Frédéric Bazille, Auguste Renoir, Paul Cézanne, Camille Pissarro, Claude Monet and Alfred Sisley among others, as well as by a number of writers who shared their realist leanings. In this and in similar establishments, notably Café de la Nouvelle-Athènes, the principles for a revolutionary movement in French art were formulated. Eventually known as Impressionism, the new school of painting would reach its apogee in the mid-1870s and gradually lose its cohesion in the course of the following decade.

A non-juried, group exhibition was proposed as early as 1867, but not realized until April 1874. Eight shows were eventually held, the last in 1886. Several prescient dealers also organized exhibitions promoting the impressionists. Paul Durand-Ruel handled their works in Paris and tried with few results to market them in London. More successfully, he introduced Impressionism to the American public with "Works in Oil and Pastel by the Impressionists of Paris," an extraordinary show of 310 works held in New York in 1886.

Although differing in background and interests, the impressionists shared a commitment to contemporaneity of vision. They drew motifs from the life about them, whether in the suburbs and the surrounding countryside or in the city. To transpose their visual sensations directly to their canvases, they developed a seemingly spontaneous technique which entailed discernible brushstrokes, high-valued colors and the elimination of traditional chiaroscuro. They sought to convey a sense of immediacy, of capturing the fleeting moment, an aim which was misunderstood by critics who frequently railed against the seeming lack of finish to their works.

Membership in the movement fluctuated. In fact, as was indicated by the title page of the first catalogue, "Société anonyme des Artistes Peintres, Sculpteurs, Graveurs, etc.," the entries were not originally limited to paintings, but included graphics and a few sculptures, with the "etc." denoting painted enamel plaques by Alfred Meyer [139]. A rift soon developed between the landscape and figurative painters. In the 1881 exhibition, for instance, Monet abstained from exhibiting, leaving the field to Degas and his realist cohorts including Jean-François Raffaëlli and Jean-Louis Forain. The following year, the situation was reversed and Degas and his friend Mary Cassatt declined to participate in the group show.

Camille Pissarro was the only impressionist to exhibit in all eight exhibitions. Born on St Thomas, which was then a dependency of Denmark, he remained a Danish

120

Edouard Manet
French, 1832–83
The Café-Concert, 1878
oil on canvas
18 5/8 × 15 1/8 in (47.3 × 39.1 cm)
purchased by Henry Walters,
1909 (37.893)

121

Camille Pissarro

Danish (French school),
1831–1903

*The Versailles Road at
Louveciennes (Snow)*, 1869

oil on canvas

15 1/8 × 18 1/4 in (38.4 × 46.3 cm)

museum purchase, part of the
George A. Lucas Collection at
the Walters Art Gallery, 1996
(37.1989)

122

Camille Pissarro

Danish (French school),
1831–1903

The Church at Eragny, 1884

oil on canvas

21 1/4 × 26 5/16 in (54 × 68.8 cm)

gift of Barbara B. Hirschhorn,
Elizabeth B. Roswell and Mary
Jane Blaustein in memory of
Jacob and Hilda Blaustein,
1991 (37.2653)

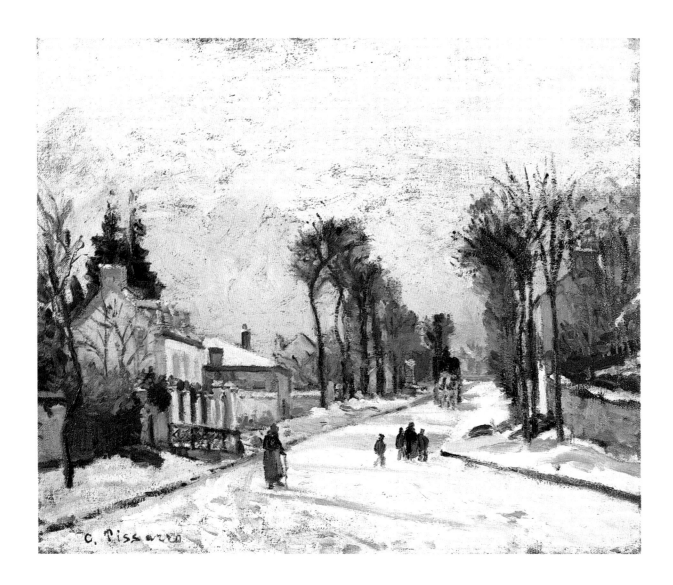

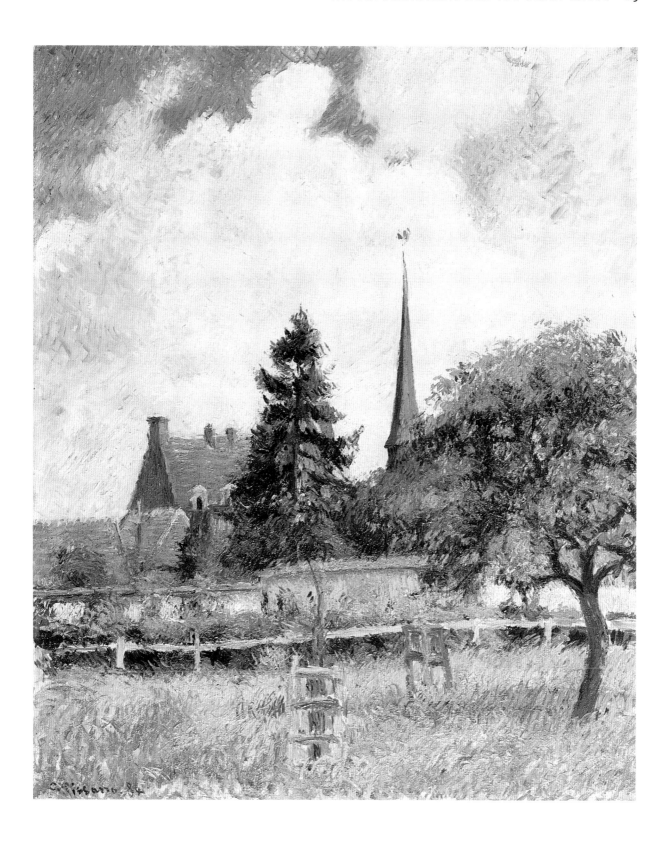

citizen although he was schooled in Passy, outside Paris, and spent almost his entire career in France. While drawing from the model at the Académie Suisse, a free studio which provided no formal instruction, he met Monet and Cézanne and, through the former, he became acquainted with Renoir, Bazille (killed in battle in 1870) and Sisley.

From May 1869 to July 1870, Pissarro and his family resided in the village of Louveciennes, northwest of Paris. That winter he worked side by side with Monet, who was then his house guest, painting views of the village streets under varying weather conditions. One of these works, *The Versailles Road at Louveciennes (Snow),* shows the route with his residence, the yellow house on the left, blanketed under a heavy snowfall [121]. It is a winter sky, leaden near the horizon, and the waning light casts long shadows across the road. Reinforcing the sense of recession is the placement of the figures on the road: an elderly woman trudging through the snow, a cluster of children and, in the distance, a horse-drawn carriage. Pissarro has employed a low-keyed palette limited to buffs, yellows, browns, blues and a few touches of red. Fortunately, he sold this small painting immediately after its completion. In 1870, during the course of the Franco-Prussian War, he lost more than 1,400 works, representing twenty years of labor, when the Prussians stabled their horses in his house.

Although several years older than his colleagues, Pissarro remained remarkably receptive to current trends. At the end of the 1870s, he changed his painting technique and began to apply his pigments in a dense layer, employing short, staccato strokes. In doing so, he achieved a greater sense of luminosity and at the same time more actively engaged the viewer's perception in discerning forms. The change is apparent in *The Church at Eragny* of 1884, a transitional year in the artist's career when he moved further away from Paris to Eragny-sur-Ept [122]. Two years later, at the last impressionist exhibition, his young friends Georges Seurat and Paul Signac introduced Neo-Impressionism. These avant-garde artists and their followers, including Pissarro's son, Lucien, rejected the impressionists' intuitive approach in favor of a more scientific analysis of color and adopted the pointillist technique in which unblended colors were laboriously applied to the canvas in small dots.

Claude Monet is often cited as the quintessential impressionist. He was Parisian by birth, but spent his youth in Le Havre on the Normandy coast. Monet first expressed his artistic inclinations in schoolboy caricatures which he sold for 10 to 20 francs apiece at a local frame and art supply shop. Also carried at this establishment were small, sketchily rendered views of the Normandy

123
Louis-Eugène Boudin
French, 1824–98
Trouville, 1871
oil on panel (a furniture panel)
7 1/4 × 18 1/4 in (18.4 × 46.4 cm)
purchased by Henry Walters,
1910 (37.840)

124
(Oscar-)Claude Monet
French, 1840–1926
Windmills near Zaandam, 1871
oil on canvas
15 1/4 × 28 3/8 in (40 × 72 cm)
purchased by Henry Walters,
1909 (37.894)

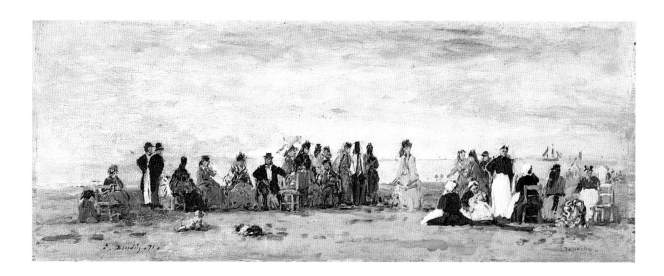

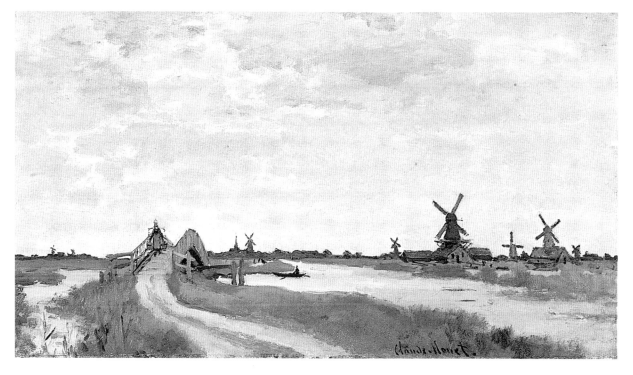

125
(Oscar-)Claude Monet
French, 1840–1926
Springtime, about 1872
oil on canvas
19 ⁸/₁₆ × 25 ¹³/₁₆ in (50 × 65.5 cm)
purchased by Henry Walters,
1903 (37.11)

ports and of vacationers promenading along the beaches, painted by a regional artist, Eugène Boudin [123]. These, Monet lightly dismissed because of their prosaic subject matter and unpolished technique, and only reluctantly did he deign to accompany the elder artist on an outing to paint directly from nature. "Suddenly," Monet later recalled, "a veil was torn away. I had understood—I had realized what painting could be."

At the age of twenty, Monet left Le Havre for Paris

where he was attracted to the landscapes of the Barbizon artists, particularly those of Troyon, Daubigny and Corot, and also to the works of the controversial realist, Gustave Courbet. During the 1860s, he painted directly from nature either in Paris and its environs or in Normandy.

With the outbreak of the Franco-Prussian War in July 1870, and the siege of the capital that September, Monet sought refuge in London. The following May, he decided to visit the Netherlands rather than return directly to Paris,

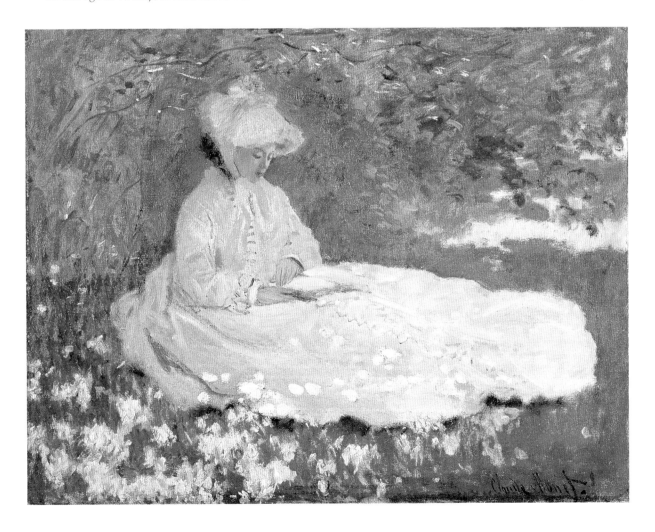

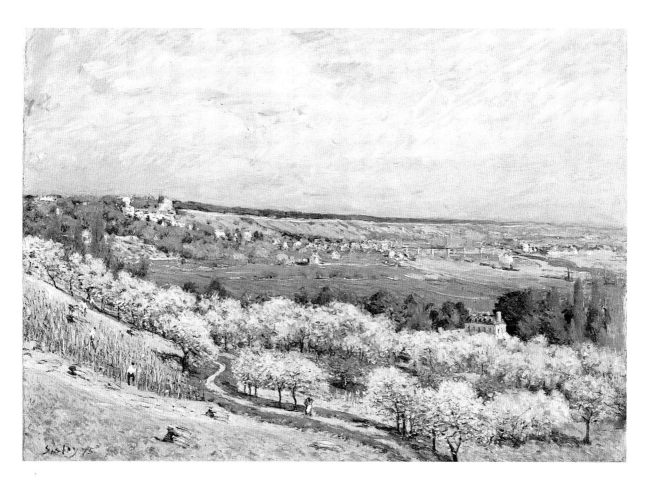

then in the throes of the Commune. For over four months, he and his family resided in Zaandam, a suburb of Amsterdam where, as he wrote to his friend Pissarro, he found enough to paint for a lifetime. *Windmills near Zaandam* is one of the 24 landscapes produced during this stay [124]. Monet has emphasized the expansive, cloud-strewn sky and the flatness of the terrain. Still relying on sharp tonal contrasts, he has silhouetted the dark windmills against the horizon. Cursorily rendered, a girl

in regional dress trudges along the Weerpad, the footpath connecting the villages of Oostzaan and Zaandam.

In late 1871, Monet settled with his family in Argenteuil, a fashionable, suburban village northwest of Paris. Easily accessible to the city by train, Argenteuil flourished as a popular resort for urban pleasure-seekers, who were attracted by the promenade along the banks of the Seine and the lively social life surrounding the boat basin and sailing regattas. His colleagues frequently

126
Alfred Sisley
British (French School),
1839–99
*The Terrace at St-Germain:
Spring*, 1875
oil on canvas
29 × 39 1/4 in (73.6 × 99.6 cm)
purchased by Henry Walters,
1900 (37.992)

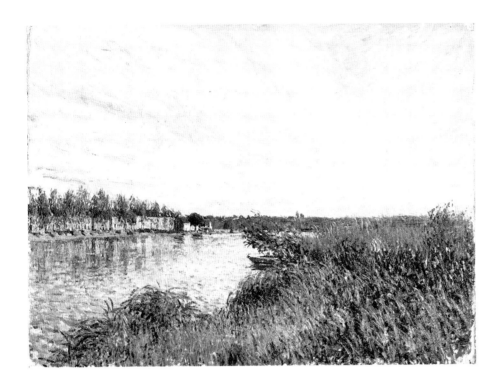

joined him and soon the village became synonymous with Impressionism.

In the spring of 1872, Monet painted a number of small canvases in his garden at Argenteuil showing his wife, Camille, either alone or with Sisley's companion, Adelaide-Eugénie Lescouezec. In *Springtime*, Camille is seated beneath a lilac bush reading a book. Sunlight pierces the foliage overhead, creating dappled patches of light on the ground and across the flounces of her muslin dress which appear to float above the grass [125]. Monet captured not only the figure, but the atmosphere enveloping it. The strong contrasts between light and dark seen in the Zaandam view have been replaced by delicate nuances of color and more modulated brushstrokes varying from

deft touches to broad, blended daubs. This enchanting scene of tranquil domestic life has been tentatively identified as *The Reader*, a painting included in the second Impressionist Exhibition in 1876.

Alfred Sisley can be distinguished from his fellow impressionists by his British nationality—he was born in Paris to English parents—and by his singular commitment to landscape painting. While in London during the 1850s, preparing for a career in commerce, he became familiar with the works of Constable and Turner. Back in Paris by 1860, Sisley enrolled in the Académie Gleyre where he met Monet, Renoir and Bazille. Together with Monet, who would remain a lifelong friend, he followed the precedents of Corot and the Barbizon masters in

127
Alfred Sisley
British (French School),
1839–99
View of St-Mammès, 1881
oil on canvas
17 $^{15}/_{16}$ × 29 $^{1}/_{8}$ in (45.5 × 74 cm)
purchased by Henry Walters,
1912 (37.355)

painting in the Fontainebleau forest until 1872 when he moved his family to the suburban village of Louveciennes.

In a vivid, panoramic view of the Seine valley at nearby St-Germain-en-Laye, Sisley captures the atmospheric and light conditions associated with early spring [126]. He has departed from the contrived compositions of earlier topographical traditions to portray a seemingly limitless expanse of the countryside. The river winding away from Paris creates a sense of recession and at the same time establishes a tension between the surface of the canvas and the illusion of depth. Summarily rendered in the foreground, laborers tend a vineyard and a solitary woman walks through the flowering orchard. On the heights in the distance stands the venerable château which housed the royal court until 1682. Notes of modernity include the town below, the steam-powered tugboats pulling barges and the railroad bridge spanning the river.

In 1880, bowing to the financial exigencies which would plague his career, Sisley withdrew from the vicinity of Paris to the Fontainebleau region where he found cheaper accommodations near the small town of Moret-sur-Loing. The following summer he painted a sequence of views of St-Mammès, the nearby barge-port at the confluence of the Seine and Loing rivers. Slightly shifting his position for each work, he depicted the row of poplar trees and the houses on the opposite quay at specific times of the day and under varying climate conditions. In *View of St-Mammès*, it is a breezy, slightly overcast day [127]. Clouds scud across the sky, grasses sway in the foreground and a ripple across the water's surface breaks the reflections of the houses. Like Pissarro at this time, Sisley has transformed his technique, applying the pigments more densely with more expressive brushstrokes varying from long, broad curves to short, staccato strokes.

Edouard Manet, a pivotal figure in the early development of Impressionism, never participated in the group exhibitions, preferring instead to pursue his career within the framework of the official Salons. He initially enrolled in Couture's independent studio, an experience which he often belittled even though it undoubtedly influenced his development. Manet supplemented this training by copying paintings of earlier schools, both in Paris and in the museums of the Netherlands, the German states, Italy and later Spain, to which his extensive travels often took him. As a result, his art was thoroughly grounded in past traditions. Historical precedents can be established even for his most controversial compositions of the 1860s, including his masterpieces of 1863, *The Picnic on the Grass* and *Olympia* (both Paris, Musée d'Orsay), a feature which only served to rile his critics who were shocked by the harsh

Realism and modernity of his subjects. During the 1870s, he occasionally joined Monet in working directly from nature. At this time, he adopted the brighter palette of the impressionist landscape painters in order to capture the evanescent effects of light and atmosphere.

The *Café-Concert* represents a consummate expression of Manet's Realism from his later years [120]. In 1878/9, he followed a precedent set by Degas in exploring the theme of individuals seated in cafés and cabarets, either inside or outdoors. It was a subject that had been popularized by Frans Hals in Haarlem during the seventeenth century. In Manet's painting, the setting has been identified as the Brasserie Reichshoffen on the Boulevard Rochechouart. The customers are from various walks of life and include, from left to right: a world-weary young woman smoker who is perhaps a prostitute, a stylish, older gentleman resting his hand on the pummel of his walking stick, and a working-class couple. Behind them, a barmaid takes a swig of beer and a singer known as "La Belle Polonaise" is reflected in the mirror in the background. The lack of any interactions between the figures conveys a sense of the loneliness or isolation perceived in modern urban society.

Manet did not delineate his figures but rather modeled them with brushstrokes. He rejected academic methods, in which forms are created by applying successive layers of pigments and glazes over a dark background, and instead placed his colors directly on the canvas with loose, repetitive strokes, leaving the light ground exposed in some areas. Totally rejected are any of the conventional concepts of composition, illustrated for example in Edouard Frère's *The Cold Day* [65]. Each individual in Manet's work has been cropped, either by other figures or by the picture frame, creating an effect comparable to that of a modern snapshot. Numerous ambiguities mark the work: spatial recession is scarcely suggested, the distinctions between the reflections in the mirror and the background are not fully defined and some of the objects in the foreground are scarcely decipherable.

Even though he was reluctant to label himself an impressionist, Edgar Degas played a key role in seven of the group shows. He shared his avant-garde colleagues' realist convictions and was determined to exhibit independently of the official salons.

Degas was born into a wealthy banking family and was reared in privileged circumstances. Abandoning a law career, he studied with Louis Lamothe, a follower of Ingres' disciple Paul Flandrin, and enrolled at the École des Beaux-Arts. His classical training was reinforced by many hours spent copying early masters both at the Louvre and in museums throughout Italy. Degas evolved a

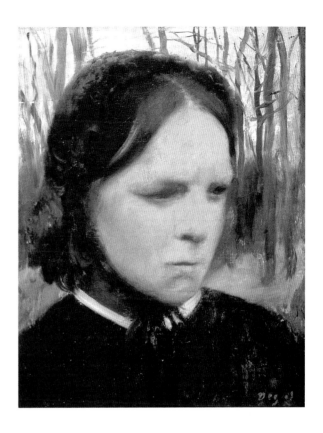

personal approach to painting which represented a synthesis of the opposing styles of Ingres and Delacroix, the two artists he most admired (he once copied Delacroix's sketch for *The Battle of Poitiers* [13]). It was a deliberate, contemplative manner involving preliminary drawings and a reliance on the expressive potential of contours. His upper-bourgeois background inevitably influenced his choice of subjects, such as portraits of relatives and close friends, scenes drawn from the opera and ballet, the racetrack and steeplechase or, antithetically, from the underside of urban life including laundries and cafés.

Estelle Musson Balfour, the daughter of the artist's maternal uncle, Michel Musson of New Orleans, sat for him on a number of occasions [128]. Her first marriage had ended tragically when her husband, Joseph Balfour, was killed while serving in the Confederate Army at the Battle of Corinth in 1862. During the Union Army's occupation of New Orleans, Estelle and her family sought refuge in Bourg-en-Bresse in Normandy. This work is thought to have been executed in 1865 towards the end of the family's stay in France. Degas commented regarding his cousin: "As for Estelle, poor little woman, one cannot look at her without thinking that in front of her are the eyes of a dying man." Her subsequent life was fraught with grief. She would soon lose her sight, her second husband

(the artist's brother, René) would desert her and four of her six children would succumb to various diseases.

Degas had been captivated by equestrian motifs since his youth. In the course of his early travels in Italy, he had recorded in sketches the race of the riderless horses marking the end of Carnival in Rome, the same event that had inspired Géricault. He incorporated horses into his early historical subjects and began to sculpt them in wax and mixed media, capturing them either still or in motion. In 1861/2, Degas first turned to the theme of horses and jockeys before the race.

128
Hilaire-Germaine-Edgar Degas
French, 1834–1917
*Portrait of Estelle Musson
Balfour*, about 1865
oil on canvas mounted on
panel
10 9/16 × 8 5/8 in (26.9 × 21.8 cm)
purchased by Henry Walters,
1903 (37.179)

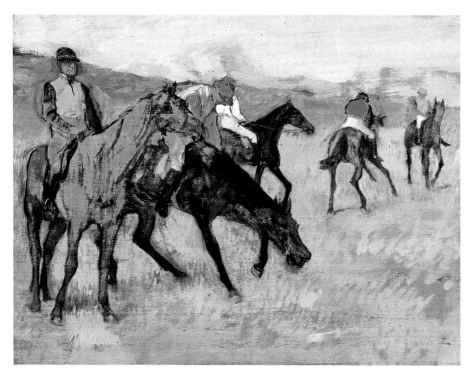

Twenty years later, he produced three closely related small paintings showing the horses and jockeys at post time. In all three entitled *Before the Race* (Williamstown, Sterling and Francine Clark Art Institute; Baltimore, Walters Art Gallery; and Mrs John Hay Whitney Collection), the figures are positioned diagonally across the surface [129]. Minor variations occur in each work, both in colors and in the degree of definition. In the Walters' version, the most sketchily rendered, the setting is barely suggested and the pigments have been thinly applied to exploit the sensuous qualities of the bare wood.

Mary Cassatt, the daughter of a wealthy Pennsylvania banker, traveled extensively through Italy, Belgium and Spain and trained in Paris with several notable teachers including Gérôme and Couture. She met Degas in 1877, and though their friendship would be fitful and end in total estrangement, the encounter proved meaningful for both artists. Under Degas' influence, Cassatt's early, earthy realist style gave way to a more impressionistic approach. He, in turn, recruited a sympathetic partisan for his realist faction of Impressionism. Like Degas, Cassatt explored various techniques, including pastels and graphics. She also shared his abiding interest in Japanese art. Excluded from many of male colleagues' haunts, Cassatt appropriated as her specialty images of upper-class women and children. Characteristic of her later work is a pastel, *Margot in Blue*, showing a child wearing a floppy white bonnet and blue dress [130]. The once dominant

129
Hilaire-Germaine-Edgar Degas
French, 1834–1917
Before the Race, about 1882
oil on panel
10 ⅜ × 13 ¼ in (26.4 × 34.9 cm)
purchased by Henry Walters, 1910 (37.850)

130
Mary Cassatt
American, 1844–1926
Margot in Blue, 1902
pastel on paper backed with canvas
24 × 19 ⅝ in (61 × 50 cm)
purchased by Henry Walters, 1925 (37.303)

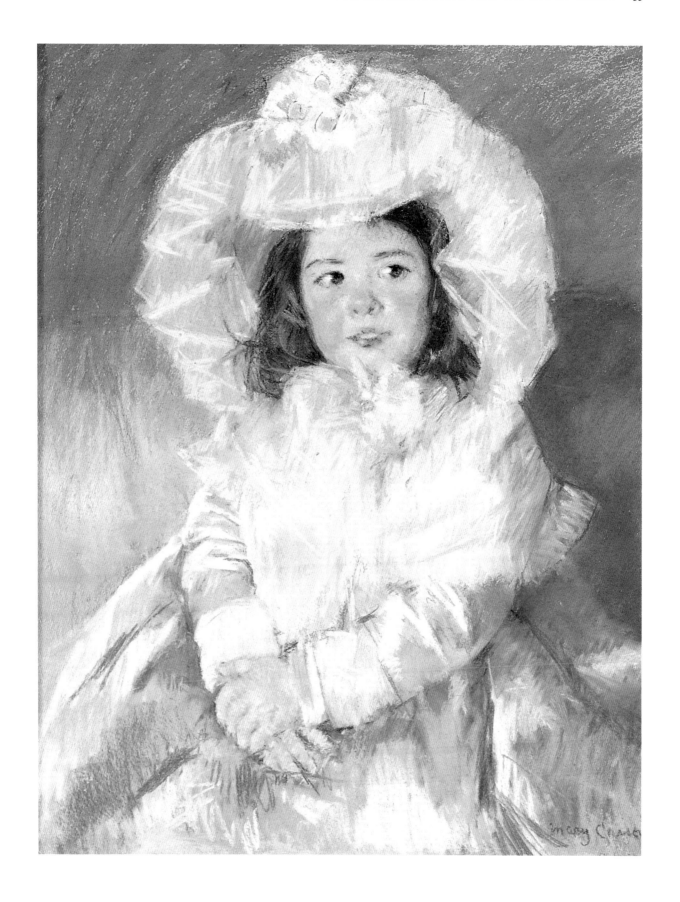

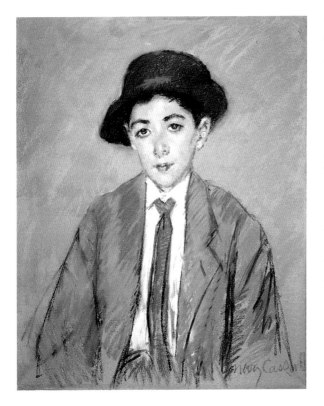

pastel tones have given way to more vivid colors applied with vigorous, intense strokes. Her vigor, even at the age of 66, is demonstrated by a pastel portrait of 12-year-old Charles Kelekian, the son of her friend and art consultant, Dikran Kelekian [131].

Pierre de Puvis de Chavannes' paintings were often included by Durand-Ruel in impressionist exhibitions. Although Puvis adopted the lightened palette of his younger colleagues, he followed an independent course, gaining the respect of both the academic artists and the modernists. The former interpreted his murals of Arcadian scenes as continuations of the classical tradition established by Poussin, and the latter appreciated his stalwart defense of the works of Courbet and of the realists while he served as a member of the Salon jury.

Puvis de Chavannes interpreted contemporary issues in allegorical terms. In one of several paintings produced in the wake of the disastrous military and political events of 1870/1, an adolescent girl holding an oak twig is superimposed against a landscape of blossoming spring flowers, shattered buildings and grave markers [132]. She personifies hope and regeneration, symbolism which Puvis de Chavannes derived from a fourteenth-century Sienese source, the representation of Peace as a seated female figure in Ambrogio Lorenzetti's mural, *Effects of*

131
Mary Cassatt
American, 1844–1926
Portrait of Charles Dikran Kelekian, 1910
pastel on paper
25 ⁹/₁₆ × 21 ¹/₁₆ in (65 × 53.5 cm)
bequest in memory of Charles Dikran Kelekian and Beatrice Altmayer Kelekian, 1992
(37.2656)

132
**Pierre-Cécile Puvis de
Chavannes**
French, 1824–98
Hope, 1872
oil on canvas
40 ⅛ × 51 in (102.5 × 129.5 cm)
purchased by Henry Walters,
1902 (37.156)

Good Government (Siena, Palazzo Pubblico). *Hope* met with mixed reviews when it was exhibited in the 1872 Salon, one critic even complaining that the figure was rather thin and therefore a little deficient in patriotism. Van Gogh, however, was much taken with it and wrote to his brother Théo that "*Hope* by Puvis . . . it is so true. There is an art of the future, and it is going to be so young and lovely."

The resurgence in mural painting during the second half of the nineteenth century can largely be attributed to Puvis de Chavannes. Working on canvases that had been primed with plaster mixed with wax, he created monumental paintings which were installed in many major public buildings in France (also in the Boston Public Library). In addition, he replicated his compositions, either in part or entirely, in smaller easel paintings. In this

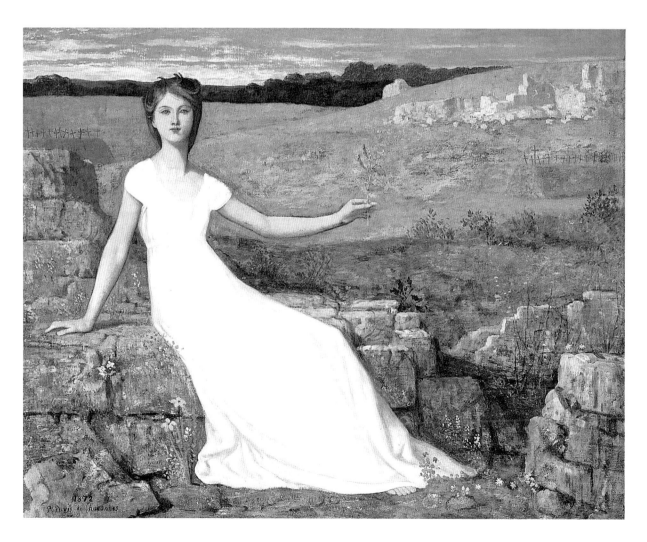

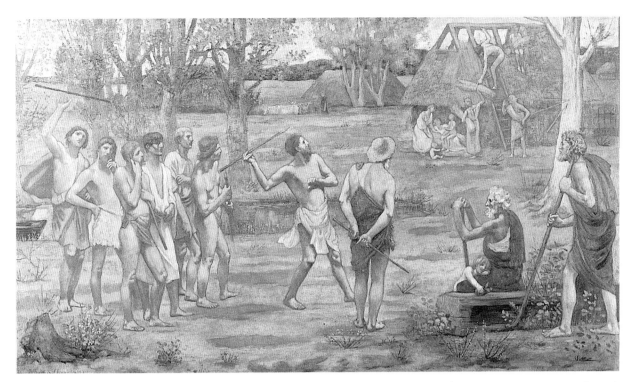

last category falls *Ludus Pro Patria* ("Struggle for the Homeland") which repeats the central section of a mural installed in the Musée de Picardie in Amiens in 1887 [133]. The themes of "Work," "Family" and "Fatherland," with their connotations of revenge following the disasters of the Franco-Prussian War, are expressed in terms of the "Golden Age" of ancient Picardy. Represented are the ages of man, from infancy to dotage. A number of young Gauls exercise with javelins or *piques*, an etymological reference to both Picardy and its early inhabitants who were noted for their adeptness with this weapon. To avoid detracting from the integrity of the architectural setting, Puvis indicated recession with several simplified planes, eliminated extraneous details including shadows and restricted the

range of colors. These characteristics were carried much further by his admirer Paul Gauguin, who would eventually find his own Arcadia in Polynesia. Gauguin abandoned Impressionism for a technique known as cloisonnism in which compositions are rendered in clearly defined, flat areas of color chosen for expressive rather than naturalistic effects.

The American expatriate James McNeill Whistler was an early associate of the impressionists. Shortly after his arrival in Paris in 1855, he enrolled in the Académie Gleyre, and several years later he befriended Manet whom he had met while copying in the Louvre. Although settling in London in 1859, Whistler maintained his contacts with Paris, and in the summer of 1865 he joined Courbet,

133
Pierre-Cécile Puvis de Chavannes
French, 1824–98
Ludus Pro Patria, 1883
oil on canvas
44 7/8 × 77 9/16 in (113.5 × 197 cm)
purchased by Henry Walters, 1897/1909 (37.16)

134
James Abbott McNeill Whistler
American, 1834–1903
Portrait of George A. Lucas, 1886
oil on panel
8 9/16 × 4 5/16 in (21.8 × 12.5 cm)
given to Henry Walters by the
subject, 1908 (37.319)

Boudin and Monet on the Normandy coast. Two years later, Whistler's style underwent a transformation. He rejected Realism and developed a personal, aesthetic approach to painting, one that shared a kinship with music and was based on the harmonious relationship of colors and form. In his portrait of George A. Lucas, sketched at Boissise-la-Bertrand, Whistler eliminated any extraneous detail and reduced his composition to an arrangement of forms in a few low-keyed colors [134].

For Whistler and many other artists during the second half of the nineteenth century, Asian art exerted a profound influence upon their vision. Although Japanese products had previously been known in Europe, it was only after Commodore Matthew C. Perry's naval expedition in 1853/4 that goods from Japan began to reach the West in quantity. Unlike the orientalism inspired by Europe's contacts with Islamic culture, *japonisme* was expressed not simply in the choice of subjects but also in formal and decorative terms. In the *ukiyo-e* prints of Hokusai, Hiroshige, Utamaro and others, for example, the impressionists discovered the "floating world" of simple pleasures and pursuits of daily life that paralleled their own suburban subjects. What particularly attracted them to these Japanese woodblock prints were the unconventional perspectives, the flattening of forms and the

simplification of color schemes. Japanese lacquers, ivories, bronzes and other goods shown at the great international exhibitions (Paris: 1867, 1878, 1889 and 1900; London: 1862; Philadelphia: 1876; Vienna: 1877 and Chicago: 1893) further whetted the public's curiosity

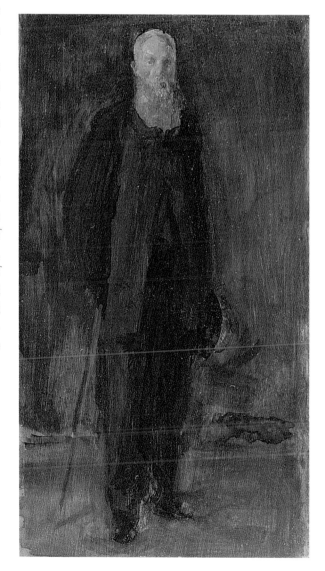

135
François-Eugène Rousseau
French, 1827–90
Vase, about 1878/84
layered glass
H: 7¼ in (18.42 cm)
purchased by William T.
Walters (47.384)

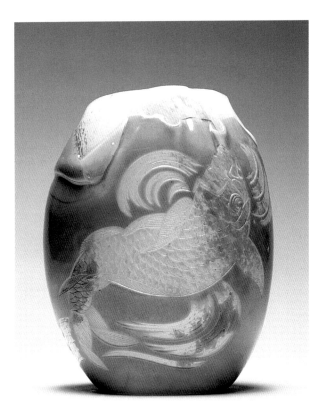

about Asian art and provided a source of inspiration to many progressive artists and designers who began to reinterpret nature, emphasizing those aspects of aquatic and terrestrial life that had previously been overlooked in the West.

Eugène Rousseau had been a pioneer in *japonisme* by commissioning a faience (or tin-glazed) service decorated with Japanese motifs in 1866. At the 1878 Exposition Universelle, he exhibited a number of spectacular examples of the style in glass, which he had produced in collaboration with the manufacturer Appert Frères [135]. Dating from this time is a vase in layered glass showing a carp struggling in swirling water. The image was derived from a print in Hokusai's *Manga*, a collection of nature studies which served as an important source book for many French artists. In its asymmetrical design and exterior layers of flowing glass, the vase simulates the forms and glazes of Japanese pottery. Even the cameo technique of cut and engraved layers of colored glass originated in the Far East in China's "Peking glass."

The New York silver and jewelry firm Tiffany & Co. received numerous awards in Paris in 1878. Its Japanese-inspired silver wares were conceived by the director of its silver department, Edward Chandler Moore, who had been converted to *japonisme* during a visit to the Japanese

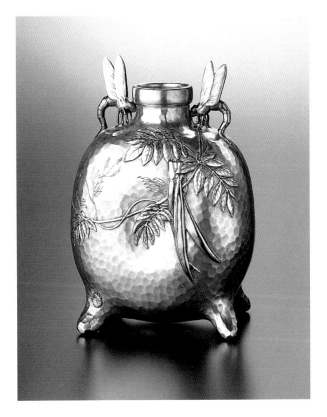

136
Tiffany & Co.
American, founded in 1837
Vase, about 1879
silver and colored metals
H: 6⅝ in (16.9 cm)
purchased by William T.
Walters (57.1706)

department at the 1867 Exposition Universelle. A vase with dragonfly handles and "martelé" (hammered) surfaces, encrusted with multicolored, vegetative motifs, recalls in technique the forged metalwork of the Japanese craftsmen who specialized in the production of swords and sword furniture [136]. Among Moore's most influential admirers was Siegfried Bing, a dealer in Japanese art who visited America in 1894 on behalf of France's directeur des beaux-arts and who played a key role in the emergence of Art Nouveau.

European and American artists did not confine their interests to Japanese art, but also re-examined other Asian cultures. The Anglo-French military expedition to Peking in 1860, followed by the pillaging of the city and the burning of the Summer Palace, resulted in a number of prize Chinese porcelains, jades, bronzes and other precious objects reaching Europe. In 1856, Napoleon III renewed relations with the kingdom of Siam, which had lapsed after the reign of Louis XIV, and five years later an exchange of diplomatic gifts followed. The Empress Eugénie installed the presents, together with the booty from the China campaign, in her "Chinese Museum" at the château of Fontainebleau.

An Alsatian stove-maker turned potter, Théodore Deck, explored various Near and Far Eastern styles. Rather than working in porcelain, the dominant medium in earlier French ceramic production, he turned to faience or tin-glazed earthenware. Deck adopted an eclectic approach, demonstrated by a large plate in the "Chinese style" [137]. The poppy and butterfly motifs recall those found on Chinese porcelains, whereas the repeated gold-yellow spiral pattern in the background is more reminiscent of Japanese Kutani wares. Distinctive of Deck's wares is the intense turquoise color which came to be known as "bleu de Deck."

137
Théodore Deck
French, 1823–91
Plate decorated in the "Chinese style"
glazed earthenware
D: 19⁷/₁₆ in (49.4 cm)
purchased by William T. Walters (48.1909)

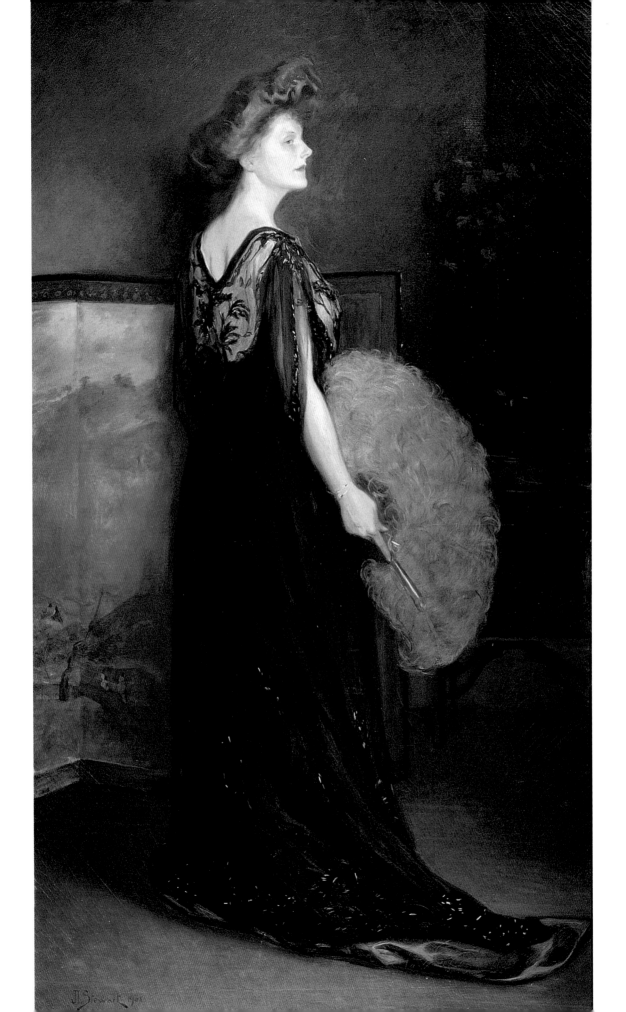

THE END
OF THE CENTURY

Visitors attending the 1900 Exposition Universelle held in Paris marveled at the extraordinary material progress of the past hundred years and prepared to greet the next century. The Belle Époque is remembered as an era of prosperity and relative political stability, but beneath the surface lay issues of deep discontent. An occasional anarchist's bomb or bullet served as a rude reminder of the disparity between the unprecedented wealth enjoyed by a fraction of the population and the abject poverty found in squalid cities and in the countryside blighted by industrialization. As the stability of the era was gradually eroded and old traditions and institutions gave way to new, prevailing optimism was tempered by a sense of apprehension, finality and even of decadence.

The underside of urban life, particularly of the downtrodden poor, provided subjects for the French poet, Jehan Rictus (Gabriel Random de Saint-Amand, 1867–1933). A deluxe cover for his *Soliloquies of the Poor Man* is set with a plaque painted by the enameler Alfred-Bernard Meyer [139]. It illustrates Rictus's verses, transcribed at the right. A wretched individual stares forlornly at a wine merchant's window on the rue Chappe, a small street in Montmartre, and sees reflected the image of Christ. Although the sun is beginning to rise, the street lamp is still burning. To convey the subtle nuances in the light,

Meyer backed the translucent enamels with glistening metallic foil. Recalling Meyer's participation in the first impressionist exhibition in 1874, Rictus inscribed this copy of his book: "*Pour Alfred Meyer/l'admirable artiste/ l'indépendant, le revolté/amical souvenir/de Jehan Rictus (mai 97)*" ("For Alfred Meyer, the admirable artist, the independent, the revolutionary, fond memory, from Jehan Rictus, May, 1897").

During the 1880s, the state's highly centralized administration of the arts began to unravel. Unable to settle disputes over the selection of Salon jurors, the government ceded control of the annual exhibitions to the artists (1880). Two organizations emerged: the Société des Artistes Français (1882) and the Société Nationale des Beaux-Arts (1890). Many of the more liberal artists, however, preferred to participate in the non-juried salons of the Société des Artistes indépendants initiated in 1884.

Both juried Salons welcomed foreign artists as exhibitors, but only the Société Nationale des Beaux-Arts accepted them as members. The American expatriate Julius Stewart, for instance, was elected an associate member of the Société Nationale in 1895 and four years later became secretary of the organization. During his youth in Paris, Stewart had met many of the popular Spanish and Italian artists patronized by his father, the influential

138

Julius LeBlanc Stewart
American, 1855–1919
Portrait of Mrs Francis Stanton Blake, 1908
oil on canvas
78 3/4 × 44 1/4 in (200 × 112.4 cm)
gift of Mr and Mrs Lawrence Houston, 1969 (37.2465)

139
Bookbinding for Jehan Rictus,
Les Soliloques du pauvre, 1897
enameler: Alfred-Bernard Meyer
French, 1832–1904
calf-skin, painted enamel on
copper
8 ¾ × 6 ¼ in (22.2 × 16 cm)
purchased by Henry Walters
(92.1)

collector from Philadelphia, William H. Stewart. After train-
ing with a Spanish genre specialist, Eduardo Zamacoïs, and
also with Gérôme and Madrazo, the cosmopolitan Stewart
quickly earned an international reputation for glittering
views of Parisian society. In his later years, he turned to por-
traiture, usually choosing subjects from his own social set.
In this category fell an elegant, full-length portrait of Mrs
Francis Stanton Blake, an American banker's wife whom
he portrayed holding a splayed ostrich fan, gracefully posed
in front of a folding Japanese screen [138].

In 1895, the Société Nationale's president, Puvis de
Chavannes, invited John LaFarge, an American designer
and painter, to mount an exhibition within the annual
Salon, an unprecedented honor for a foreigner. LaFarge,
already famous for his stained-glass windows, decided to
show a selection of paintings, mostly in watercolor,
recording travels in Japan and the South Seas which he
had undertaken with the historian Henry Adams nine
years earlier. These were selected from a larger exhibition,
"Records of Travel," organized by his dealer, Durand-Ruel.

During a six-week stay in Japan, LaFarge traveled to
Nikko, a Tokugawa mortuary temple town 145 kilometers
northwest of Tokyo, to visit the Boston "japanophiles" and
recent converts to Buddhism, William Sturgis Bigelow
and Ernest Francisco Fenollosa. On this trip, LaFarge

140
John LaFarge
American, 1835–1910
Avenue to the Temple of Iyeyasu,
Nikko. Mid-Day Sun, 1886
watercolor and gouache on
paper
$9^{1}/_{2} \times 11^{1}/_{4}$ in (24 × 30.8 cm)
purchased by Henry Walters,
1907 (37.917)

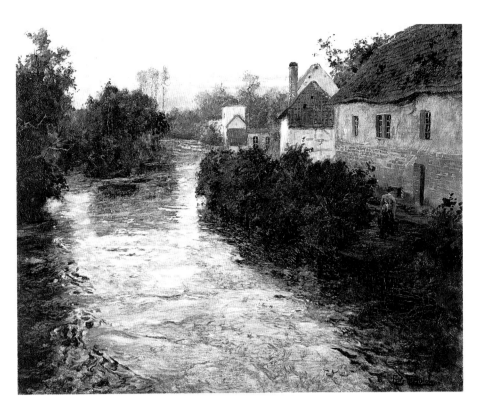

painted a watercolor, *Avenue to the Temple of Iyeyasu, Nikko. Mid-Day Sun*, showing the mortuary gateway leading into the temple complex of Emperor Iyeyasu (1543–1616) [140]. Although he used a photograph as a memory-aid in completing this work, LaFarge demonstrated his remarkable skills in faithfully recording the scene and in capturing the fleeting atmospheric effects. Ironically, the French critics who had previously praised his stained-glass windows were dissatisfied with the watercolors and complained that they reflected the artist's lack of formal, academic training.

For the Norwegian landscape painter Frits Thaulow, 1874 was a pivotal year. His initial visit to Paris that April

coincided with the opening of the first impressionist exhibition, and he also married Ingebord Gad, the sister of Gauguin's recent Danish bride, Mette. Instinctively a realist, Thaulow was attracted to the works of the French academic realists rather than to those of the impressionists. Nevertheless, his name was inevitably linked with the new movement. At a dinner honoring Puvis de Chavannes in 1895, he met Monet and persuaded him to spend a winter in Norway painting snow scenes. Four years later, Georges Petit, Durand-Ruel's principal rival as a dealer for the impressionists, included Thaulow's paintings and pastels in an exhibition featuring the works of Monet and Sisley and several other French landscape painters.

141
John Frederick (Frits) Thaulow
Norwegian, 1847–1906
Village on the Banks of a Stream,
about 1897
oil on canvas
25 9/16 × 31 7/8 in
(64.9 × 80.9 cm)
purchased by Henry Walters
(37.175)

142
Gaston La Touche
French, 1854–1913
The Arbor, or *The Conflict,*
about 1906
70⁷/₈ × 79¹/₈ in (180 × 201 cm)
gift of Roger Goiran in
memory of his grandfather
Emile Chouanard, 1991
(37.2626)

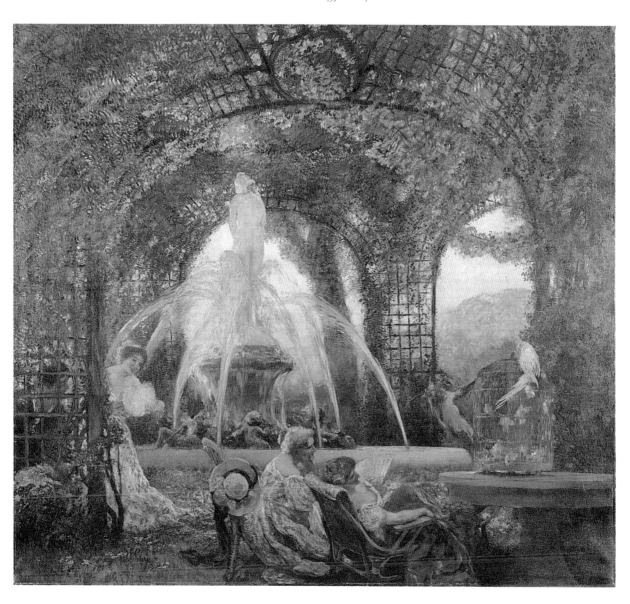

NOTES:CRITICAL
& BIOGRAPHICAL
BY R·B·GRUELLE
COLLECTION OF
W·T·WALTERS

BOWLES EDITOR
AND PUBLISHER

Characteristic of Thaulow's work during the mid-1890s is *Village on the Banks of a Stream*, a painting showing a Normandy village with its distinctive thatched roofs. At this time, Thaulow frequented the fashionable port-town of Dieppe and explored on bicycle the neighboring villages. The high horizon in this composition permitted him to focus on one of his favorite motifs, a swiftly eddying stream. As is typical of his landscapes, the lighting is subdued and the colors are warm and suffused [141].

The French artist Gaston La Touche, also began his career as a realist, perhaps as a result of an early friendship with Manet. About 1890, when he started to exhibit in the salons of the Société Nationale des Beaux-Arts, La Touche changed course and turned to large, decorative paintings

recalling the *fêtes galantes* and *fêtes champêtres* of the early eighteenth-century master Antoine Watteau. Typical of this genre is a redolent scene of ladies languorously reclining in a park, either at St-Cloud or Versailles [142]. They appear oblivious to the conflict between a parrot and a monkey on the cage in the foreground. La Touche's charming reveries, painted in distinctive, harmonious colors, captivated wealthy collectors who may have shared his nostalgia for France's *ancien régime*.

Ever since the Great International Exhibition held in London in 1851, nations had vied with one another in promoting their art manufactures. The rapid industrialization of the "applied arts" had not been without detractors. One reaction in Great Britain and America during the

143
Title Page, R.B. Gruelle, *Notes: Critical and Biographical— Collection of W.T. Walters*, Indianapolis, 1895.

The typography is Old Style Antique and the decorative motifs and the title page are the work of Bruce Rogers (1870–1957).

H: 9 ¹/₂ in (24.2 cm)

commissioned by William T. Walters, 1894

1880s and 1890s was the emergence of the Arts and Crafts movement. It was largely based on the principles of the designer and author William Morris, a socialist and an idealist who called for works of art to be true to materials, and for simplicity of form and economy of means. For inspiration, Morris looked to the Middle Ages, a period, he maintained, when art was made for and by the people. Seeking to reform the art of typography and to print books which were both beautiful and easy to read, Morris established the Kelmscott Press. The influence of his press would have wide-reaching effects, even in the United States, as is demonstrated by a catalogue of the Walters collection written by R.B. Gruelle and issued by J.M. Bowles from the press of Carlon and Hollenbeck of Indianapolis in 1895 [143]. Set in "Old Style Antique" and printed in black and red, the typography resembled that used at the Kelmscott Press. Page proofs were, in fact, submitted to Morris for approval. Bruce Rogers, who designed the initial letters and ornamental motifs, came to be regarded as one of America's foremost typographers of the twentieth century.

In the mid-nineteenth century, France lagged behind other European countries in the promotion of the industrial arts. To remedy this situation, the Union Centrale des Beaux-Arts appliqués à l'Industrie was established in 1864. However, it was not until the 1890s that

144
Louis Comfort Tiffany
American, 1848–1933
Tall Vase, 1895/8
cased, cut and engraved favrile glass
H: 12 3/8 in (31.1 cm)
purchased by Henry Walters
(47.385)

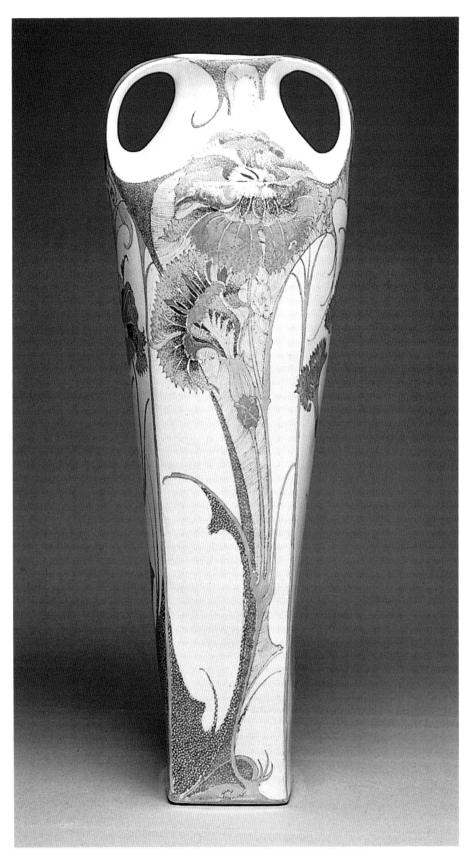

145
Vase
Dutch, 1902
Rozenburg Art Pottery
designer: Jurriaan Jurriaan Kok
decorator: Sam Schellink, Jr.
"egg-shell porcelain"
H: 10¼ in (26 cm)
gift of Mrs Campbell Lloyd
Stirling, 1973 (48.2356)

146
René Lalique
French, 1860–1945
Pansy Brooch, 1902/4
gold, glass, *plique-à-jour*
enamel, sapphire
3 ¹/₁₆ × 5 ¹/₂ in (8.1 × 13.4 cm)
purchased by Henry Walters,
1904 (57.943)

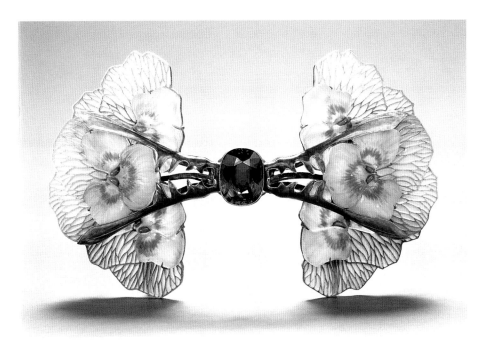

decorative arts were exhibited together with fine arts in the Paris salons.

Just as the salon paintings at the turn of the century had defied easy stylistic categorization, the decorative arts reflected a diversity of trends. Art Nouveau emerged during the mid-1890s, but its roots can be traced to the preceding decade. Primarily decorative in nature, it called for a unified approach to the arts and was most vividly manifested in interior decoration, architecture and graphics. More a movement than a single style, Art Nouveau assumed various guises in different countries and cities, often reflecting earlier, regional traditions. In Glasgow and Vienna, for example, rectilinear designs dominated, but elsewhere, especially in France, Belgium and Italy, where rococo traditions were deeply ingrained, Art Nouveau was more often conceived in organic, curvilinear

terms. Basically a rejection of historicism, it called for a re-examination of the vegetative and zoological aspects of nature, particularly as seen in the light of Japanese art. Originally, this development went under various names including "Style Moderne," "Style nouille" (noodle style), "Jugendstil" and "Stile Liberty," but the term that has prevailed is derived from the gallery, "L'Art Nouveau," opened in Paris in 1895 by Siegfried Bing, a former dealer in Japanese art. This establishment, together with Julius Meier-Graefe's La Maison Moderne, established in 1898, became the principal purveyors of Art Nouveau.

In his report on the state of the arts in America, published on behalf of the French government in 1896, Bing singled out for special notice the products of the Tiffany Glass and Decorating Company operated by Louis Comfort Tiffany, the son of the founder of Tiffany & Co.

147
André-Fernand Thesmar
French, 1843–1912
Cup with Poppies, 1903
gold and *plique-à-jour* enamel
D: 3 5/8 in (9.1 cm)
purchased by Henry Walters
(44.573)

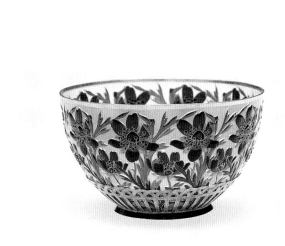

When Bing featured Tiffany's Favrile glass (after *fabrile*, Old English for hand-wrought) in his Paris gallery, it was immediately recognized as a principal manifestation of Art Nouveau. An early example is unusual in that rather than being decorated in the rich hues and with the iridescence associated with Favrile glass, it is cased or layered and then cut and engraved with water-lily and wild carrot motifs [144]. The engraving is attributed to Fredolin Kreischmann, an Austrian glass-cutter who was employed by the company from 1893 until his death five years later.

The eggshell porcelain (actually thin, earthenware made with pipe-clay) produced by Jurriaan Jurriaan Kok at the Rozenburg Art Pottery in The Hague is the quintessential expression of Art Nouveau in ceramics. A slender, delicate vase demonstrates the harmony between form and decoration characteristic of these wares [145]. The

dynamic outlines of the vase's handles and the subtle transition of its contours, flowing from a square base to a rounded neck, are matched by the asymmetrical, rhythmical patterns of the stylized floral decoration rendered in pastel shades over a cream-colored, translucent ground. What distinguishes Art Nouveau floral designs from earlier nineteenth-century decoration in which blossoms were emphasized, is the exploitation of the taut curves of the plant stems and leaves. The gossamer and the pebble-like designs in the ground have been likened to those occurring in Dutch East Indian crafts, including Javanese shadow puppets and batiks.

René Lalique stands apart from his colleagues at the turn of the century as one of the most innovative designers working in any medium. He and his competitors, Alphonse Fouquet and the Maison Vever among others, transformed the role of jewelry, elevating it from personal adornment to a major vehicle for artistic expression. Drawing from the Arts and Crafts movement, Japanese art, renaissance jewelry and, most significantly, from the observation of nature, Lalique revolutionized jewelry design. Although he had apprenticed in *joaillerie*, or precious, gem-set jewelry, he turned in the early 1890s to *bijouterie*, or the arts of the goldsmith and the enameler. He incorporated into his designs such materials as horn,

148
Tiffany & Co.
American, founded in 1837
Iris Corsage Ornament
gold, sapphires, demantoid
garnets, topaz and diamonds
H: 9 ¹/₂ in (24.1 cm)
purchased by Henry Walters,
1900 (57.939)

149
George Spaulding Farnham
American, 1859–1927
Design for Iris Corsage
Ornament, about 1900
watercolor on tracing paper
11 ²/₅ × 8 ³/₅ in (28.9 × 21.8 cm)
gift of Tiffany & Co., New York,
1988 (37.2632)

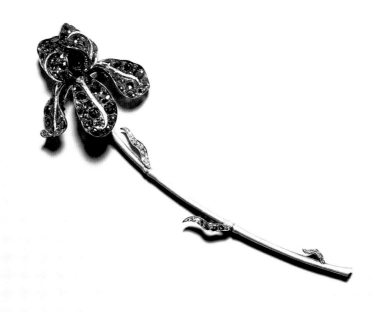

ivory and glass which had little monetary value, but which offered unusual aesthetic possibilities. At the Exposition Universelle in 1900, Lalique displayed his highly imaginative creations embodying such motifs as rooster heads, peacocks, serpents and mutations of various life forms. These brought him official honors and confirmed his position as one of the foremost exponents of Art Nouveau.

By 1904, when he mounted a large display at the Louisiana Purchase Exposition (St Louis, Missouri), Lalique had already begun to abandon Art Nouveau. Among the pieces he showed on that occasion was a corsage ornament of pansy blossoms executed in a combination of cast glass and *plique-à-jour*, or openwork, enamel [146]. Lalique's symmetrical design and use of molded glass anticipates his decision in 1909 to renounce jewelry production and turn to manufacturing glass.

Lalique may have learned the *plique-à-jour* technique from André-Fernand Thesmar, an enameler whose remarkable skills were demonstrated in his small, exquisite cups. In their production, he temporarily backed a gold-wire framework with a metal support which was removed after the firing of the enamels, creating an effect similar to that of stained glass [147].

The exuberance of the age is conveyed by a spectacular brooch in the form of an iris which Tiffany & Co. displayed in Paris in 1900 [148]. George Spaulding Farnham, the firm's chief designer, and George F. Kunz, its illustrious gemmologist, collaborated in its production. To translate naturalistically Farnham's design and to render the variations in the blossom's color, Kunz, a longtime advocate for American gemstones, employed 139 Montana sapphires ranging in color from cornflower blue to violet.

The antithesis to Art Nouveau was a conservative, classicizing trend, sometimes termed the Edwardian Baroque or the garland style, which remained very much in vogue, especially among the higher strata of European society, until World War I. It is characterized by the retention of eighteenth-century decoration and is most vividly expressed in the opulent arts of the goldsmith and jeweler.

Czar Nicholas II appointed the Fabergé firm to represent Russian jewelry production at the Exposition Universelle in 1900. Awards including a gold medal as well as the Order of the Légion d'honneur were showered on Peter Carl Fabergé as a result of his firm's display of imperial Easter eggs and of replicas of the crown regalia. Fabergé revived the motifs and techniques of eighteenth-century France, an era of unsurpassed refinement in the arts of goldsmithing and jewelry, but he employed them with a feeling for amplitude, or even grandeur of scale, expressive of his own time. This quality is illustrated in an

egg commissioned by the Czar in 1907 as a gift for his wife, Alexandra Feodorovna, to celebrate the birth of their son, Alexei Nikolaievich. Henrick Wigström, the firm's head workmaster after 1903, was responsible for its creation [150]. A rose bush with blossoms and leaves of opaque and translucent enamel stretches across a trellis of rose-cut diamonds. The green background is rendered in translucent enamel applied over *guilloché*, or machine-engraved gold, a technique perfected during the second half of the eighteenth century. Recent research has confirmed that the egg once contained, as a surprise, a diamond necklace (now lost) with an ivory miniature of the Czarevich. This dazzling jewel bespeaks an era of opulence that was doomed to extinction by the outbreak of World War I.

150
Peter Carl Fabergé
Russian, 1846–1920
workmaster: Henrick Wigström
The Rose Trellis Easter Egg,
1907
gold, enamel and diamonds
H: 3 $^1/_{16}$ in (7.7 cm)
purchased by Henry Walters,
1930 (44.501)

INDEX

Figures in **bold** refer to illustrations